BEYOND THE BASICS

By

GEORGE D. LEPP

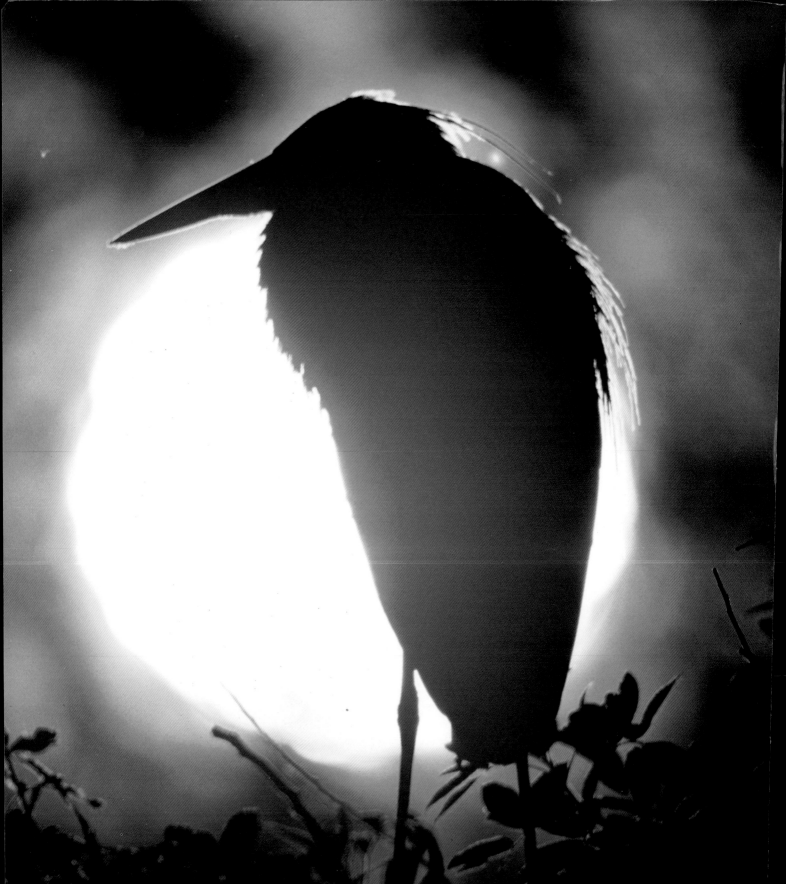

BEYOND THE BASICS

INNOVATIVE TECHNIQUES FOR NATURE PHOTOGRAPHY

By

GEORGE D. LEPP

PHOTOGRAPHS BY

GEORGE D. LEPP

TEXT BY

GEORGE D. LEPP &

KATHRYN THOMAS ROBERTS

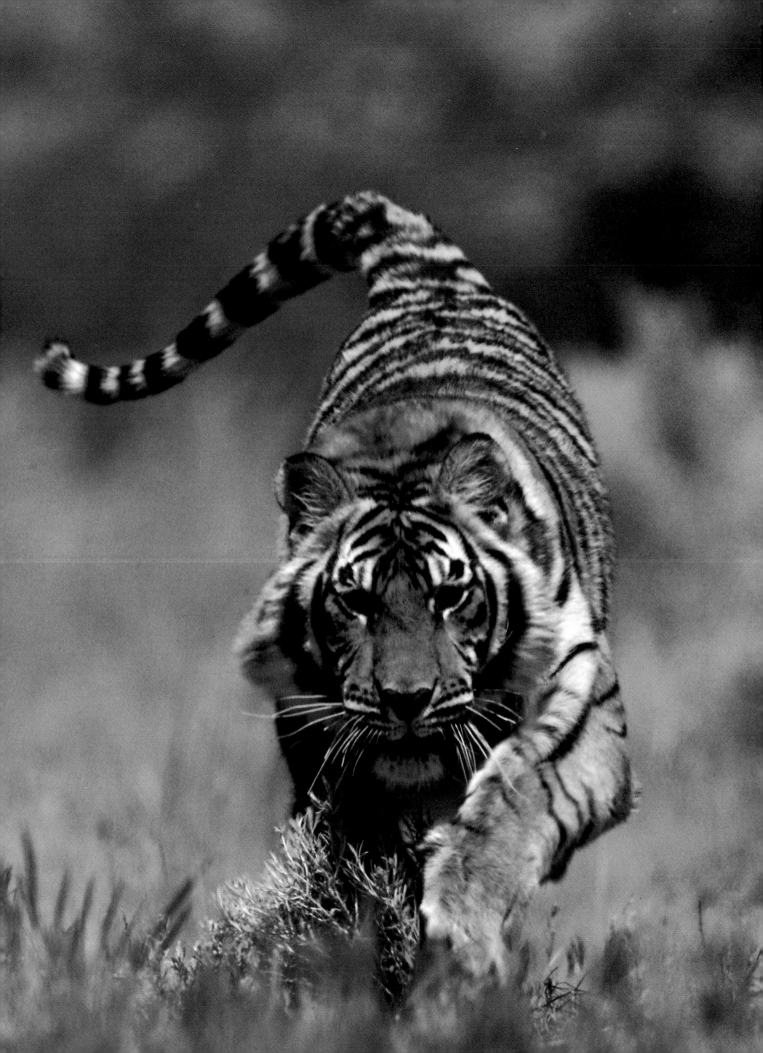

TABLE OF CONTENTS

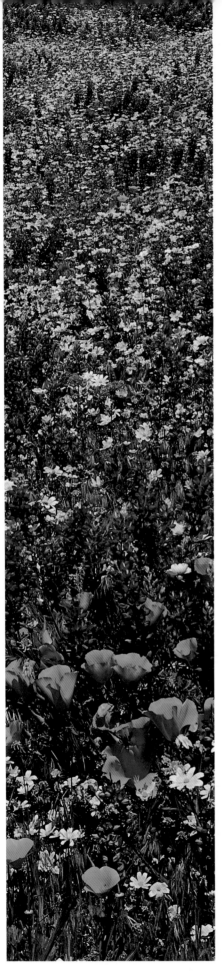

The grand show is eternal. It is always sunrise somewhere; the dew is never all dried at once; a shower is forever falling; vapor is ever rising. Eternal sunrise, eternal sunset, eternal dawn and gloaming, on sea and continents and islands, each in its turn, as the round earth rolls.

John Muir, 1913

Cover: **Great Egret Courtship Display**. Western Florida rookery. 600mm f/4 lens; 100 ISO film.

Page i: **Surf Bubbles.** California central coast. 100mm f/2.8 macro lens; 64 ISO film.

Page ii: **Blue Heron Silhouette**. Western Florida rookery. 600mm f/4 lens with 2X tele-extender (1200mm); 100 ISO film.

Page iv: **Bengal Tiger Rush**. Controlled animal. 600mm f/4 lens; 1/500 second at f/5.6 on 100 ISO film.

Page vi: **Wildflower Array**. Antelope Valley, California. 24mm tilt/shift lens; 50 ISO film.

Page vii: **Arlie's Favorite.** Belding's ground squirrel with shooting star, Yosemite National Park. 500mm f/4.5 lens; 50 ISO film.

Page viii: **California Poppy and Buttercup.** California State Poppy Preserve, Antelope Valley. 100-300mm zoom lens; 50 ISO film.

Page xi: **Rising Sun over Indian Chief.** Monument Valley, Arizona. 500mm f/4.5 lens with 1.4X tele-extender (700mm); 50 ISO film.

Book design and production by Pandora & Company, Los Osos, California. Produced: Macintosh Centris 650 using QuarkXPress, Photoshop and Kodak's CD Access. Text imported from IBM to Mac using Microsoft Word. Low resolution CD ROM photographic images placed for position and sizing for open pre-press interface. Typestyles: Adobe Garamond, Bouvelard, Charlemagne, Helvetica Narrow and Tekton.

Beyond the Basics
Innovative Techniques for Nature Photography

ISBN 0-9637313-0-0
Library of Congress Catalog Card Number: 93-091588

Published by: Lepp and Associates
 P.O. Box 6240
 Los Osos, CA 93412
 805.528.7385

Printed in Hong Kong

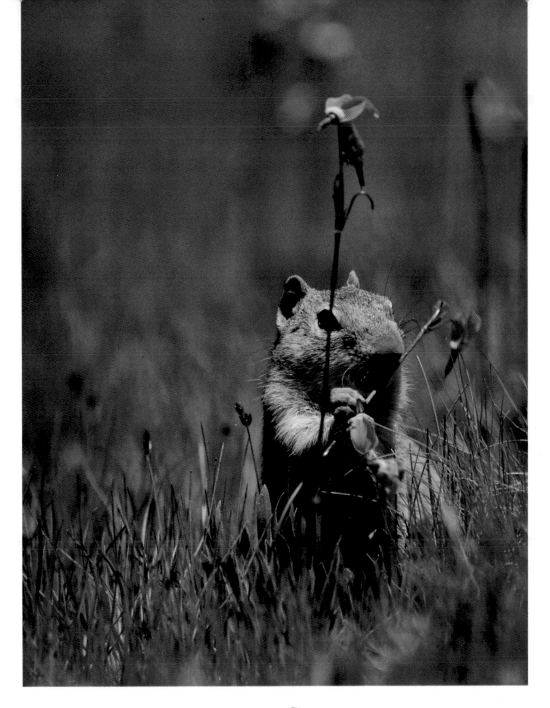

For Arlie, my wife,

who for 26 years has

shared and supported

my dreams, projects,

passion — and my view

from the window.

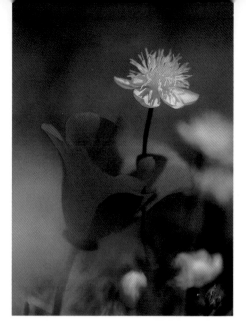

ACKNOWLEDGMENTS

If you find this book easy to read, or the words eloquent at times, I can't take all the credit. Kathryn Thomas Roberts has taken my convoluted thoughts and made sense of them by administering the "Kathy test" and then restructuring it all in a readable form.

When dealing with the photography of natural subjects, information comes from biologists as well as photographers. I have some college background in wildlife biology, but working with experts on specific subjects is tremendously helpful and the only way to accomplish significant photographs of a species. Over the years I've learned a lot from Lee Waian about black-shouldered kites, the natural world in general, and the interaction of humans with wildlife; Lincoln Brower, with his wealth of knowledge of monarch butterflies; Paul and Cindy Sherman about wildlife in the eastern Sierra Nevada mountains (they introduced me to the Mono Lake area and I will be eternally grateful for that); and Richard Hansen with his field knowledge of birds and ability to find nests where I've already looked. Thanks to ecological biologist Andrea Kaus for her comments on conservation, and to the other scientists who have so willingly shared their time and knowledge with me.

The photography side of what I do is supported by my colleagues
in the form of helping with workshops, sharing information on
subjects, and the continuous problem solving that nature
photography entails. John Shaw, Dewitt Jones, Rod Plank,
Wayne Lynch, David Middleton, Darrell Gulin, Jeff Foott,
Linde Waidhofer, Ron Garrison, Roger Tory Peterson, Hal Clason,
and Jack Clark have earned my respect and appreciation; their
freely shared experience and advice have contributed to the
content of this book.

Each of us has come by our education in a different way. I am
grateful to Brooks Institute of Photography and its president,
Ernie Brooks, Jr., for giving me the foundations on which to
build a satisfying career in photography.

I wish to acknowledge Joe Van Os and Randy Green of Van Os
Photo Safaris for the opportunity to travel to photographic
destinations, and all of the workshop participants that
photographed with me and shared those experiences. Various
manufacturers have supported the images you see here by designing
and marketing superb equipment. But Dave Metz and Chuck
Westfall from Canon USA are the best examples I know of a
company giving support to the users of a product. If I have answers
for you, it's because they were willing to make available to me the
methods and equipment to find those answers.

Without a voice, I wouldn't be able to reach the photographers
that may benefit from my efforts. *Outdoor Photographer* magazine
has been an important vehicle to reach the readers and develop the
writing that is presented here. Steve Werner took a chance on me
at the start of his publication, and Jim Lawrence and Tom Harrop
have worked with me over the years to develop the information
presented in the magazine and on these pages.

Friends and family also play a large part in any success I may have had and in the pleasure I find in what I do. My parents, Dave and Elly, gave me my first camera at an early age and have always encouraged me in whatever it is that I am doing. Arlie, my wife and partner in all things, has supported my work in every way. My son Tory has been a delight and a help for all his eighteen years, recently enhancing my enjoyment of my work by sharing it with me. Good friends Bill and Lanier Sleuter have shared in the making of so many of the images presented here, with Bill adding considerably to my base of outdoor and photographic knowledge. Jack Clark is not only a great friend but also a wonderful photographer who has collaborated with me on many projects; some of his expertise is shared with you in these pages through me.

Lastly, I want to acknowledge two dear friends and avid amateur photographers who influenced me greatly. Warren Karber shared in the taking of many of these images, helped create my slide shows and seminar presentations, and demonstrated an appreciation of life that all of us would do well to follow. David Thomas had a love of photography and nature that gave pleasure to everyone around him. He introduced me to hummingbirds, a subject that has given Arlie and me much enjoyment. We miss them both.

\mathcal{F}OREWORD

With all the books available for nature photographers, why do we need one more? Because nearly all the other books are written for the photographer just getting started in the field. The thousands of dedicated photographers who come to my lectures have taught me that many of you already have mastered the basics and are eager to explore the more sophisticated techniques that elevate images toward professional levels of quality. You're looking forward to the creative opportunities offered by the increasingly precise and flexible equipment that is revolutionizing the way we think about practicing the art of photography.

I've always photographed with the idea that future viewers of my images will need to find something new in them. I have to present the subject in some way that is different from the perspective offered on a daily basis. These days, with instant global communication and photographers combing every nook and cranny of the planet for the ultimate image, we've seen just about everything at least once. The day is gone when all a photographer had to do was to show the audience something they'd never seen before. The compelling image now goes beyond simple documentation of the subject; it's closer, brighter, from a different angle, and it bears the photographer's particular mark of creativity or aesthetic perspective.

Nature photography carries with it the special bonuses of sensual pleasure and environmental education. It teaches us, the photographers, to look more closely at what's around us and to understand and appreciate the non-human complexities of the world. Take a group of average tourists who aren't "into" nature photography and send them to Yellowstone National Park. They'll make the loop through the park in probably two days, admire the bison, elk, maybe a coyote and a moose, spend a few minutes gazing from each of the overlooks in the canyon, and may even be lucky enough to see a spouting geyser. Each day they'll probably make sure they get back to camp or a motel before it gets too late. They're on vacation, so they'll sleep late in the morning. But take a collection of nature photographers to Yellowstone, and you'll be lucky to drag them out in a week. They'll seek out the same bison, elk, and other wildlife, but after finding them they'll stay and watch to see what the animals are going to do, capturing any notable behavior on film. The landscape isn't just to be seen, admired, and left behind by these folk. They're waiting for when the light is just right for the photograph that conveys what they are feeling about the place. They'll get there before sunrise and leave after dark. Which group sees the surface of Yellowstone, and which experiences the depth of the beauty and explores the mystery of the park and its residents?

Nature photography is a picture window onto the natural world. It is revealed to others through our photographs. But how clear your window is, how bright, or how inspiring, will depend on how well you apply the tools of your craft. For what you want to do, this book's for you. I'm looking forward to seeing your results.

THE NATURE PHOTOGRAPHER IN THE NATURAL ENVIRONMENT

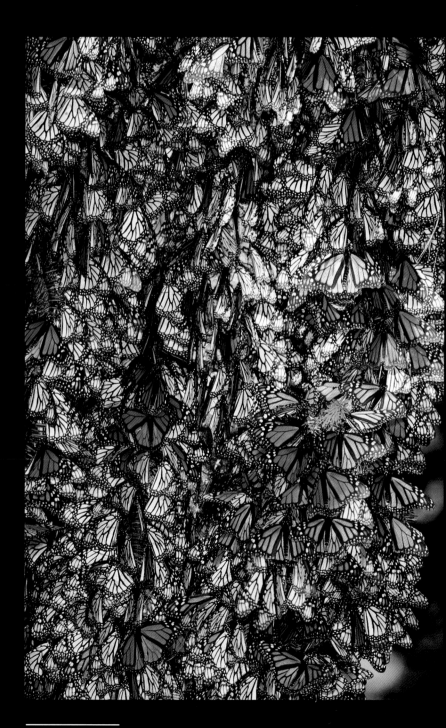

Monarch Tapestry

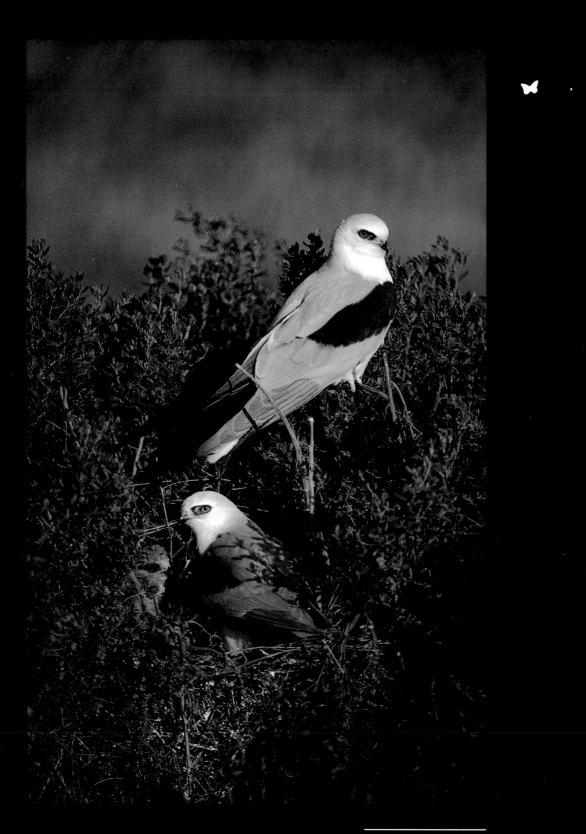
Black-shouldered Kites

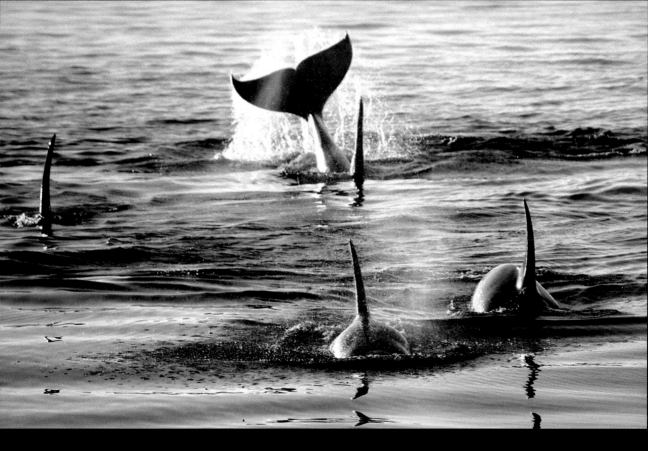

Orca Pod on the Move

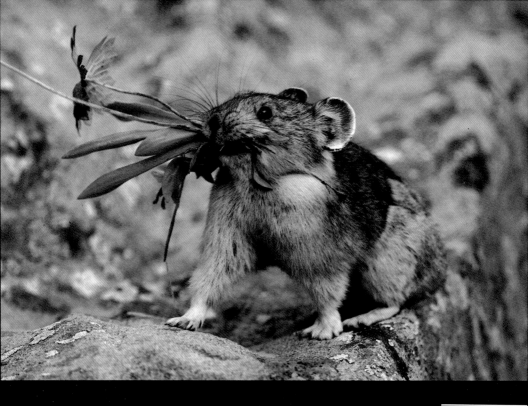

Pika Collecting
Winter Forage

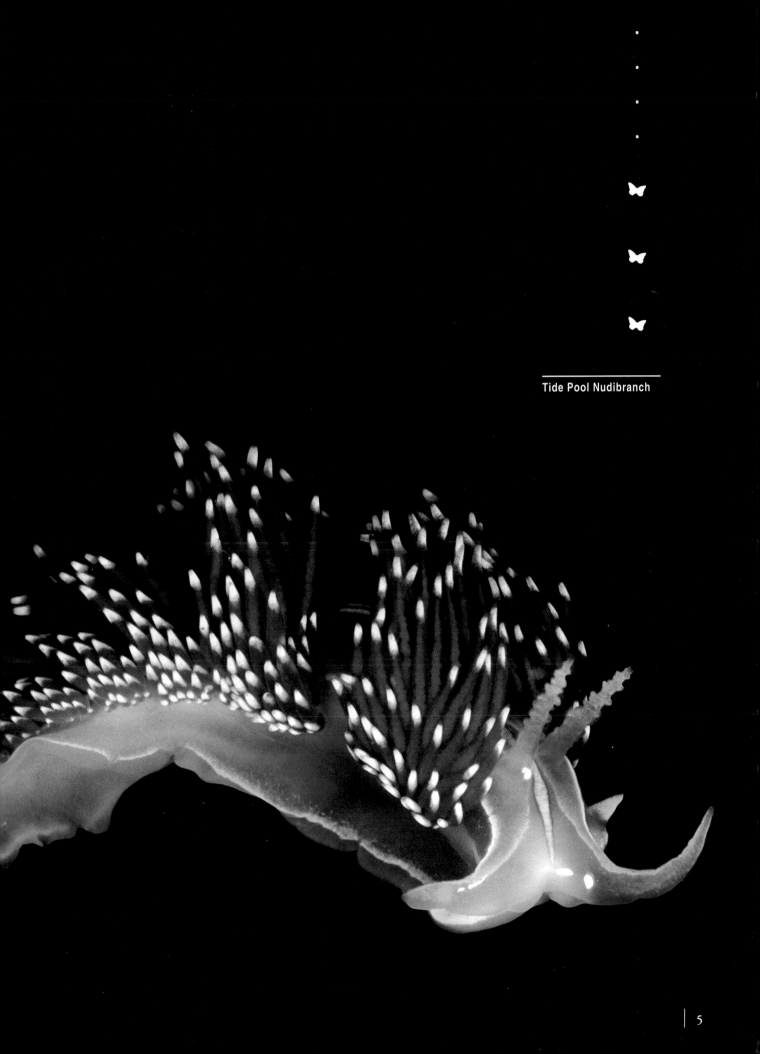

Tide Pool Nudibranch

Monarch Tapestry

Overwintering monarch butter-flies blanket a pine branch in the high mountains of central Mexico. An electronic flash was used to bring out the color of the heavily shaded clusters of butterflies. The correctly exposed sky in the lower right corner was accomplished by matching the electronic flash exposure to the ambient light behind the subject. 200mm lens; 64 ISO film.

Black-shouldered Kites

Until recently, these raptors were threatened by loss of habitat to grazing livestock. The kites' main food source, field mice, thrive in deep grasses. Kites are named for their method of hunting; they hover on the breeze above a prospective meal. Photographed from a blind near Santa Barbara, California. 500mm lens; 25 ISO film.

Orca Pod on the Move

A pod of orca whales heads directly towards the boat. It wasn't in the way; they simply dove under it, surfaced immediately, and continued their trajectory on the other side. Autofocus is a useful tool for photography of such subjects, because their activity is unceasing and unpre-dictable. Critical focus is accomplished automatically while the photographer frames the subject, since there is seldom time to accomplish both adjustments separately. These orcas were photographed off Vancouver Island, British Columbia, Canada. Autofocus camera and 100-300mm f/5.6 lens; 100 ISO film.

Pika Collecting Winter Forage

Pixieish pikas scurry around collecting vegetation to store in their rocky homes for winter. Autofocus kept the image sharp while this small mammal scampered back and forth before the photographer. Subjects like these give considerable pleasure and are a satisfying alternative to the large hairy mammals many nature photographers pursue. Photographed at Yankee Boy Basin in the San Juan Mountains of Colorado during the month of August. Autofocus camera with 300mm f/2.8 lens and 2X tele-extender (600mm); 100 ISO film.

Tide Pool Nudibranch

A Hermissenda nudibranch (thick-horned aeolid) glides through a tide pool along the central coast of California. This beautiful marine snail is only an inch in length and was photographed using macro techniques and electronic flash. A 100mm macro lens and two powerful hotshoe flashes were used on a Macro Bracket to light the subject, which was just below the surface of the water. If tide pool specimens are moved to a more convenient location for photography, it is imperative that they be returned to their exact original locations. Tide pool animals have very specific life-sustaining rquirements. The film used was 50 ISO.

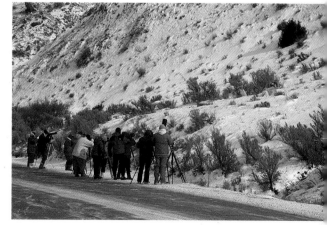

THE NATURE PHOTOGRAPHER IN THE NATURAL ENVIRONMENT

Principles for Field Photography

No thorough discussion of wildlife and nature photography can separate photographic technique from environmental sensitivity, a concept not only of conscience, but of practical and aesthetic importance to the photographer seeking to capture images that are rare, beautiful, and informative. The more sophisticated the photographer's knowledge of the subjects, the better the chances of bringing back extraordinary photographs without jeopardizing any of the plants or creatures in the photographic environment—including the photographer.

Those on the cutting edge of conservation science now maintain that there is no virgin wilderness—that the modern or ancient presence of humans has influenced virtually every place. Even protected areas—land set aside from humans—represent a human intervention. Humankind is a part of, rather than a witness to, the biosphere.

Thus when approaching "natural" subjects, the photographer joins a larger community of flora and fauna, their protectors, exploiters, and observers. Every independent action could have long-term import for other members of that community, including human residents, visiting photographers, researchers, and nature hobbyists. It is incumbent upon each of the humans entering the natural photographic environment, therefore, to maintain high standards of conduct based upon keen observation skills and thorough understanding of the various residents of the area.

When photographing in the wild it is important to remember a few basic concepts. First, carelessness may endanger your life,

A horde of photographers gathers on the road between Gardiner, Montana and Mammoth Hot Springs in Yellowstone National Park to photograph a couple of bighorn sheep. While this looks like a clear case of group harassment, the photographers observed the Park rules by staying on the road and not displacing the animals. The animals, seemingly oblivious to the encounter, were bedded down and stayed in that position until after the photographers left. 28-105mm lens; 100 ISO film.

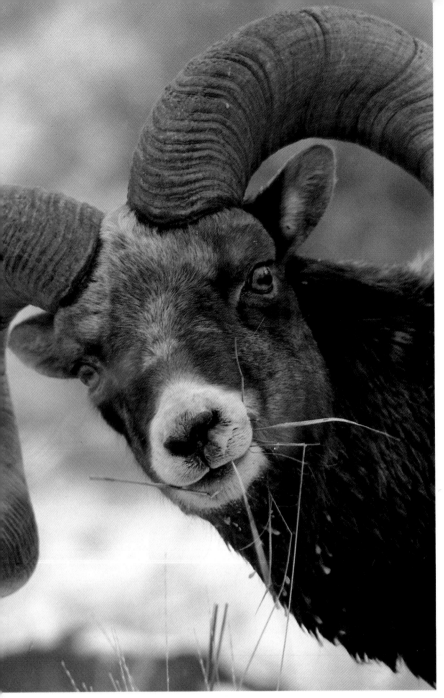

A herd of bighorn rams feeds along a road in Yellowstone National Park in winter and offers a unique opportunity for photographers to take close-up portraits of some exceptional animals. As long as the animals aren't displaced or cut off from their food supplies, safe close photography is possible. The rules of the Park prohibit any approach to an animal closer than 75 feet. In this case, I held my position and the ram (apparently unaware of the rule) grazed to within 30 feet of the camera. The use of a large telephoto (600mm with 1.4X tele-extender, or 840mm) gave a face-to-face view of this magnificent animal. Photographed on 100 ISO film.

or the life of another human or animal. Second, the irresponsible behavior of a photographer with sophisticated camera equipment reflects upon all nature/outdoor photographers, professional or otherwise, in the public eye. And third, your actions, no matter how sensitive, when combined with the actions of those who precede and follow you, contribute to a cumulative environmental effect.

To prepare properly for a photographic expedition into a natural area, first study the kinds of wildlife and plants you are likely to encounter, paying particular attention to dangerous, endangered, and protected species. Unusual conditions may demand additional consideration of the animals. Read available materials and posted signs, and listen to local wildlife experts, rangers, and wardens. Be aware of the human activities likely to take place in the area, from research to hunting. Armed with your knowledge and your best manners, you'll be ready for a much more rewarding photographic experience.

Following are some general points to remember about various categories of wildlife you may encounter in the field. Be sure to expand your knowledge with particular information about the subjects you seek before you enter their habitats.

Mammals

Big game mammals are much sought-after as photographic subjects because of the excitement and hint of danger the resulting images suggest. Hunting animals with a camera tests

survival skills and pits the photographer's intelligence and instincts against those of formidable adversaries.

The large mammals are sensitive to changes in their environments, and those concentrated in the national parks are particularly vulnerable to cumulative effects of harassment and multiple intrusions into their habitats. I define "harassment" in this context as any human action that provokes the animal to unusual behavior, or a change of behavior, that may cause harm or threaten the well-being of an animal. However, be aware that state fish and game and federal park agencies have their own definitions of harassment, some of which pertain to particular species. Whether or not you agree with them, you could be held accountable for any violations of regulations drawn from the governmental definitions.

Most lively discussions of the harassment issue center on large mammals because of their high profile, smaller numbers, ability to respond aggressively, and the greater interest they generate from photographers and the general public who visit the parks. But every animal has a different capacity to tolerate intrusion, and this is equally true of individual bears, hummingbirds, and butterflies. Of course, in order to identify *unusual* behavior, the photographer must be familiar with the animal's *normal* behavior. With experience, and, unfortunately, only after causing some mild forms of harassment and making note of the results, the sensitive photographer learns to stop short of pressing the animal, staying at the periphery of the individual's tolerance. For example, minimal stress may be caused by forcing an elk to stand up as you slowly and indirectly approach her. But even this small disturbance may be too much if the animal is already stressed by multiple human encounters, a hard winter, or lack of food. You should be aware, also, that even before the animal's behavior demonstrates a reaction to your presence, biological reactions to stress, such as increased heart rate or other chemical changes, are occurring. Be conservative in your approach. Photographers are better able to keep a safe and non-threatening distance if they use longer lenses, even though the animals are large. At a minimum, start with 200 to 300mm lenses. With longer lenses in the 400 to 600mm range, intimate close-ups are possible.

Another remedy to the harassment dilemma is to find new locations for photography. It's not that easy in today's crowded world, but there are ways an individual photographer can make a difference.

I was looking for pronghorn antelope when I spotted this long-tailed weasel checking out the burrows of ground squirrels. By moving very slowly on my hands and knees, I was able to edge closer to the curious animal. Every so often I paused to fire a series of frames, thinking that they would be my last opportunity. The limit of the close focus ability of the 400mm lens stopped the session before the weasel did. This is a good example of the fun and imaging potential offered by some of the smaller mammals on a little-used wildlife preserve 50 miles from the crowded roads of Yellowstone. A 400mm f/5.6 lens and 64 ISO film were used.

Using trained or restrained animals, the photographer can capture many images that would be impossible, or too dangerous, to attempt in the field. In this often-published photograph, a trained cougar jumps from one position to another in front of the camera. The lighting and the auto-focus combined to give a unique image that conveyed the cat's movement but still maintained as much detail as possible. Autofocus camera with 100-300mm zoom, two hotshoe flashes off-camera; 1/30 second at f/11 on 50 ISO film.

Work in state and county parks instead of the popular national parks. Concentrate on smaller mammal species whose populations are more plentiful and sustainable. These also can give great satisfaction in the final image. I have received both personal gratification and financial reward from photographing small mammals such as weasels and ground squirrels. It may not be as exciting as an eyeball-to-eyeball encounter with a grizzly or polar bear, but it has its compensations.

The stress factor and the risk of danger to both the photographer and the subject are highest when mammals have young. Parents and youngsters are vulnerable to predators and starvation, and the adults are unlikely to tolerate interference or annoyance. They may aggressively protect their young at the expense of the intruding photographer.

The practice of feeding or baiting animals to entice them into photographic range is controversial. In U.S. national parks it is strictly forbidden. Nonetheless, I have seen the results of illegal coyote feeding in Yellowstone. The animals become dependent on handouts that will not always be available, fail to develop the hunting skills necessary for continued survival, and are encouraged toward dangerously close interaction with humans and automobiles. Sadly, the animal that bites the hand that shouldn't be feeding it is usually destroyed. Occasional feeding of some animals on private land in order to bring them into camera range is not, however, a necessarily negative activity. Providing a salt lick for deer in a protected location or feeders for birds in your backyard are good examples. With feeding, as in all interactions with natural subjects, the photographer must act only after careful evaluation of the potential short- and long-term effects on the subject.

Game Farms and Controlled Subjects

In recent years, working with controlled mammals at game farms, zoos, rehabilitation centers, and natural history museums has gained popularity with outdoor photographers and greater acceptance with publishers. This method can be very constructive if, first and foremost, the animals at the facility are being kept and handled in a humane manner. Those operations lacking proper enclosures or rendering inhumane care should be strictly avoided. Your patronage will perpetuate bad conditions.

olled animals offer possibilities for photographs that could not, or should
tempted in the field. Many intimate closeup or "real-life" action wildlife
phs published in the past were, in fact, taken by professional photographers
ntrolled animals. As a result some amateurs, seeking the same spectacular
nd not recognizing the method, pursued, harassed, and got too close to wild
in the field. When photographs are taken under controlled conditions, pro-
ethics demand acknowledgment of the fact directly on the image. Editors
e their decisions based upon this information. By today's publication stan-
the behavior and location conveyed in an image are correct, it can be used
ditorial purpose. But if a set-up image depicts unnatural behavior or
oth photographer and editor are sure to be embarrassed eventually.

A good example of wise whale-watching. The observers parallel the pod of orcas, neither approaching nor impeding their progress. The whale group is close enough for excellent images with lenses between 80 and 300mm. The photograph was taken as the rubber boat and pod passed by the stationary mother boat. 100-300mm zoom lens; 50 ISO film.

Guidelines for Photographing Nesting Birds

- Learn about the bird species likely to be found in the area you will photograph.
- If your activities upset the adults or endanger the nest, leave the area.
- Repeated human encounters cause accumulative stress on the nest.
- Human scent around the nest will attract predatory animals.
- Leave foliage around the nest as you found it.
- Observe the parents' natural pathways to the nest, and keep them unobstructed.
- Photographic activity may alert predatory birds and curious humans to a nest's location, with disastrous results.
- Enable the adults to visit the nest at will, especially in a colony where predators may be close at hand.
- Respect the privacy of endangered birds, and keep their nesting locations to yourself.

Marine Mammals

Ocean-bound mammals such as whales and dolphins hold a special attraction for humans, and photographing them is especially challenging because of their elusive disappearances beneath the sea, punctuated by sudden whole-body displays. Photographers who have the opportunity to work on marine mammals at sea are often in the company of several boats loaded with spectators. The combination of numerous boats concentrated in a small area holds potential for collective harassment, of course, and the conscientious photographer may have to be assertive on behalf of the subjects.

It is extremely important to remember that marine mammals reproduce very slowly, and their populations are particularly vulnerable to stress. Some species are severely endangered and protected by U.S. and international law.

As a general guide, marine mammals such as whales should not be directly approached or maneuvered to change their direction or behavior. The rule of engagement in the gray whale calving areas along the coast of Baja California, Mexico is that the *whale* must approach *you*. And they do! The orca whales I've photographed in the waters off British Columbia, Canada, are quite different and will usually ignore boats that slowly parallel their movements.

Nesting Birds

When photographing any wildlife, great care must be given to the approach and handling of the subject within its environment. This is particularly critical with nesting birds and their young. Some nesting birds are so obliging that anyone can get close enough to photograph their nests. The knowledgeable photographer will be especially aware of the tolerant bird's vulnerability and exercise measures to protect the nest and its occupants.

A thorough understanding of nesting behavior will make it relatively easy to determine proper photographer etiquette from the birds' perspective, as well as contributing to your chances of great photographic opportunities. The ninth chapter of this volume contains detailed discussion of the generic elements of bird behavior and how responsible photographers can respond appropriately to it. For quick reference, apply the guidelines presented on the previous page every time your camera encounters nesting birds.

Each individual within a species has a different capacity to tolerate photographic intrusion. This Anna's hummingbird was determined to thwart my intention to photograph her eggs. She never budged from the nest while I took her portrait using a twin flash bracket allowing maximum depth of field with a 200mm macro lens. Most hummingbirds will not allow such intimacy, even after the eggs have hatched. 64 ISO film.

Plants

Conserving the world's diverse genetic pool (biodiversity) is of special concern with isolated botanical species whose environments are threatened. Vernal pools are especially likely to harbor endangered species which thrive only under certain specific rainfall and evaporation conditions.

The photographer who is also a basic biologist will be equally considerate of large fields of flowers and fragile environments with small masses of wildflowers. Drive only on established roads. Don't lie down in the middle of a flower mass; work the

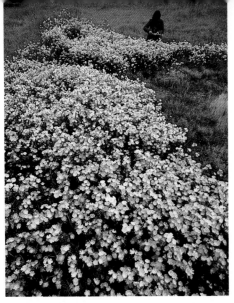

A vernal pool once located near Sacramento, now lost to development. The photographer is carefully working the edges of the fragile environment. 18mm lens; 64 ISO film.

edges. If the flowers don't complete their bloom, no seeds will be produced for future seasons. Remember that the flowers are part of a complex ecosystem that is the home of insects, birds, and other wildlife. Don't interfere with this process, out of courtesy to the environment and to those photographers and viewers who follow you to the site.

Insects

Even some insects are endangered due to loss of habitat. A compelling example is that of the monarch butterflies east of the Rocky Mountains, whose only suitable overwintering habitat located in central Mexico is severely threatened by deforestation, causing a significant increase in butterfly mortality from cold temperatures. The threat is accompanied by the loss of milkweed plants, the species' primary larval food source, to agricultural and commercial development.

When obtaining specimens of exotic insect species for close-up photography, be sure that they were propagated within the United States, rather than collected from their natural habitats. Many species native to Central and South America are becoming endangered within their ecological zones. Some of the problems stem from demand by collectors.

Some insects are losing critical habitats, such as the monarch butterfly whose chief overwintering site is located in pine forests of central Mexico. The trees, such as this one which is completely obscured by clustering butterflies, are important because they provide the exact environmental conditions necessary to the monarch's survival during the winter months. 55mm macro lens; 64 ISO film.

You can assist beneficial or benign insect populations by planting hospitable gardens and trees. Don't transfer insects (or their host plants) to non-native areas where they are either unlikely to survive, or may thrive so well in the absence of their natural predators that they overpower resident populations.

Tide Pools, Ponds, and Streams

Tide pools are wonderful photographic resources, but their resident plants and animals are especially vulnerable to trampling and careless collecting. Never permanently move specimens to new locations; their immediate environments are critically composed, and others may not be life-sustaining. Despite their sometimes hardy appearance, animals taken from tide pools cannot survive long away from them. If you remove an animal for photography, carefully maintain its natural conditions by setting up a small tank next to the pool, using water taken from around the specimen. Work quickly, and put your subjects back exactly where you got them.

The same principles apply to specimens found in freshwater ponds and streams, such as salamanders, frogs, and turtles. If you transport any amphibious subject

to a new location for photography, be sure that you don't allow it to escape, jeopardizing the animals already established in that ecosystem.

Aquatic insects, found under rocks in streams, are the major food source for freshwater fish and amphibians. If rocks are left overturned during your search for photographic subjects, the insects are likely to perish, affecting the long-term food supply.

Working with Biologists

It can be beneficial to both parties when a photographer teams up with a biologist. Biologists often need quality photographs to document their work, and photographers can profit from the biologists' field knowledge. Together, they may be better able to find a particular animal and to document its behavior safely. Be advised, however, that great photography and close proximity to a subject are not always possible or desirable from the biologist's point of view. The biologist's ethics will be drawn from his or her intimate knowledge of the subject, and this may discourage photography in some situations. Some biologists themselves are competent, and even professional, photographers who market their images. They may not be willing to lead you to their photo sites, but usually will be generous with good advice about protecting the subjects' welfare.

You Can't Fool Mother Nature

In the following chapters, I'll continue to offer advice about photographer behavior in specific photographic situations. The nature photographer's alert but non-threatening demeanor is essentially connected to powerful and unique images.

As you embark on your photographic expeditions into the "wild," keep your intelligence and wits about you. Curious innocents energetically "interacting with nature" endanger themselves and their potential subjects and rarely bring back photographic prizes. Mother Nature may suffer fools with cameras, but she will not gladly give up her secrets to them. Prepare yourself instead to become part of a working natural system, proceed methodically and thoughtfully, and exciting and rewarding photographic opportunities will reveal themselves to you.

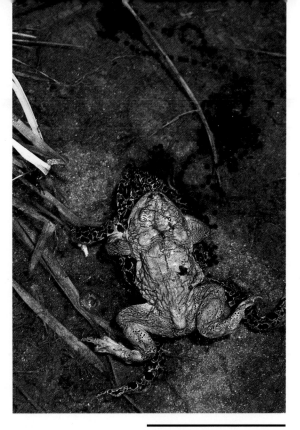

Tioga toads mate in early summer ponds formed by melting snow. Years of drought and an unexplained decline in nearly all toads and frogs have made the Tioga toad a rare find. Note the eggs being fertilized underneath and in front of the pair. This photograph was taken with the help of research biologist Cindy Sherman. 100mm macro lens with two electronic flash units; 64 ISO film.

HIGH-
MAGNIFICATION
FIELD
TECHNIQUES

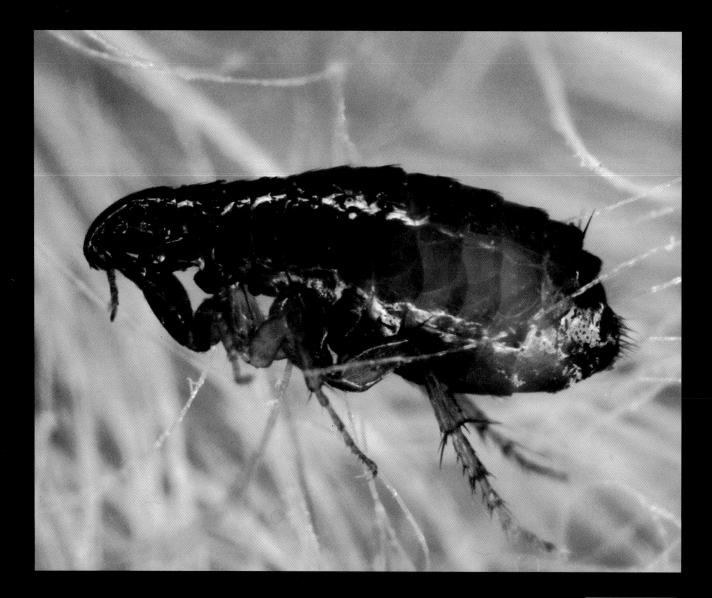

My Dog Has Fleas

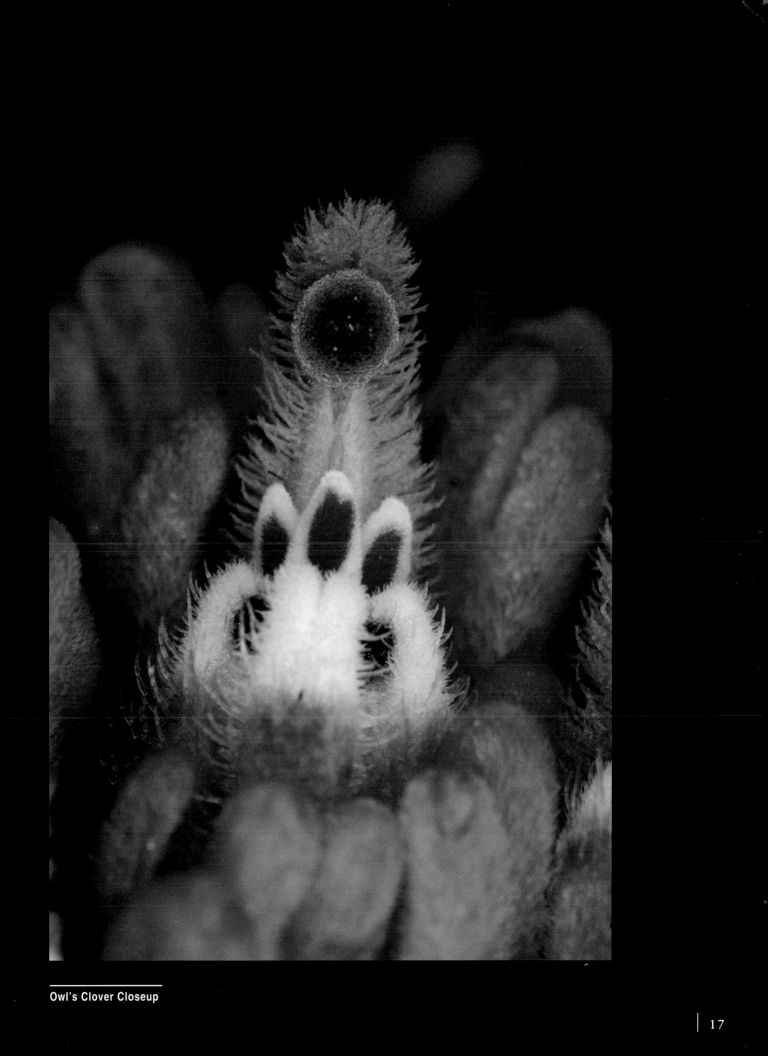

Owl's Clover Closeup

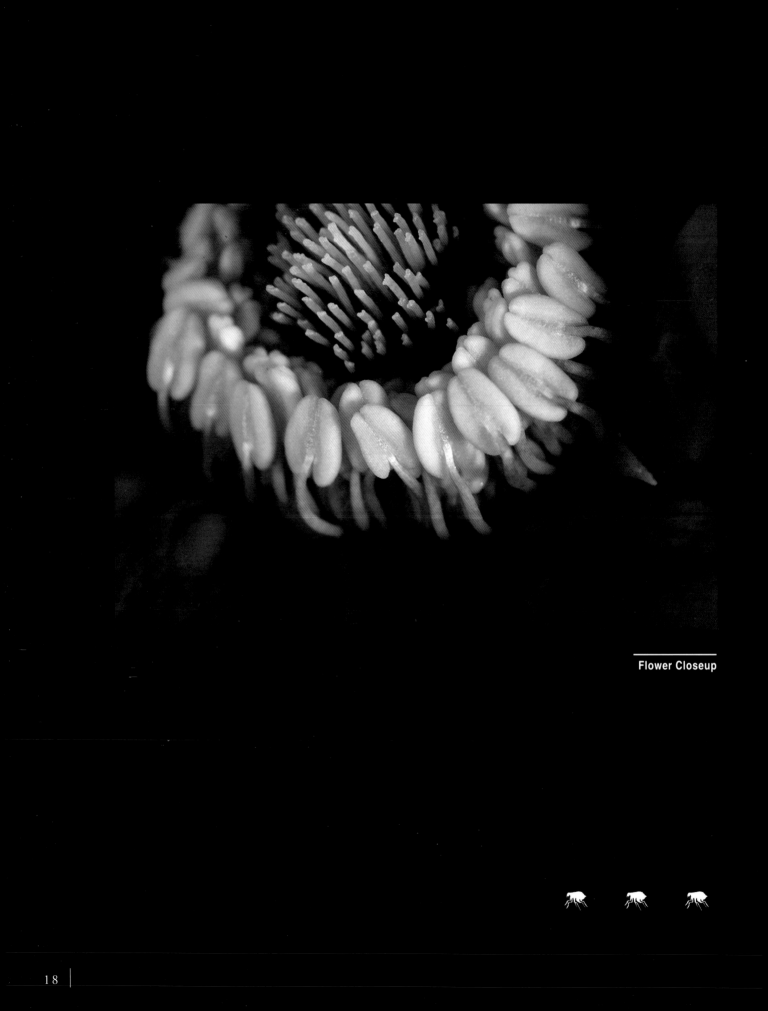

Flower Closeup

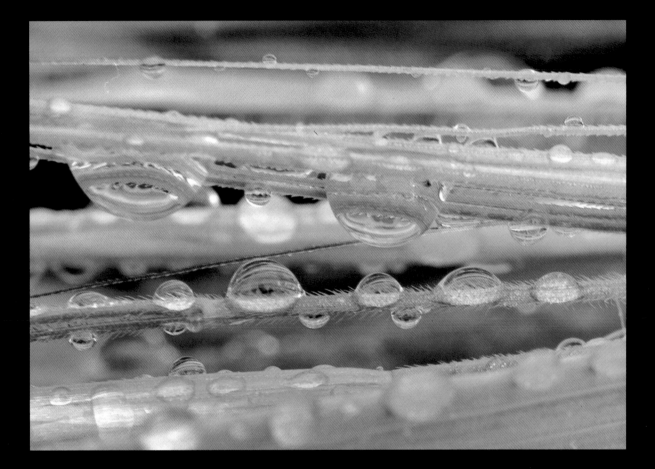

Grasses in the Rain

My Dog Has Fleas (6X)

Using a portable macro system comprised of two electronic flashes, extension tubes, and a special macro lens of 19mm allowed me to photograph a dog flea in its favorite environment, the fur of our poodle Kernel. The most difficult aspect of working at a magnification of 6X is that the subject seems to move within the viewfinder at 100 mph. Slight movements of the photographer, the subject, and the subject's host are exaggerated at high magnification. Compounding the problem is the minimal depth of field at higher magnifications. 19mm macro lens, telescoping extension tube, and two small electronic flash units; on 64 ISO film.

Owl's Clover Closeup (3X)

A common wildflower reveals bizarre shapes and colors when observed at three times life-size. A combination of 50mm macro, extension tube, and 2X tele-extender provide the magnification. 50 ISO film at an effective aperture of f/22.

Flower Closeup (2X)

The structural parts of a flower become a design element at 2X. By adding a 2X tele-extender to a 100mm macro lens set at 1X, the magnification is doubled to achieve two times life-size. Macro flash; effective aperture of f/32 on 50 ISO film.

Grasses in the Rain (1.6X)

Having stopped to photograph wildflowers along a country road, I noticed the fine drops forming interesting patterns in the grass. The 90mm tilt/shift lens was modified to work as a macro. A 25mm extension tube, 2X tele-extender, and two-element closeup supplementary lens were all part of the system. 50 ISO film.

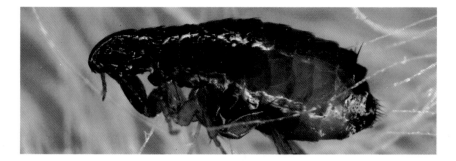

HIGH-MAGNIFICATION FIELD TECHNIQUES

The key to an interesting photograph is to present the subject in a way that is unique to viewers—from an unusual visual or locational perspective, by insertion of unusual design elements into the composition, or by rendering it larger or more intimately than it can be seen by the human eye. Beyond life-size is in fact the beginning of the inner limit to photography, because high magnification allows the photographer to dissect the subject and break it into essential parts forming images that stand by themselves.

A rose is no longer a rose when one petal is photographed at 2X, or two times as large as life. A butterfly wing becomes an intricate design of brilliant scales not immediately associated with an insect subject. Rock crystals become towers of colored glass in some future-world city. With high-magnification photography, we put our subjects under the glass and discover they are no longer the distinct, whole, one thing our eyes saw before. We look at less and see more.

Photographing in the field at magnifications beyond 1X (life-size) is not the easiest of endeavors, but the results justify the extra efforts. At high magnification, every photographic flaw is magnified. Thus camera movement must be absolutely eliminated. Minimal depth of field means that focus must be achieved with maximum precision. Ambient light will rarely be sufficient, so the photographer must carefully control artificial light sources. Considering these constraints, the upper limit of magnification in the field is probably around 4X. Any magnifications beyond this point are best accomplished in a studio with special equipment, where up to 30 or 40X magnification is possible.

Magnifications in the 1-4X range are sufficient for insect closeups, design elements associated with flower parts, and details of smaller subjects—as long as the subjects themselves are large enough to be found with the unassisted eye. These magnifications can be achieved with the addition of relatively inexpensive equipment to supplement lenses found in most camera bags. The techniques, once mastered, are easily and consistently applied. In fact, the most difficult element of high-magnification photography is the adjustment that must take place in the photographer's perception of the subjects. No longer a single entity, the high-magnification subject is a Chinese box of subjects-within-subjects, each waiting for the photographer's definition and interpretation.

Modifying Existing Equipment

A number of lenses are capable of giving high-magnification results. Macro lenses are usually the best because they can immediately attain the 1X threshold and are easily expanded to higher magnification. With additional accessories, some moderate wide-angle lenses and zooms cross over into higher mag. An unusual, but excellent lens for this technique is the Canon EOS 90mm tilt/shift lens. It has exceptional sharpness even when used in conjunction with macro-accomplishing accessories and has the added advantage of tilting the zone of depth of field to maximize the area of sharpness.

Some special lenses are specifically designed for extremely high magnification; these need additional accessories such as bellows, extension tubes, or tele-extenders to achieve higher magnification—as much as 40X. These accessories have different capabilities. They can be used singly or in combination to increase magnification and to solve different problems associated with high-magnification photography.

Two-element Closeup Lenses

Two-element closeup supplementary lenses (diopters) modify the focal length of the primary lens to which they are attached. They are more highly corrected than the single-element closeup lenses used in the past which did not produce images of professional sharpness from edge to edge.

Canon and Nikon market two-element closeup supplementary lenses which are designed to be used with primary lenses in the 70 to 300mm range. Nikon's 3T and 4T (52mm filter size), 5T and 6T (62mm filter size), and Canon's 500T (58mm) allow continued use of autofocus and cause no loss of light, even at 1X. Attaching

A combination of 90mm tilt/shift lens, 2X tele-extender, 25mm extension tube, and Nikon 6T two-element closeup supplementary lens magnified this dew-covered poppy petal by approximately 3X. Lighting was supplied by a macro flash attached to the front of the lens. 50 ISO film.

one to the front of a 100-300mm zoom lens that might normally allow a .2X, or 1/5 life-size rendition, can produce magnifications of up to 1X, or life-size. Any telephoto zoom lens similarly accessorized becomes a zooming closeup lens throughout a defined range.

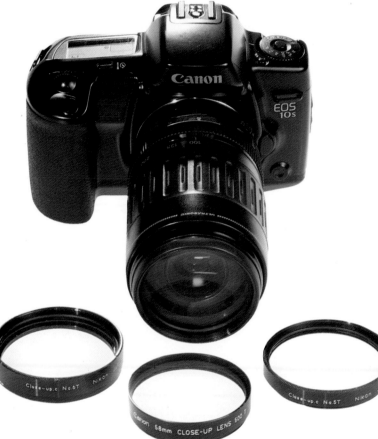

An assemblage of available two-element closeup supplementary lenses: Nikon 5T (62mm filter size), 6T (62mm filter size), and Canon 500T (58mm filter size). With the addition of step-up adapters, these two-element closeup supplementary lenses can be used with any manufacturer's lens of equal or lesser filter size.

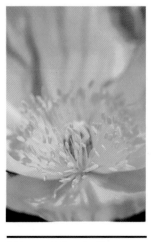

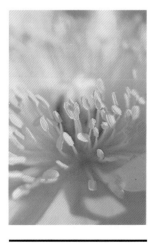

This is the closest focus of a Canon EF 100-300mm f/4.5-5.6 zoom lens set at 300mm. The achieved magnification is .2X or 1/5 life-size.

With the addition of a 5T two-element supplementary closeup lens, the 100-300mm lens achieves a magnification of approximately .6X.

The same 100-300mm lens with the addition of the Nikon 6T two-element supplementary closeup lens. Magnification is at aproximately 1X.

By adding the Canon 58mm 500T two-element supplementary closeup lens, .75X is achieved.

Extension Tubes

The addition of an extension tube between a macro, wide-angle, or zoom lens and the camera will allow focus closer to the subject and result in higher magnification. 1X magnification is achieved by each extension equal to the original focal length of the lens when focused at infinity. For example, a 50mm extension tube added to a 50mm lens set at infinity increases magnification to life-size, and 100mm of extension on the same lens achieves 2X. Thus a 20mm macro lens will need very little extension to get to 3X (60mm), while a 300mm lens would need an unwieldy 900mm to reach the same magnification. Too many extension tubes can cause vignetting with some lenses. Conduct a test with your combination.

Using automatic extension tubes for high magnification allows the primary lens to maintain its automatic functions, an advantage in the field. Most important, the diaphragm will stay open until the moment of exposure, providing a brighter viewfinder for focusing. Keep in mind that as the lens is positioned farther away from the film plane, the exposure time increases. At 1X magnification using extension tubes or a similar extension, like bellows, a loss of two f/stops is realized. At a magnification of 2X, the photographer must compensate for three lost f/stops.

An automatic extension tube that maintains the lens's autofocus capability is shown between the Canon EF 100mm macro lens and a camera body. The same extension tube can be used to modify lenses that normally cannot accept the Canon EF 2X tele-extender.

Bellows

Bellows can be used with most lenses and are especially appropriate with powerful high-magnification lenses for studio photography. But seldom are they efficient field tools. Most bellows do not maintain the automatic functions between the lens and camera. This makes focusing and following a moving subject difficult. A bellows is also too fragile for most field work. Those made of either cloth or plastic are easily damaged by sharp vegetation and rocks. In the field, several extension tubes will be more effective and less cumbersome than a bellows. When a lot of magnification is needed, and the subject can be placed in a sheltered and convenient place for photography, the bellows can be a useful tool.

Tele-extenders

Tele-extenders (also called teleconverters) can help the macro photographer in two ways that are extremely beneficial in field work. Added between the camera and the primary lens, tele-extenders immediately magnify the image by the power of the extender when used at the same working distance as the lens alone. If more working distance is needed, tele-extenders give you additional room without resulting loss in magnification. For example, a 100mm macro lens set at 1X may provide a working distance of approximately six inches from the front of the lens to the subject. An added 2X tele-extender will render 2X from the same six inches, or the photographer can move back to 12 inches and still have the original 1X magnification. A 1.4X tele-extender will give corresponding increases of 40% in either magnification or working distance.

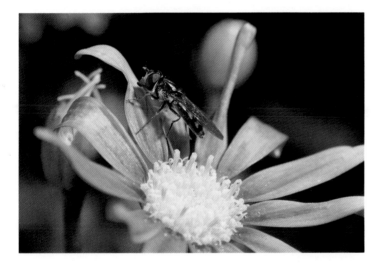

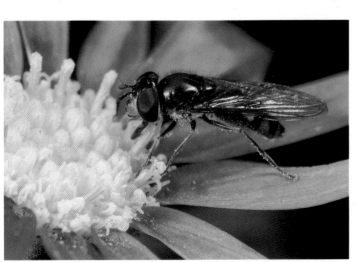

Light Loss with Magnification Using Extension Methods

Magnification	Light Loss
.5X	1 stop
1X	2 stops
1.5X	2.5 stops
2X	3 stops
2.5X	3.5 stops
3X	4 stops
3.5X	4 stops
4X	4.5 stops
4.5X	5 stops
5X	5 stops

The photographer has a choice when using a 2X tele-extender with a close-focusing lens. Either the magnification or the working distance can be doubled. The first photograph of the flower and bee-fly was taken at 1X. The second is from the same distance but with the added 2X tele-extender. The magnification is now 2X. Doubling the working distance will render 1X magnification as in the first photograph.

Don't forget the dark side of using tele-extenders. A loss of two f/stops of light occurs with a 2X tele-extender, and one stop of light is lost when using 1.4X extenders. Electronic flash is usually necessary with tele-extenders to minimize loss of image quality and maximize depth of field.

Combinations

Combinations of the tele-extender, diopter, and extension tubes will affect both magnification and working distance in various ways to solve a particular macro photography problem. A 100mm macro lens set at 1X with a 2X tele-extender (a combination which renders 2X) plus a 25mm extension tube (needed to fit the 2X tele-extender) and a Nikon 6T two-element supplementary closeup lens, yields a final magnification of approximately 3.2X.

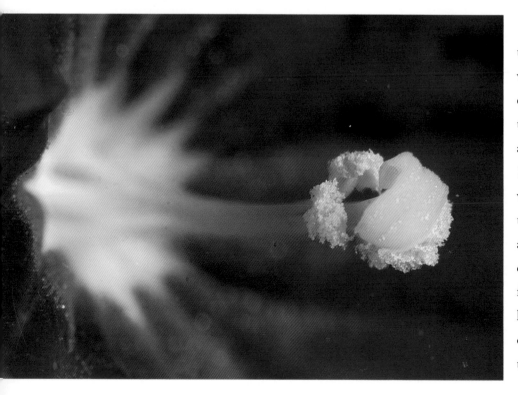

Canon A2 camera with EF 100mm macro lens, EF 25mm extension tube, EF 2X tele-extender, and Nikon's 6T two-element supplementary closeup lens.

Below: The combination of a macro flash unit attached to the front of a 100mm macro lens with a 2X tele-extender gave well-illuminated magnification at 2X, revealing the pollen grains on the anthers of this flower. 50 ISO film.

The Canon EOS 90mm tilt/shift lens set at its closest focus with a 2X tele-extender, 25mm extension tube, and Canon 500T two-element closeup lens produces a magnification of approximately 1.6X. Replace the Canon 500T with a Nikon 6T closeup lens, and the magnification increases to approximately 1.8X with a working distance of 4.5 inches from the front of the lens. The tilt/shift lenses have the added bonus of tilting the depth of field to maximize use of the area of sharpness.

Even a 100-300mm zoom lens set at 300mm and its closest focus, a 25mm exten-
sion tube, a 2X tele-extender, and a Nikon 6T diopter will furnish an enterprising
photographer with approximately 2.4X of surprisingly sharp magnification.

Special Lenses for Macro

The relatively expensive group of macro lenses available from the leading manu-
facturers is for serious macro photographers only. These lenses are the very best
equipment for high-magnification photography. Their optical design is optimal
for macro. They are flat-field lenses, sharp from center to edges, and their short
focal lengths (12-38mm) require little extension to attain high-magnification
results. The lenses are very small, so they are easy to use in tight places and leave
room to get light to the subject. Surprisingly, a universal mounting thread allows
all the major manufacturers' macro lenses to be adapted to any camera system.

A selection of special macro
lenses and adapters used for
macro photography at magnifica-
tions of 1/2X to 40X. The three
rings on the left are adapters for
various manufacturers. The center
thread is a standard RMS type.
The lenses in the back row are,
from left, the macro Nikkor 60mm,
the Zeiss 16mm, Zeiss 25mm,
Olympus auto-macro 38mm, and
Olympus auto-macro 20mm. The
last two only fit Olympus OM
SLRs. In the front row, left to right,
are a macro Nikkor 19mm, macro
Nikkor 35mm, Canon macro
35mm, Canon macro 20mm,
Minolta macro 12.5mm, and
Olympus RMS thread 38mm.

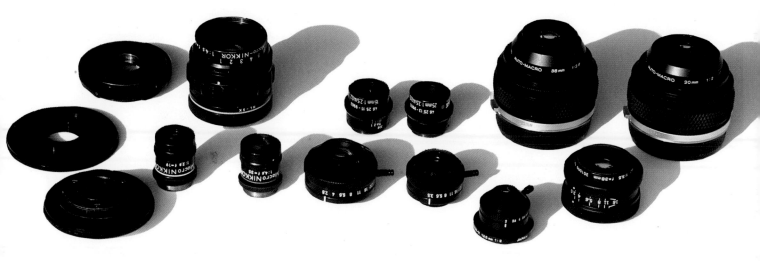

While they are capable of superb results, special macro lenses are complex
and sometimes frustrating to use. Most of the automated functions of the camera,
and most importantly automatic diaphragm, are rendered useless by these lenses.
The viewfinder will be very dark due to the light loss attendant to higher magnifica-
tion and the diaphragm's inability to be kept open automatically during focus.
Fortunately, exposure can be controlled automatically by the TTL metering systems.

Viewfinders and Special Viewing Screens for Macro

Some accessories that attach to or modify the viewfinder can be of great assistance
for high-magnification field work.

A right-angle finder which allows the photographer to use the viewfinder from a right angle.

Right-angle finders. A viewfinder accessory helpful in ground-level macro photography is the right angle finder, which facilitates the use of the camera at low angles. The right-angle finder extends the viewfinder up at a right angle and allows you to photograph an earthworm without eating dirt.

Magnifying hoods. Some cameras with removable viewfinders offer magnifying hoods as replacements that allow the photographer to view the image from above, rather than from behind, the camera. By increasing the size of the image in the viewfinder by up to six times, their internal magnification assists critical focus. An example is the Nikon F4 DW-20 6X magnifying hood.

Aerial image viewing screens. Most serious SLRs have removable focusing screens, and at least two manufacturers offer aerial imaging replacements. The focusing screen, receiving the image projected by the lens, presents it to your eye in the viewfinder focused exactly as it will record on the film. But considerable light is lost with normal matte-surfaced screens. While this is not a serious problem for general photography, the additional tremendous loss of light in the viewfinder attendant to macro photography can make focusing very difficult. One solution is to replace the light-absorbing matte-surfaced screen with a clear aerial image focusing screen in the viewfinder. This accessory is effective only with magnified images associated with macro photography and telephoto photography, however, and it requires independently focusing right-angle finders and magnifying hoods to adjust the eye to the aerial image focusing screen.

Field Methods for Macro Photography

Working at high magnification in the field poses some particular methodological challenges to the outdoor/nature photographer. Focus is especially important in macro photography, but field conditions such as wind and skittish subjects make it more difficult to maintain critical sharpness. Because depth of field is minimal at high magnification, the incredibly small zone of critical sharpness compounds the problem.

With assembly in hand and subject located, the macro photographer must employ highly specific methods to resolve the unique focusing problems encountered in the field. First, set the camera/lens combination

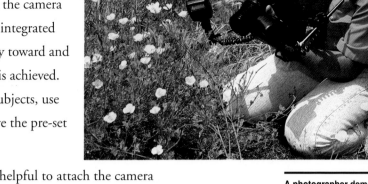

for the desired magnification. Then, with the camera system and photographer working as one integrated unit, move the camera and body smoothly toward and away from the subject until critical focus is achieved. When working on the ground with low subjects, use a rocking motion from the elbows to move the pre-set camera slowly and precisely into focus.

If a tripod can be employed, it may be helpful to attach the camera and flash assembly to a focusing rail or slider and to move the camera back and forth to accomplish minute corrections in focus. Subjects close to the ground can be handled more easily with a Bogen Superclamp attached near the bottom of the leg of a lowered tripod. Attach a tripod head or ball head with a focusing rail or slider to the clamp.

When the subject is one that can be moved to another location, and wind or other conditions preclude working where the subject is found, reposition it in a sheltered area, even inside a car or trailer, and at a convenient height.

Although the photographer's back may cry for assistance in supporting the mass of flashes, their connectors, extension tubes, and bracket assembly, use of a tripod is not always possible. Fortunately, the use of electronic flash for macro photography has the advantage of very short flash duration (1/1000 second or less, depending on the magnification and f/stop used). Camera movement is not usually a problem. The flash duration effectively becomes the shutter speed at which the photograph is taken, because the ambient light usually doesn't record. Just remember that the zone of focus is very narrow, even at f/22, and even though the image probably won't be blurred by camera movement, you just might miss having the critical focus on the subject. Use a tripod if at all possible.

The photographer must provide most of the light needed for proper exposure; ambient light is never sufficient for high-magnification photography of a moving subject. Putting together and using the necessary lighting equipment is so critical that I've devoted the following two chapters to illumination of macro subjects. Complicated though it may seem to be, mastery of macro lighting techniques is not overly difficult and will make the critical difference in your high-magnification field photography.

A photographer demonstrating the proper method to hand-hold a macro flash bracket assembly when photographing in the field at high magnifications.

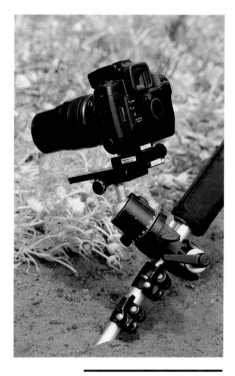

The Bogen Super Clamp attached to the extended leg of a Bogen 3021 tripod. Underneath the camera is a slider rail from Really Right Stuff; it facilitates minute adjustments of camera placement without having to move the whole tripod.

MULTIPLE TTL ELECTRONIC FLASH FOR MACRO

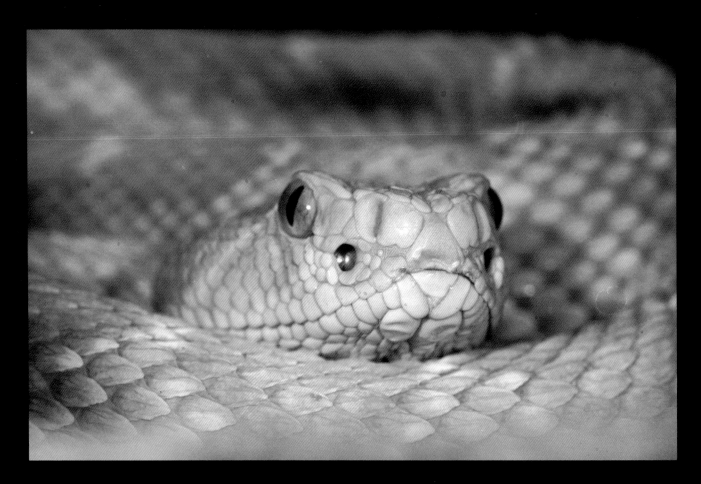

Albino Rattler

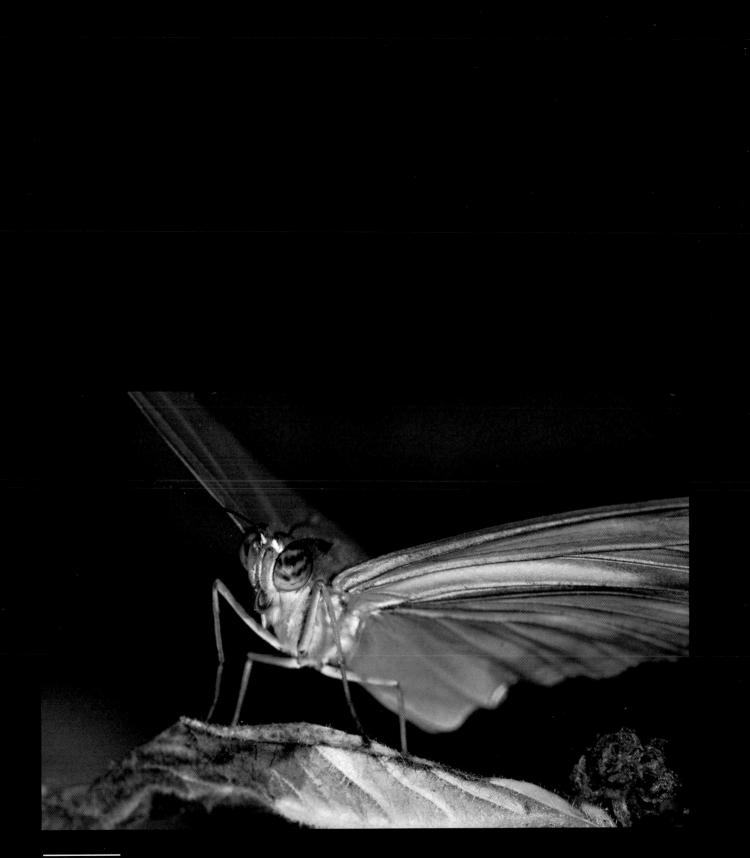

Julia Butterfly

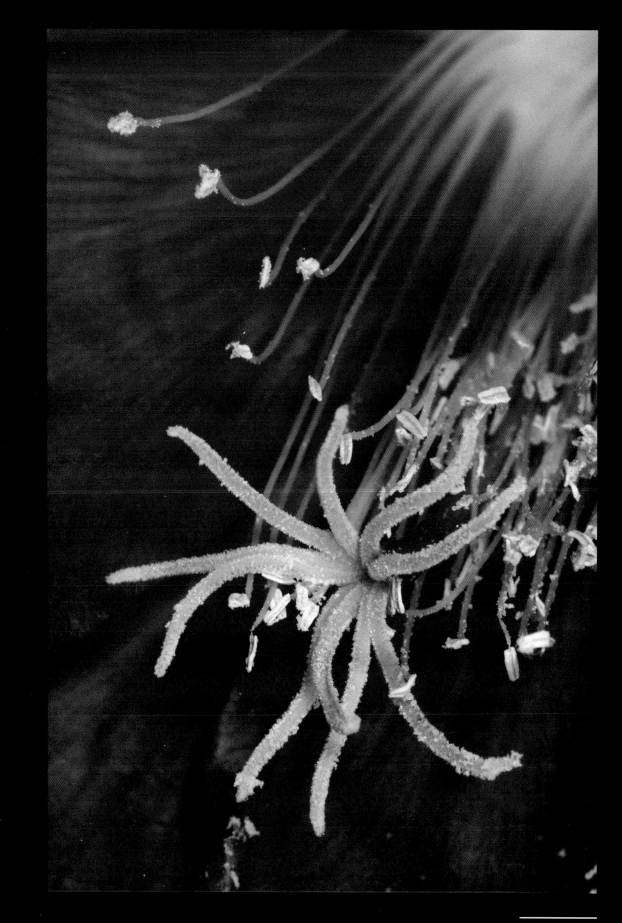

Cactus Flower

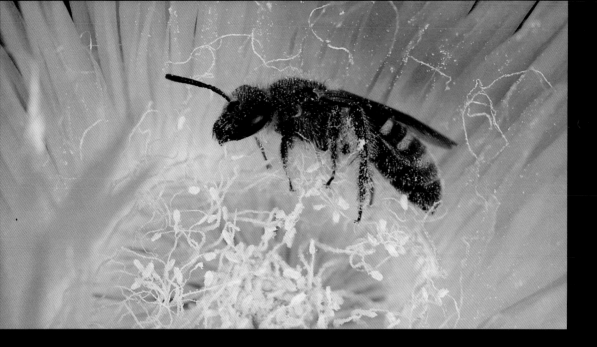

Bee in a Blossom

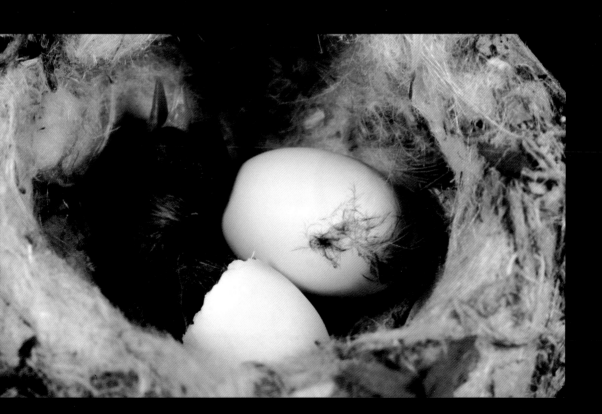

Hatching Hummingbird

Albino Rattler

Safely behind glass at the Sonora Desert Museum near Tucson, this unusual subject presented problems in lighting, framing, and reflections. Two hotshoe TTL flashes on a Macro Bracket set out at 45 degrees helped control reflections on the glass. A 100-300mm zoom lens and a Nikon 5T two-element supplementary closeup lens allowed close enough working distance to maintain the camera at the glass to eliminate any reflections. Framing was then accomplished by zooming the lens. 50 ISO film.

Julia Butterfly (1X)

Two hotshoe flashes on a Macro Bracket system furnished the even light to capture this Julia butterfly at Butterfly World near Fort Lauderdale, Florida. 100-300mm lens and Nikon 5T two-element supplementary closeup lens. 50 ISO film at f/16.

Cactus Flower (1.3X)

A night-blooming cactus was photographed using a macro flash and 90mm tilt/shift lens. The closeness to the lens of the two flash heads helped to light the inside of the tube-shaped flower. The 90mm tilt/shift lens increased usable focus up into the flower. 50 ISO film at f/16.

Bee In a Blossom (2X)

A small native bee gathers nectar from the depths of an ice plant blossom. The fast flash duration and copious amount of light add up to a sharply frozen subject that in reality never did stop moving. A macro flash with its flash heads close to the lens axis was able to direct the light into the deep flower. 100mm macro lens and 2X tele-extender; f/22 on 50 ISO film.

Hatching Hummingbird (1.5X)

Two TTL hotshoe flashes on a Macro Bracket system equalized the light to furnish maximum detail of the hummingbird chick emerging from its shell. The magnification on the film is 1.5X with a 55mm macro lens and extension tubes. Due to the limited working distance of this lens combination, the two flashes were positioned very close to the lens axis. 64 ISO film.

MULTIPLE TTL ELECTRONIC FLASH FOR MACRO

A number of excellent nature photographers do very well without electronic flash, while others use it exclusively and are equally successful. My opinion is that there is a place for each, and the ability to work both with and without electronic flash will broaden your choices in rendering a natural subject. In outdoor photography, which is both natural (aesthetic) and biological (informative), it is nearly always best to approximate natural light. This is much more difficult in high-magnification photography of subjects such as insects, flower parts, mineral details, and minuscule plants and animals.

If you live by showing great amounts of information in your photographs, electronic flash is an absolute necessity. But under adverse field conditions it's sometimes all you can do to get light, any light, on the subject. Multiple Thru the Lens (TTL) electronic flash will solve macro lighting problems with natural-looking artificial light.

The advantages of any flash are consistent light coloration (color temperature) at any time of day or even at night, a lot of light, allowing small aperture settings with resulting increased depth of field, and a very short flash duration, giving what amounts to a fast shutter speed to stop movement.

During different times of the day, at different elevations, and in shade versus direct sunlight, the color of light is different. This color rendition is expressed in terms of color temperature. Electronic flash is designed to approximate daylight at or near noon (5400-5600 degrees Kelvin), a blue color. The color temperature one hour after sunrise or one hour before sunset on a clear day is typically 3600 degrees

The subject is lit by ambient light. 100mm macro lens; 50 ISO film.

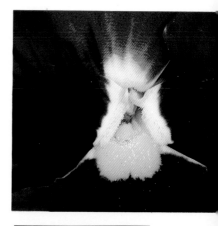

The same subject lit completely using two 430EZ flashes arranged to give a natural lighting effect. The fill flash on the left is two stops less powerful than the main light on the right. 100mm macro lens; 50 ISO film.

Below top: A single light source can be contrasty with little information discernible on the shadow side of the subject. 100mm macro with one 430EZ flash; 1/200 second at f/22 on 50 ISO film.

Below bottom: When a second light source that is two stops less powerful than the main light is added, the shadow side of the subject reveals more information. The same effect is possible with a reflector, but the second flash is smaller, easier to handle, and contributes to as well as concentrates the light when needed for darker or distant subjects. 100mm macro lens with two 430EZ flashes (one modified with a 2/stop neutral density filter); 1/200 second at f/22 on 50 ISO film.

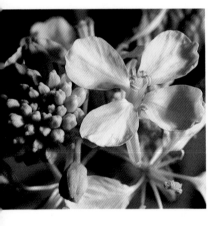

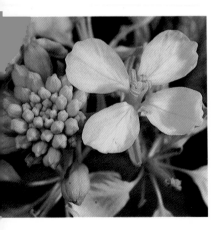

Kelvin and very orange. These variations in the natural light source will affect the color recorded by your film, but flash is consistent and will match the film's daylight color bias. From a scientific perspective, this factor is extremely important.

Lens extension and the variations in light transmission of some macro lens combinations cause considerable light loss in macro photography. Two stops of light are lost at 1X, four stops of light are lost at 3X, with corresponding increases in loss of light as the magnification increases. Thus accurate exposure with available natural light can require painfully slow shutter speeds, resulting in wide apertures and shallow depth of field. Flash, however, allows small apertures with maximum depth of field and an effectively fast shutter speed determined by the short flash duration.

The maximum sync shutter speeds on most of today's 35mm SLRs are in the range of 1/60 second to 1/300 second. As long as sunlight doesn't become the main light source for the picture, the exposure from the flash, from 1/500 to as little as 1/30,000 second in duration, can freeze the subject's motion. This is ideal for hand-held field work, because the effect of camera movement is minimized.

For macro photography, however, one flash is not enough. On the planet Earth we have one main light source, the sun. If it were not for the open sky and reflection from surrounding objects to lighten the "dark" side, objects would appear to have only one side. Everything would look like the pictures taken on the moon and on Mars because the difference in light between the sun side and shadow side of the subject is literally like day and night. This difference in illumination from one side of an object to the other is called contrast. Adding a second and less powerful light source fills in the opposite side of the subject and strengthens information about its form and content.

In macro where flash is used as the sole source of light, it is important to use a second light to add roundness to the subject and to give information about all its sides. Some photographers use a white or foil fill card in combination with one flash unit, but this can be awkward and disruptive to many live subjects. A second, less-powerful flash unit will approximate the open sky and reflected light. Usually a one-to-two stop difference between the main and fill lights will give a natural effect.

A combination of ambient and flash light sources can be extremely effective. Background sunlight eliminates the nighttime look we associate with flash photography. Using a slower than normal shutter speed with the flash will allow the background ambient light to record. The sunlight will show up, but the emphasis will stay with the subject because of its correct exposure from the flash.

Remember that two light recordings are being made at the same time. The flash image will be sharp due to the fast flash duration, but the sunlight image is at a slow speed and could be blurred by subject and camera movement, resulting in a ghosting effect from the overlapping blurred and sharp images. You can do this on purpose for effect.

All aspects of multiple-flash macro photography can be simplified by taking advantage of TTL flash exposure technology. TTL flash units interrupt the flash when their sensors determine that sufficient light has reached the film plane to insure proper exposure for the set f/stop. Determination of the flash exposure off the film plane takes into consideration the f/stop, amount of lens extension, focal length, and any other properties of a given lens, as well as the darkness or lightness of the subject. By calculating these variables quickly and accurately, TTL flash frees the photographer to concentrate on the subject and its portrayal.

TTL Flash Units

A multitude of types and brands of TTL flash units can be used in macro photography. Some are designed expressly for macro photography, such as the macro lights available from Canon, Minolta, Olympus, and Nikon. These specialized flashes may seem to be expensive for a single application, but can be well worth the investment for serious macro photography. Others weren't intended for macro but work very well due to their low power, light weight, and configuration. Even some large, heavy, and powerful units can be pressed into service for TTL macro flash with excellent results.

Ring-lights. Ring-lights have a flash tube that encircles the front of the lens. A control module fits into the camera's hotshoe and supplies power to the flash module. The advantages of the ring-light are ease of use and compact size. But the evenness of the light emanating from all sides of the lens can render the subject very flat in appearance, and in some cases it even will have a slight shadow all around it.

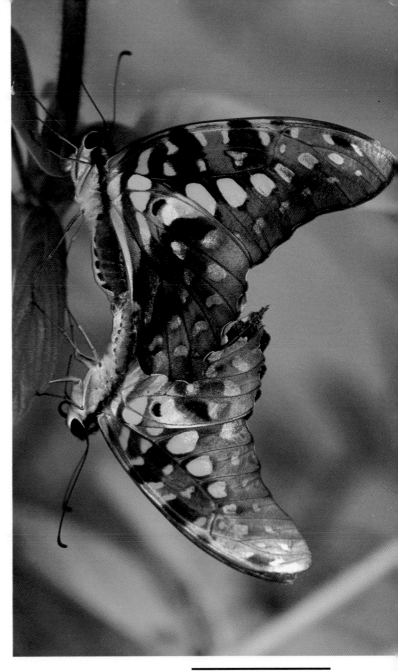

Often a more natural effect is possible if flash and ambient light are combined. Remember the flash exposure is controlled only by the f/stop, while both the shutter speed and f/stop determine how much ambient light will record on the film. Start by setting the ambient exposure, keeping in mind the limitation of your camera's fastest sync speed for flash. The flash will correctly expose to the f/stop set for the ambient light unless the aperture is so wide that the flash can't modify its flash duration to prevent overexposure. Usually a minimum of f/8 is necessary with larger flashes. 100mm macro lens; 1/60 second at f/16 on 50 ISO film.

Macro Flashes. These units are designed specifically for macro photography and attach to the front of the camera lens in the same manner as a ring-light. Instead of a single flash tube encircling the lens, however, the macro lights incorporate two or more separate flash tubes that can be activated independently. A built-in auxiliary light facilitates focusing in low-light.

Macro flash units offer significant advantages in their simple operation, compact flash and control modules, and independently controlled light sources.

Small TTL Flashes. The major camera manufacturers all include a small TTL flash in their systems. These weren't intended to be used for macro photography, but they often work better than the specialized macro flashes. The photographer's options for articulation of light on the subject are limited, because the macro flashes are fixed and cannot be moved away from the lens. But the small, lightweight TTLs, easily attached in pairs to a Macro Bracket, provide the greatest flexibility in positioning of the light sources. They are also relatively inexpensive, but this benefit is offset by the cost of the Macro Bracket and the series of special cords and accessories necessary to connect the flashes off the camera's hotshoe.

Above top: Two macro flash units: the Canon ML-3 Macro Lite (left) and the Nikon SB-21 Macro Speedlight.

Above bottom: The Lepp Macro Bracket II set up with two small Canon 200E TTL flashes. The flashes are connected to each other and the camera with a set of accessory cords.

Full-size Hotshoe Flashes. Just about everyone has at least one heavy, powerful, expensive, full-size hotshoe flash. If you already have two, adding a bracket and a set of cords will give you the best available macro arrangement. If you have only one, it can be complemented by an additional less-powerful unit used as fill flash.

Full-size hotshoe flashes recycle quickly and have the extra power needed to compensate for loss of light in special applications such as cross polarization. Despite their cost, weight, and size, they are a powerful macro tool.

Connections

When using a pair of independent TTL electronic flashes, the photographer must connect them to integrate their electronics with those located behind the camera's film sensors. Each of the major manufacturers has a set of special cords to accomplish this task. The system will consist of a cord that connects to the camera's hotshoe and goes either to the first flash (in Nikon products), or to a distributor (in other manufacturers' products) where additional cords branch to two or more flashes. The cords from the distributor can be short for a contained macro system, or of considerable length for use in other field applications such as nest photography. Each cord terminates with an accessory hotshoe for a flash connection. Nikon and Olympus have provisions for the cords to plug directly into the terminal flash.

The number of flashes that can be tied together is dependent on the particular manufacturer and the type of units. All the systems allow at least three TTL flashes to fire at one time. The output of each flash will be identical unless they are of different power. One way to vary the amount of light emanating from a particular flash unit is to place neutral density material in front of the flash reflector. In this way, natural lighting ratios can be used to control the light on the subject. Another way to vary the light from the group of TTL flashes is to vary their distance from the subject. The fill light can be placed farther away from the subject than the main light.

Multiple TTL Flash Is Not for Lightweights

The decision to enter the realm of multiple TTL flash field photography is hefty in terms of cost and weight, but it will significantly expand your creative options for photographing small natural subjects. And once you have assembled your multiple TTL system, you'll be able to apply it to another little-known but important macro technique: cross polarization. The method is discussed in the following chapter.

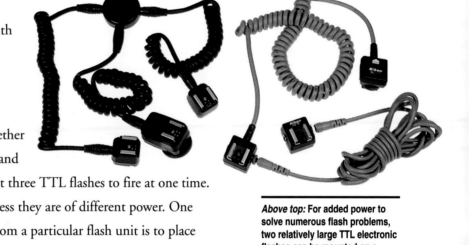

Above top: For added power to solve numerous flash problems, two relatively large TTL electronic flashes can be mounted on a Macro Bracket. This arrangement has a greater range, recycles faster, and can be used for cross-polarization macro photography. The added weight and mass may be too much for some photographers.

Above bottom: Special cords to connect a series of flashes are available from each of the major camera manufacturers. The Canon TTL flash cord system (left) uses a central distributor to add additional flash units. The Nikon system strings the flashes one after the other.

CROSS-POLARIZED LIGHTING FOR MACRO

Red Gerber Daisy

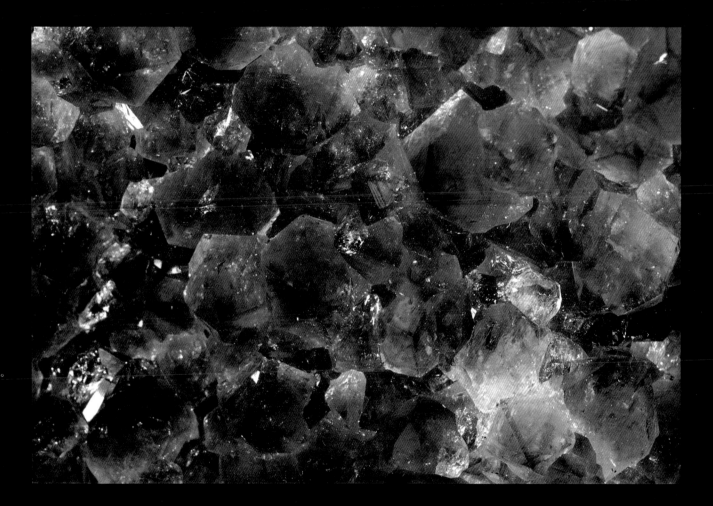

Amethyst Crystals

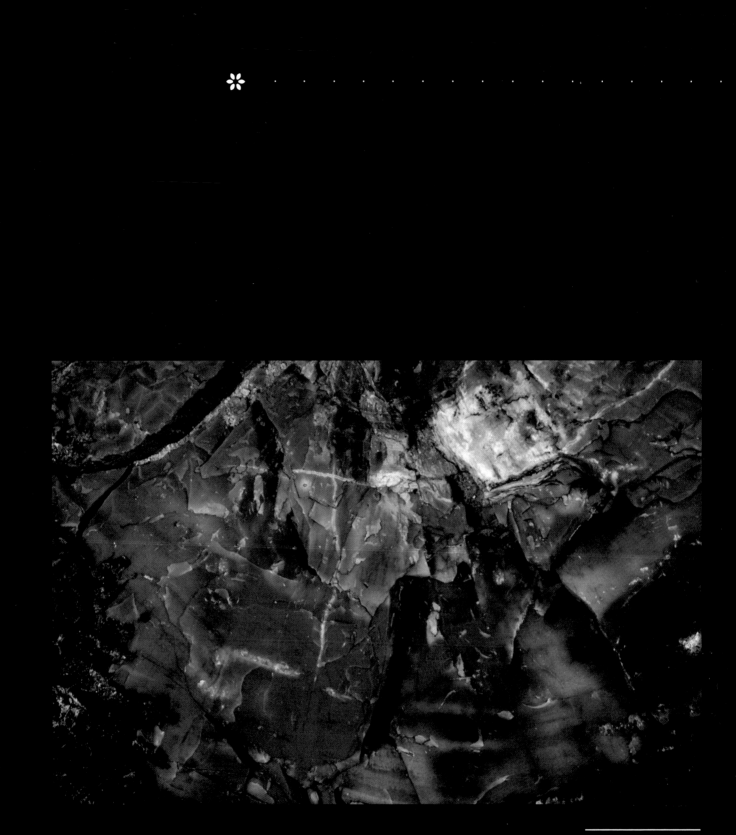

Petrified Wood Detail

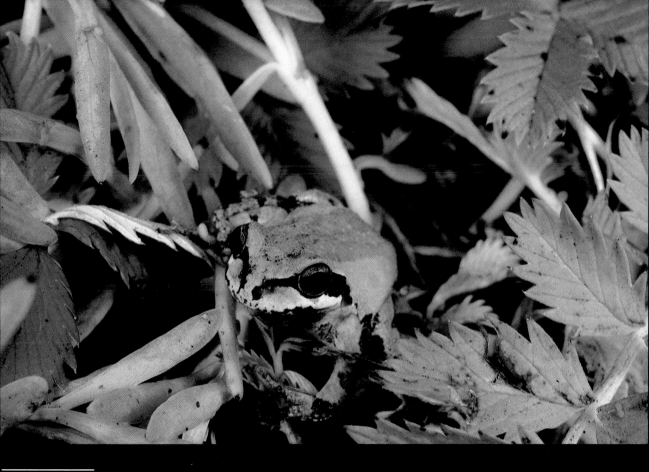

Pacific Tree Frog

Red Gerber Daisy (.75X)

The rich, saturated color of this daisy was revealed when both the light sources and the camera lens were cross polarized. Cross polarization eliminated reflections off the surface of the flower, reducing color degradation caused by scattered light rays entering the lens. 100mm macro lens with a Macro Bracket and two hotshoe flashes; 50 ISO film.

Amethyst Crystals (1X)

The intense lighting needed for macro is reflected back at the camera by the many facets of a crystalline structure. Cross polarization eliminates nearly all reflected light and allows the true color of the structure to record on the film. 100mm macro lens with Macro Bracket and two hotshoe flashes; 1/200 second at f/16 on 100 ISO film.

Petrified Wood Detail (1X)

Cross polarizing both the lens and the light source eliminated all reflections off the wood-turned-to-stone, revealing the natural color and detail in maximum clarity. The entire assembly of 100mm macro lens with two powerful hotshoe flashes on a Macro Bracket was hand-held in the field. 50 ISO film at f/16.

Pacific Tree Frog (.5X)

The advantages of cross polarization for photographing moist specimens are evident in the brilliant green color of this Pacific tree frog and the plants in its typically damp habitat. The absence of specular highlights, even in the frog's eye, increases the clarity of the image. 100mm macro lens with Macro Bracket system set up for cross polarization; 64 ISO film.

CROSS-POLARIZED LIGHTING FOR MACRO

Cross polarization is a technique that most photographers haven't encountered or used, but knowing the concept can be extremely useful in certain photographic situations. When used in macro photography, the method prevents specular highlights from recording on the film. Elimination of nearly all reflections from the surface of the subject allows considerably more detail to be presented and, in many cases, increases color saturation.

The effect is useful with moist subjects such as amphibians and residents of tide pools. Oily or waxy surfaces of plants and flowers tend to produce specular highlights that diminish color saturation; this is especially true with many green leaves. The reflective surfaces of shiny minerals can wash out any color when photographed close up by standard methods. By eliminating the reflections in all these subjects, cross polarization reveals startlingly enhanced colors seldom seen by the human eye.

The principle of polarization is one of selectivity: A polarizing filter placed over the lens eliminates diverging rays of light and allows only beams emanating from the subject and parallel to the lens to enter. A single polarizing filter is a common photographic tool used to darken skies and improve color saturation on landscapes, and to eliminate reflections when photographing into glass and Plexiglas enclosures and other shiny surfaces.

Note the improvement in color and detail in the cross-polarized subject on the bottom. 105mm macro lens with two hotshoe flash units on a Macro Bracket; 1/125 second at f/16 on 50 ISO film.

When the selectivity of light direction is further extended to the light source, even more control is gained over the direction of the light entering the camera lens. Cross polarization is achieved when almost all divergent rays of light, selected first from one direction by the filter on the light source, and second from the opposite direction by the filter on the camera lens, are screened out. Cross-polarized lighting occurs sequentially: The polarizing filter over the properly placed light source eliminates some of the divergent rays from hitting the subject. The opposing polarizing filter over the camera lens then screens out additional rays not emitted from the subject and so prevents them from entering the lens. If the two filters are perfectly opposed, nearly all divergent light will be eliminated.

Eliminating divergent rays, of course, significantly reduces the light available to the film. In single polarization, between one and two stops of light are lost, and perfectly opposed cross polarization can result in loss of up to five stops.

Equipment Needed to Accomplish Cross Polarization

It is preferable to use a camera and flash system capable of through-the-lens flash exposure, and the flash needs to be the highest-power hotshoe type available due to the five-stop loss the technique engenders.

Camera filter. The standard polarizing filter regularly used for landscape photography is suitable for use in cross polarization. Either the older linear or newer circular polarizing filter will accomplish the cross-polarization technique effectively.

Light source filter. Commercial grade material with a polarizing efficiency of approximately 99% is available in plastic acetate sheets from Edmund Scientific Company. A sticker with an arrow denotes the polarizing axis of the sheet. Do not remove this arrow, and when you cut the filter to cover your electronic flash, note the axis on each piece of material. Polarizing material will fade after repeated flashes through it. A light area in the center of the material signals the need for replacement. Be sure the new material is oriented in the same direction as the material you are replacing.

Flashes. Two flashes are recommended for cross polarization, and each needs to have a fair amount of power to compensate for the five-stops loss of light attendant to the technique. A minimum guide number of 100 for ISO 100 film is necessary. The Canon 300TL, 300EZ, 430EZ, the Nikon SB-24, SB-25, and SB-22, Minolta Maxxum 5400xi, and the Pentax AF 400 and 500 FTZ are a few examples of units with sufficient power for cross-polarized lighting for macro. If the flashes have a built-

in Fresnel, it may be helpful to set the Fresnel to telephoto to concentrate the light. Be sure that the narrower beam from the polarized flashes adequately covers the subject.

Setting up the System

To be sure that your polarizing filter and light-source polarizing material work properly together for complete cross polarization, place the camera filter in front of the sheet of polarizing material and hold them up to the light. As you rotate the camera polarizing filter in front of the sheet, it should go nearly black. If the filter goes only gray, and you can still see through it, then the sheet material is not configured properly for use in cross polarization.

An example of full cross polarization achieved by the camera polarizing filter and light-source polarizing material. The light coming through the two filters is reduced by approximately five f/stops.

A bracket system like the Lepp Macro Bracket II from Saunders Group will be useful to hold the two electronic flashes in a consistent orientation at an approximate 45 degree angle to the subject. Cover each flash head reflector with a sheet of polarizing material. The polarization axis on each sheet must be the same. The material can be attached to the flash heads with tape or Velcro strips, or by sliding the material into the filter slot that some flash units provide.

Hold the lens polarizing filter in front of one of the covered flash heads, and rotate the camera polarizer until it renders the flash polarizing material black. Note this orientation by marking the top of the filter ring,

A cross-polarization system ready for photography. The Nikon N90 has a 105mm macro lens with polarizer and the SB-24 and SB-25 flash heads are covered with polarizing material.

and position it on the camera with the mark at the top. The camera and polarized light sources are now cross polarized, and the system is ready for macro photography. With the camera and light source filters marked with their opposite orientation, it should be a simple task to duplicate the system's setup later.

To assure that the three filters are properly oriented for maximum cross polarization, place a normal lens on the camera with the polarizing filter attached and look *through* the camera into a mirror. The polarizing material on the two flashes should look

black. Rotate the polarizer on the camera lens to observe the flashes changing from gray to black. If the two flashes don't react similarly during the rotation, they are not oriented identically. When both flashes are at maximum black, check to see that the mark on the camera's polarizing filter is truly at the top. If not, adjust the mark.

Exposure Considerations

A TTL flash exposure system will eliminate the need for extensive testing to determine correct exposure. When first trying the cross-polarization technique, you should do some bracketing towards overexposure. The Nikon and Canon systems I have used for this procedure tended to give the best rendition of the subject at one to two stops overexposed.

The overall tonal value of the subject will influence the TTL flash exposure as it normally does. White subjects will tend to gray, and dark subjects will be reproduced in a lighter gray tone. Additional manipulation of the exposure compensation will fine-tune the exposure to the photographer's desired interpretation.

Light Up the Field

Once you've mastered these advanced multiple TTL flash techniques, you'll find plenty of photographic opportunities to use them. You can apply these new skills immediately in uncommon photographs of the two common high-magnification field subjects discussed in the following chapters: butterflies and flowers. The increased clarity and color you will achieve in your macro photographs are well worth the investment and time needed to perfect your use of multiple TTL and cross-polarized flashes in the field.

❁ ❁ ❁

PHOTOGRAPHING BUTTERFLIES

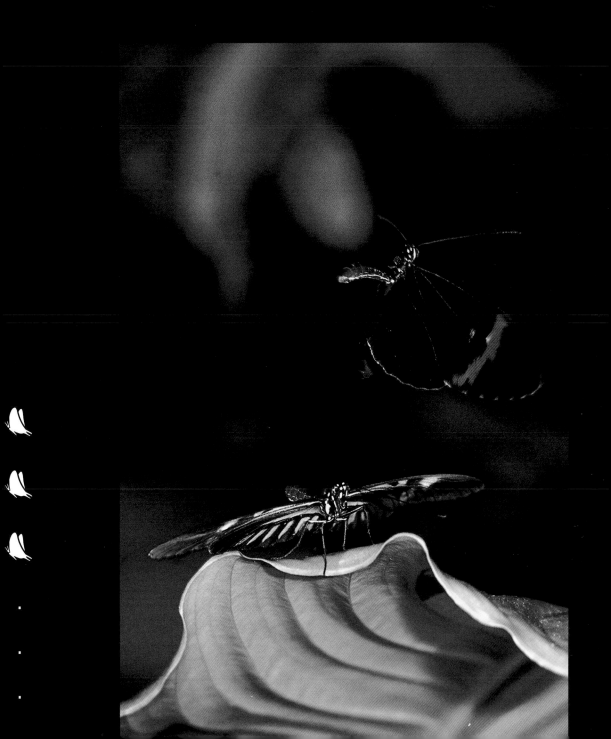

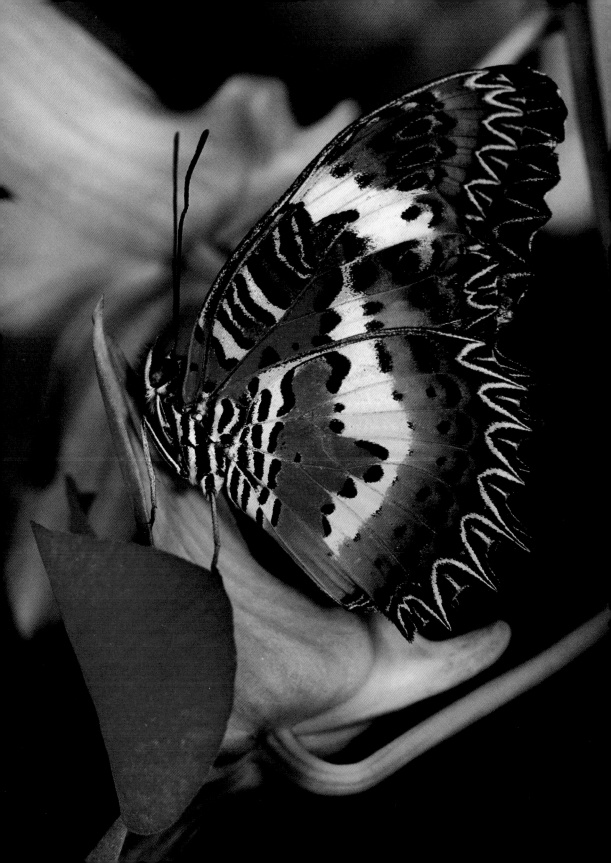

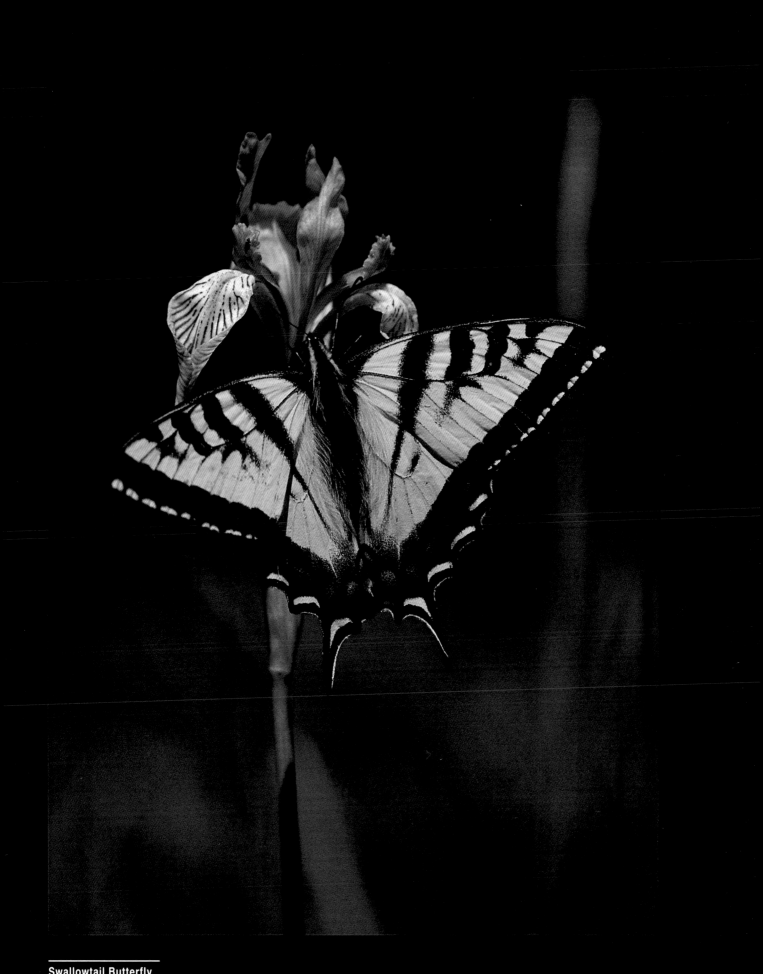

**Swallowtail Butterfly
Nectaring on Iris**

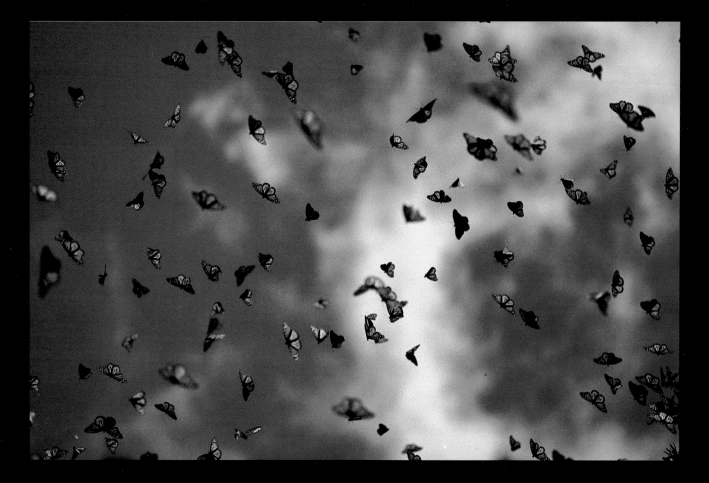

Monarch-filled Sky

Courting Butterflies

Autofocus and a single hotshoe flash stop the action of these heliconius butterflies. The amount of light available from the top-mounted flash allows considerable depth of field. Photographed with a 100-300mm zoom lens at Florida's Butterfly World; 1/250 second at f/11 on 50 ISO film.

Lacewing Butterfly Resting on Orchid (1/2X)

Macro lighting techniques evenly illuminated the butterfly, providing enough depth of field for sharp rendering of the complete subject. Two hotshoe flashes on a Macro Bracket, 100-300mm zoom lens, and Nikon 5T two-element supplementary closeup lens; 1/250 second at f/11 on 50 ISO film.

Swallowtail Butterfly Nectaring on Iris (1/2X)

With only available light, this butterfly was captured during a short stop on one of several irises. To be successful in catching these flighty insects, the photographer must preset the focus and frame, predict the butterfly's next likely perch, and move quickly and smoothly toward and away from the subject until focus and framing are correct. 200mm macro lens; 1/125 second at f/8 on 100 ISO film.

Monarch-filled Sky

I heard this swarm of butterflies before I saw it. To capture the phenomenon, I aimed my 200mm lens skyward and chose a shutter speed-f/stop combination to both stop the wings and get a few butterflies in focus. 1/250 second at f/8 on 64 ISO film.

Butterfly Wing Scales (40X)

Using macro techniques and a special bellows, magnification of 50 times life-size can be achieved. Any greater enlargement requires a compound microscope. 19mm lens on Nikon Multi-phot macro system, two TTL hotshoe electronic flashes; 25 ISO film.

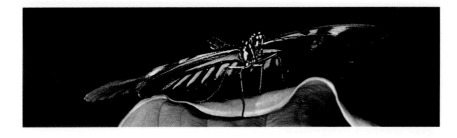

PHOTOGRAPHING BUTTERFLIES

Great photographs of butterflies are not easy, but sharp, well-exposed images of these insects can be among the most interesting and evocative in your portfolio. Butterflies offer a compelling combination of elusiveness, delicacy, and astonishing design, and, by virtue of their environmental preferences, come complete with lovely floral or foliage backdrops for portraits. Catching a butterfly in your photographic net conveys a sense of serendipity, of being in the right place at just the right moment.

Indeed, the most difficult part of butterfly photography is finding the subjects. They may be common local species found in your own garden or at a nearby plant nursery or botanical garden. But you'll need to brush up on basic butterfly biology to determine where and when you're likely to find them. Some zoos and nature centers have opened walk-through butterfly "aviaries". Or you can go on a butterfly safari to the highlands of Mexico to photograph overwintering monarchs, or to the jungles of South America to stalk the huge morpho butterflies. The butterflies are different, but once you've found them, the photographic methods are the same.

Butterflies are spirited, wary, and appear to move at random from one perch to another. In fact, careful observation will reveal some predictable behavior patterns. Still, butterfly photographers need to be deft, careful, and ready to shoot with equipment that is portable, quick to use, and allows good working distance. The most critical factor in butterfly photography is the gear itself. Fortunately, most of what you need in lenses, closeup accessories, and flashes can be found in the bags of most serious photographers.

In this chapter, you'll find discussion of the innovative techniques, simple equipment combinations, and approaches you can use to get really close to butterflies. Mounted on your wall, larger than life, these will be some of your most rewarding and admired photographs.

Basic Butterfly Biology

The presence of butterflies in a particular area is the result of a complex combination of inter-related natural factors. Climate is the most significant of these, because adult butterflies cannot survive freezing temperatures. Rainfall and seasonal temperature changes affect the abundance of food sources and host plants. Because of climatic variations, a moist mountain meadow filled with wild iris will draw multitudes of tiger swallowtails in a water-rich year, and a following dry year will produce different nectar sources preferred by other butterfly species. A drought-stricken area which produces no flowering plants will support no butterflies.

If you seek to photograph a specific butterfly species, you must first find its primary larval food source, for the host plant's availability will determine the insect's abundance and migration patterns. The monarch east of the Continental Divide provides an especially eloquent example of migration driven by food source. A tropical butterfly, the monarch has adapted to the

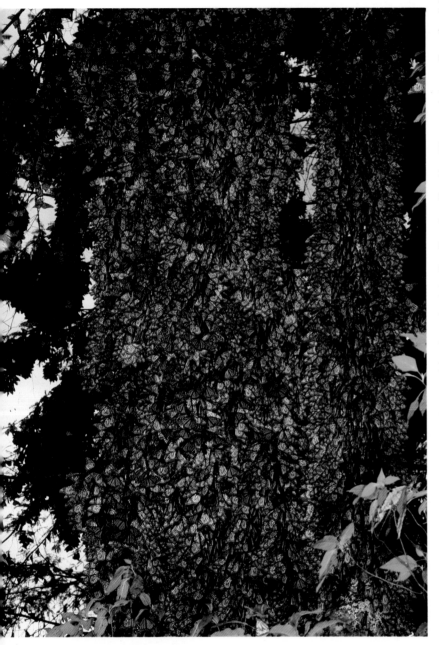

The ultimate butterfly experience can be found in the high mountains of Central Mexico where hundreds of millions of monarch butterflies overwinter each year. To compensate for the great difference between full background sun and foreground shade, an electronic flash was used to lighten the shaded areas and to bring out the color of the butterflies. 55mm macro lens; 64 ISO film.

extended range of milkweed essential as a food to its larval stage. When the northern temperate seasons warm, both milkweed and monarchs appear ever-farther north, even into southern Canada. As winter approaches, milkweed disappears in the northern zones, the monarch's reproductive activity ceases, and migration quickly reverses to overwintering sites in central Mexico.

The egg, larval, chrysalid, and adult stages will direct the photographic methods needed to document the life history of a particular butterfly species. The first three

stages, which are somewhat static, lend themselves to primarily macro techniques. These three stages usually will be found in and around the butterfly's host plants. Thus their location and availability are fairly predictable. You can encourage the presence of local species in your garden by planting appropriate host plants and nectar sources.

Adults, of course, are highly mobile, and their behavior appears to be unpredictable. However, each species has favorite foods, and as long as wind is moderate and temperatures are warm, photographic opportunities may present themselves at preferred nectar sources. Once you've found a likely location, observe patterns of behavior before you begin to photograph. Are the butterflies nectaring? Are they chasing each other around in territorial or mating displays? Which flowers do they seem to prefer for nectaring? How long do they stay at a flower while they nectar?

Usually, an individual butterfly will follow a predictable pattern in its quest for food. It will look for flowers of a certain maturity, stay on one for a consistent period of time to collect the nectar, and then fly to the nearest flower of similar maturity and repeat the procedure. The challenge is to predict which flower might be next and to get there about the same time as the butterfly so that you have enough time to focus and compose the photograph before the subject heads off to the next feeding station.

Positioning the Camera

Observation of the butterfly subject's behavior should have given you the key information you need to determine the best photographic angle to use. At the necessary close focus with its limited depth of field, it will not be possible to photograph the wings when spread at more than one plane—one or the other will be out of focus in the resulting image. If the butterfly consistently lands with wings spread, position the camera from above the insect perpendicular to the unfolded wings. Some species land and nectar with the wings folded above the body. An angle from the side will render the wings and body of the butterfly sharp within the limited depth of field.

Macro techniques are necessary to document the early stages of butterfly development, such as these swallowtail butterfly eggs and first instar caterpillars at 3/4X. 100mm macro lens with two TTL hotshoe flashes on a Macro Bracket; 1/125 second at f/22 on 50 ISO film.

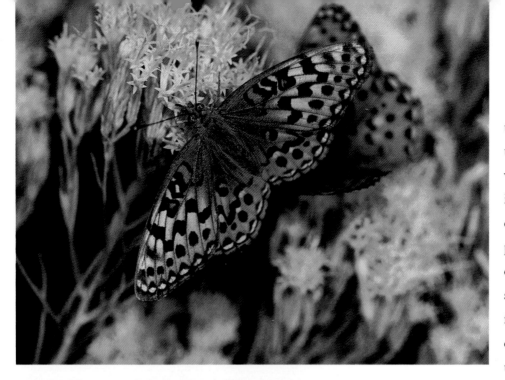

The camera/lens combination should be set to a predetermined magnification that will properly frame the intended subject. Once the camera is set, the photographer moves quickly and efficiently towards the subject until it comes into focus. This eliminates time-consuming manipulation of the focus and zoom controls on the lens. Autofocus, of course, may be an especially valuable tool for butterfly photographers who have difficulty in critical focus, but the preset manual focus method generally works faster and more efficiently.

Particular consideration should be given to the direction from which light reaches the subject. Light coming from the side of the frame is optimal only if it comes from the direction of the insect's head. Light from behind the subject is fine if the desired effect is backlighting. Exposure is critical in backlighting since the mood of the photograph depends on how much information is available in the shadow side of the backlit subject. A complete silhouette with a rim of light is very dramatic, while a subject with detail in the shadow side with a highlight around it can be informative and still interesting. You can fill in the front shadow area with a small flash, or a white card if the subject will tolerate it.

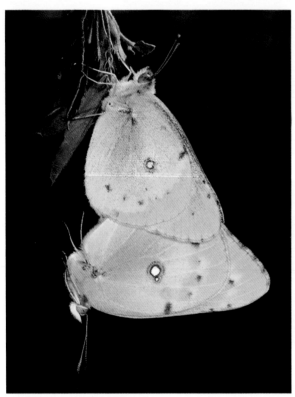

Butterfly closeups allow so little depth of field that it is very difficult to keep spread wings in focus. Keep the film plane parallel to the subject's wings, photographing from above the wingspread, as demonstrated with the fritilary on yellow rabbit bush at top, and from the side of closed wings, such as the mating sulphur butterflies at bottom.

Equipment Combinations for Butterfly Photography

The conditions under which great butterfly photographs are taken suggest a telephoto lens that is lightweight, quickly adjustable, and focuses relatively close to the subject. A large number of zoom lenses within the ranges of 70 to 300mm fit these criteria perfectly. The one limiting factor with these lenses might be their close focus, but simple accessories such as extension tubes and supplementary two-element closeup lenses can solve the problem.

An effective setup for chasing butterflies is a zoom lens of 100 to 300mm which focuses close enough to full-frame larger butterflies when zoomed to its full potential and set to its closest focus. Other zoom telephoto lenses which will work well are 70-210, 80-200, and 75-300mm.

Fixed focal length lenses of 200 to 300mm will work nearly as well as the zooms within this range. Some manufacturers also offer macro telephoto lenses of 200mm which provide both working distance and, if needed, a closer view of parts of the subject.

For smaller butterflies and moths, use an extension tube or a low-power, two-element closeup supplementary lens. Placed between the camera and the lens, extension tubes allow the telephoto lens to focus closer to the subject. The result is a larger image on the film, but the price is paid in loss of working distance. The more extension, the closer the camera can approach. If your subject doesn't flee in response, you'll have a larger image.

Several of the two-element closeup supplementary lenses (diopters) available are designed specifically for zoom lenses in the 70-300mm range. Depending upon the optical power of the supplementary lens, once focus is achieved at a working distance the photographer merely zooms the lens to vary its magnification. For butterfly photography, the less powerful supplementary lenses work best, as they afford a longer working distance and an image size appropriate for the animal's size.

Electronic flash can be used to augment the available light when conditions are overly contrasty, or as a primary light source when the ambient light is insufficient to achieve the necessary depth of field or to allow a shutter speed that will stop the subject's movement. Due to the close proximity of the camera and the subject, the flash can be a general hotshoe variety. The very best units are those with built-in flash fill capabilities. Be sure the flash mounted on the hotshoe above the camera lights the same area the lens is viewing, which may be a problem at such close quarters unless the flash can be angled slightly downward. Another answer to this problem is to set the flash for a wider-angle coverage, which will include the area lower than the unit itself.

A simple setup for butterfly photography includes an autofocus Nikon N90 with close-focusing 75-300mm telephoto lens and an electronic flash for fill lighting.

Super Closeups

Any magnification beyond three times life-size is difficult and requires specialized macro equipment and precise lighting techniques such as those described in the third chapter of this book, "Multiple TTL Electronic Flash for Macro". For chasing subjects as flighty as butterflies, the multiple-flash apparatus is certainly cumbersome, but it is essential for super closeups of small butterfly and moth subjects, or portions of them, in all developmental stages.

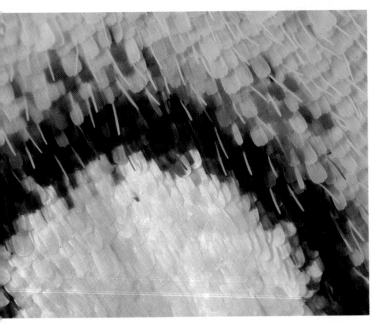

These butterfly scales were recorded at 10X, the minimum magnification necessary to do them justice. The magnification is fairly easy to accomplish with a 19mm special macro lens and bellows. Lighting is with two electronic flash units with a guide number of 116 for 100 ISO film.

Magnification of at least ten times life-size is necessary to do justice to the intricate patterns formed by the scales on the wings of butterflies, however. This painstaking work demands particular care in preparation and lighting of the subject, so you will want to accomplish high-magnification wing photography in your studio.

Be sure to start with a clean wing, and protect the subject from dust and disturbance between working sessions. At magnifications from 10X to 50X, tiny bits of dust are boulders in the butterfly landscape. If the scales are especially shiny or iridescent, cross polarization of the light sources (as described in the fourth chapter of this book) will reduce reflection and increase color saturation.

There is a tendency to place electronic flashes extremely close to the wing due to great loss of light at such high magnifications. But if they are too close, the burst of light from the flashes may actually ignite some of the very fine scales on the wing. Placing the flashes at a distance of four or five inches from the subject should be sufficient to prevent singed scales.

The Place Is As Good As the Chase

Enjoy your pursuit of butterflies in each of their developmental stages. The adults will reveal themselves to you only if it's a pleasantly warm day, the wind is still, and the flowers are in bloom—marvelous conditions for nature photography. Even if the butterflies elude your camera, you'll have plenty of other insect subjects to choose from, and you can use many of the same high-magnification equipment and field techniques on the host flowers themselves. So before you head out in search of butterflies, read the next chapter and learn how to make the most of great opportunities for flower photography.

Isolated Coreopsis

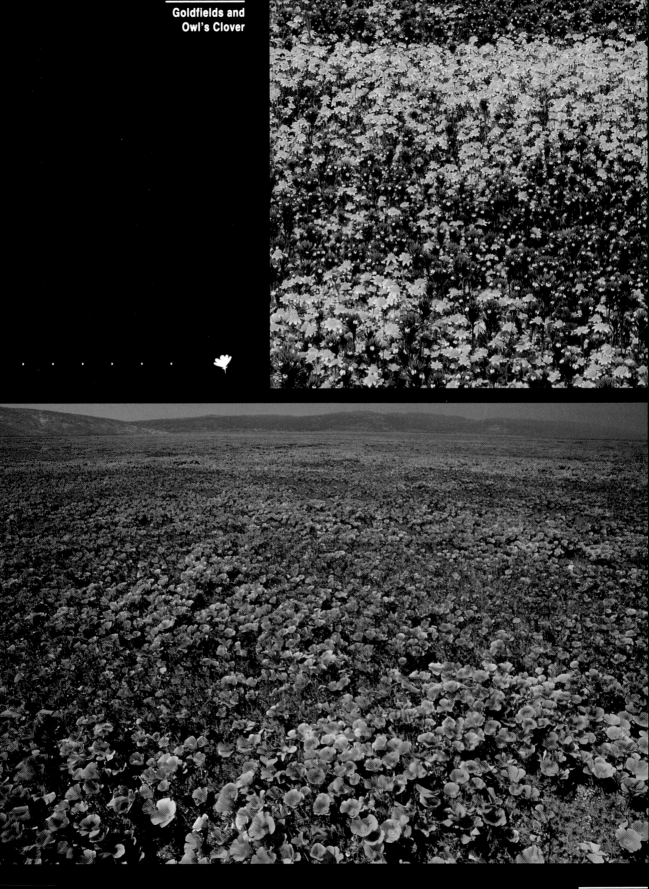

Goldfields and
Owl's Clover

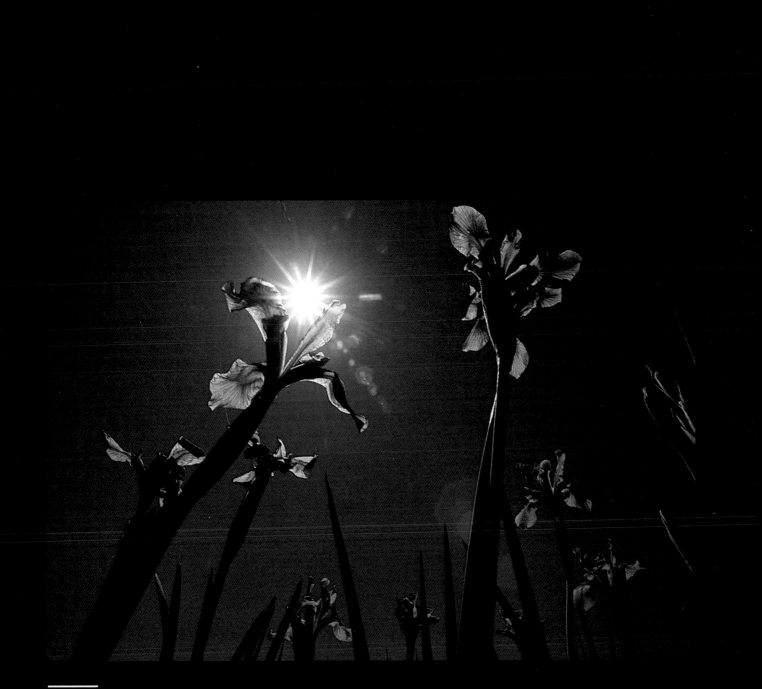

Wild Iris

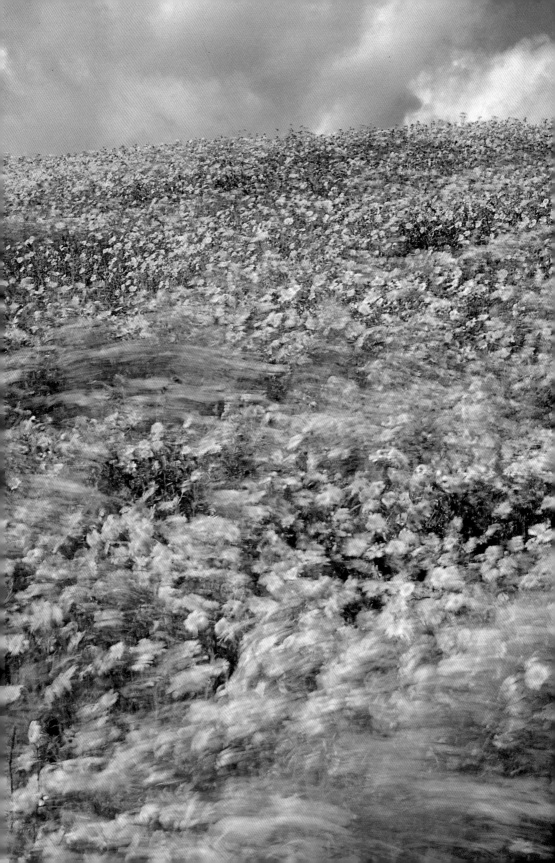

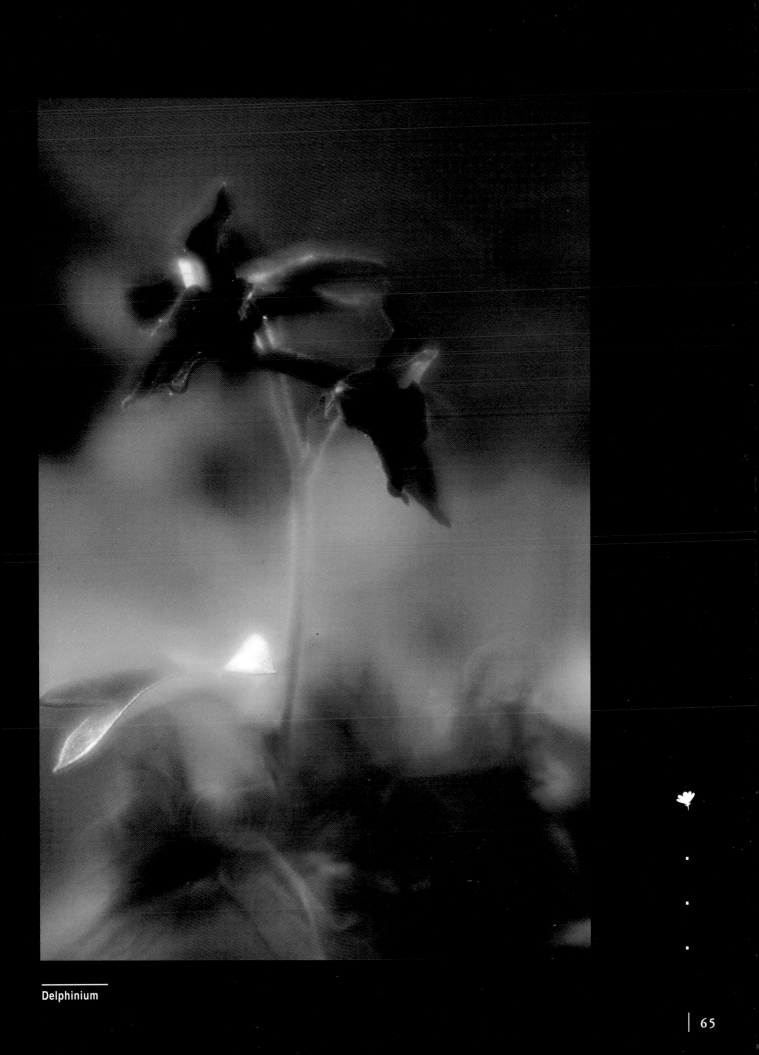

Delphinium

Isolated Coreopsis

The shallow depth of field of a telephoto lens used wide-open helps to isolate this flower. The effect is enhanced by the brilliance of the ambient light and the coreopsis's color and height, which separate it from the poppies around it. The out-of-focus flowers indicate the abundance of the field without distracting attention from the primary subject. 100-300mm lens; 1/500 second at f/5.6 on 50 ISO film.

Goldfields and Owl's Clover

A 90mm tilt-shift lens with 2X tele-extender (180mm) enable extraordinary depth of field across the surface of this field along with an unusual, compressed perspective. Flowers just beneath the sharp plane are slightly out of focus throughout, producing this rare image that would be impossible to capture with a conventional 180mm lens. 1/80 second at f/11 on 50 ISO film.

Poppy Field

A 20-35mm wide-angle lens set at 20mm and a high horizon amplify the view of this field, clearly showing both individual flowers in the foreground and the endless expanse of poppies. Use of hyperfocal distance is critical to maximize the needed depth of field. 1/15 second at f/22 on 50 ISO film.

Wild Iris

Photographing from underneath taller flowers, such as these blue flag irises, affords a different perspective and the opportunity to include the sun within the photograph. A wide-angle lens of 18mm set at its closest focus and smallest f/stop gave depth of field throughout the blossom area. The sunburst is caused by the small aperture of a wide-angle lens and the underexposure of the sky. The exposure of 1/60 second at f/22 is a one-stop underexposure from basic daylight. 64 ISO film.

Monolopia Sunflowers in the Wind

When the wind disrupts a session, go with it. Breezy tendrils of wind snaked through the scene, moving parts of the field and leaving others motionless. 90mm tilt-shift lens; 1/15 second at f/22 on 50 ISO film.

Delphinium

A 135mm soft-focus lens with a 25mm extension tube gives an ethereal effect. The image becomes sharper as the lens is stopped down. The same holds true for soft-focus filters. Some area of the image must be sharp; otherwise, the soft-focus can be construed as missed focus. 1/1000 second at f/4 on 50 ISO film.

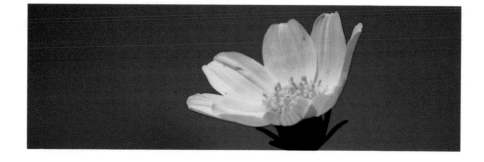

CREATIVE FLOWER TECHNIQUES

Flowers are some of the most commonly photographed of nature's subjects, but much of today's flower photography is undeniably boring. We are overexposed to two-dimensional scenes of fields of flowers on calendars, billboards, magazines, food packaging, and television news backdrops. In our busy, highly mobile society, we've become complacent about masses of flowers—iceplant on freeway median strips, poppies on country roadsides, the neighbor's spring rose garden, pansies at the shopping center, and petunias at the library.

Since we've all seen lots of flower pictures, and lots of flowers, it's difficult for a photographer to give us an interesting, fresh view of this old favorite subject. You can take the viewer to your flowers, but you can't make him look unless there's something new to see. Since the flowers can't be new, you have to show them to your viewers in ways they've never seen them before: from an unusual angle, with more intense color, extra close up, with resident critters, or in exotic locations.

With some creative techniques supported by the appropriate equipment and a willingness to assume positions not common to the average viewer, you can create unusual and interesting images. By using telephoto lenses and their inherent shallow depth of field, you can make a particular area, or even an individual flower, stand out from the crowd. But with wide angle lenses, you can emphasize the grandeur of an endless field by expanding the view. Include the sun in the frame to add another feature never seen by most people who remember their mother's warnings against looking directly into the sun. Or use the same wide-angle from low angles, even from beneath the flowers, to give a bug's-eye perspective. Use high magnification to enter the flower's inner world, where it is broken into its basic forms and colors.

Set a tender mood with the use of soft-focus, or add a second exposure with the subject thrown out of focus. Multiple exposures on the same frame can create a whimsical profusion of out-of-register images.

In this chapter, then, we'll discuss the many options of technique and equipment which, combined with a creative photographer, can render even the simplest lily into a photograph that demands a viewer.

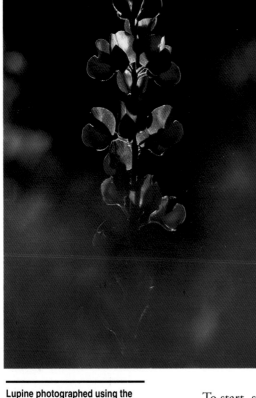

Lupine photographed using the isolation technique with a 100-300mm lens set at 300mm. The flowers between the camera and the subject are rendered out of focus and used to provide a color-wash frame. The background is shaded to maintain a dark base for the backlit subject. 1/500 second at f/5.6 on 64 ISO film.

Isolation Using Telephotos

By de-emphasizing both the foreground and background and directing the viewer toward the photographer's chosen subject, the technique of isolation selects a flower or flowers and separates them from the surrounding field. In a sense, the photographer uses the field as a backdrop or setting from which many different natural vignettes can be extracted. This is a particularly satisfying endeavor; it draws upon the photographer's artistry, keen perception, and composition skills.

Lenses of 100mm to long telephoto, used with a large lens opening, will give the desired effect—shallow depth of field. I particularly like to use a 100-300mm zoom lens that allows me to fine-tune the composition with the lens's varied focal lengths. On occasion, I've even used lenses as long as 600mm to achieve the isolation effect, but these are difficult to manage and not really ideal for the close focus you want to achieve on your isolated subject.

To start, survey the scene, and look for a good place to locate yourself. Shoot from the edge of the field, or from a sparsely flowered spot into a heavily populated area, so that your activities will have limited impact on the fragile plant system. You have to commune with flowers on their own level, so get down. There's a reason why early morning flower work is called "wet belly" photography. Lie on your stomach on the ground and look, really look, at the various scenes around you, but only within the range your lens can accommodate. Once you've selected some possible shots, observe them through your camera with your telephoto lens set at its widest aperture.

A tripod probably won't be necessary when using the isolation technique, and it might feel cumbersome, since the wide aperture is giving you fast shutter speeds

even with the slower transparency films. But for serious compositions where all aspects of the scene are to be studied and fine-tuned, the tripod will slow you down and force you to take the time to check all of the elements of your composition. Your images will take a quantum leap in quality.

Be aware that in this case what you see in the viewfinder is exactly what you are going to get. Now work to perfect the image you are framing. Check the out-of-focus flowers in the background for placement, and look for any overly bright areas that may call attention away from the subject, since the eye is drawn toward the lightest elements of a composition.

Remember that many viewfinders show you only 90 to 95% of what will appear on the film, so check carefully for any unwanted or unattractive elements just outside the field of view that may protrude into your image from the top, sides, and bottom. A helpful trick is to look into the viewfinder as if you were examining a finished slide being projected on a screen; check all of the elements of composition.

Now that you've eliminated unwanted intruders, look at the flowers between you and the subject; can they be used to your advantage? Adding out-of-focus foreground color can do much to enhance otherwise uninteresting areas. The closer the flowers are to the lens, the more out of focus, and thus less distracting, they will be. Foreground flowers closer to the subject may draw attention away from it, because they will be perceived as flowers rather than neutral color areas.

If there are no foreground flowers handy, it's tempting to move one into place. First, consider whether the flowers in question are endangered, or rare, or even just sparse in

A photographer holds a flower at arm's length in front of the lens to add supportive color to the foreground of the image.

that year. If they are, move yourself instead of the flowers. If they aren't, you still should be courteous to the field and the flower aficionados and photographers who may follow you to the site. Perhaps you can bend a stem into place. You need hold only one flower at arm's length in front of the lens, and move it until it provides a wash of color just where you want it.

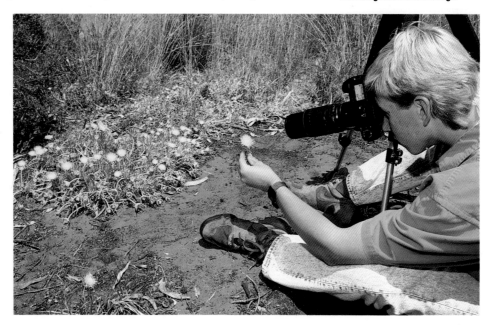

Three Steps Toward Improved Flower Photographs

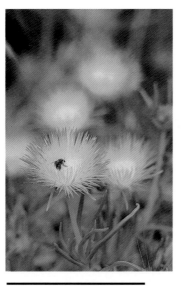

Determine camera placement and frame the subject. Many photographers never proceed beyond this basic step. Much more can be done to improve the overall image.

Look past the subject and identify any degrading elements such as distracting light areas, twigs intruding into the frame, dried leaves or flowers past their prime, or a blade of grass that obscures the subject. Correct anything that detracts from rather than adds to the photograph. Remember the 92% viewfinder. Only the Nikon F3 and F4 and the EOS 1 have 100% viewfinders.

The finishing touch might be to bring an element of color into the foreground to enhance a neutral area. A blossom or leaf placed immediately in front of the lens will be rendered an out-of-focus wash of color. While looking through the viewfinder, experiment to achieve the desired effect.

Expansion Using Wide Angles

Using the expansion technique allows the photographer to convey the full glory of an endless field of flowers, or to give the impression that a huge expanse of blooms exists when it may not. The resulting image invites the viewer to enter the field in the foreground and to continue on into the scene. Because of the depth of field, the viewer can see the details of the individual flowers in the foreground, but they are replicated in increasingly indistinct waves to infinity in the background. Infinity can be suggested by where the photographer crops the frame, or can actually occur at the horizon.

Expansion is a landscape technique, and many of the concepts discussed here are pivotal to portrayal of the "grandscape", addressed more fully in "Wide-Angle Landscape" later in this volume. No matter what the subject, hyperfocal distance is critical to execution of the expansion technique.

Hyperfocal Distance

When you focus a lens with a set aperture at infinity, the nearest point of acceptable sharp focus is called the hyperfocal distance for that lens set at that aperture. This could also be called the beginning point of the depth of field achieved by that lens and aperture. Refocusing the lens at the hyperfocal distance with the same aperture maintained renders everything in sharp focus from halfway between the camera and the hyperfocal distance point on to infinity.

Why is knowing the hyperfocal distance of a particular lens and aperture important? Considerable depth of field can be gained by using the hyperfocal distance. This is most important in the use of wide-angle lenses for landscapes. The ability to set a 20mm lens to give a sharpness range of 13 inches to infinity (using f/22) expands your creative opportunities.

You can use mathematical formulas to determine the hyperfocal distance for any lens at any aperture. I've written out on a card the hyperfocal distance for a couple of lenses at their smallest apertures. This way I can use my wide-angle zoom lenses to their best advantage, without stopping to do my math homework first.

When using hyperfocal distance charts, it is important to consider the level of sharpness used to calculate the distance. A single point of black on a white background can be measured by its diameter as it is imaged by a lens. The imaged single point of information spreads out as it is degraded by the photographic process. The enlarged measurable point is called a circle of confusion. For our purposes we'll use the circle of confusion of .001 inch, a standard I believe should be used for all lenses. You will see other hyperfocal distance charts with closer figures for depth of field, but these charts use a larger circle of confusion and the near focus point may not be as sharp as you'd expect. Use the constant .001 inch standard to maintain the best sharpness.

Non-zooms, such as a fixed focal length 50mm, will have a depth-of-field scale that makes finding the hyperfocal distance easy without math or a chart. Set such lenses at a small aperture like f/16 or f/22. Place the infinity focus mark on the f/stop mark that you're using. Reading the distance scale from that f/stop mark to the opposite same f/stop mark will give you your total depth of field, approximately the same as a hyperfocal distance chart would indicate.

Hyperfocal Distance Chart
Circle of Confusion = .001 inches

Lens	f/16	f/22	f/32
15mm	1.8 ft	1.3 ft	0.9 ft
16mm	2.1 ft	1.5 ft	1.0 ft
17mm	2.3 ft	1.7 ft	1.2 ft
18mm	2.6 ft	1.9 ft	1.3 ft
20mm	3.2 ft	2.3 ft	1.6 ft
24mm	4.7 ft	3.3 ft	2.3 ft
28mm	6.3 ft	4.5 ft	3.2 ft
35mm	10.0 ft	7.0 ft	5.0 ft
50mm	20.2 ft	14.3 ft	10.1 ft

To use this chart, set the indicated distance in feet for the chosen f/stop on the focus mark of the lens. **Do not refocus the lens after setting it!** The depth of field will begin at half the distance between the camera and the number of feet set on the lense. EXAMPLE: 50mm lens set at f/32— the lens is set at 10 feet and everything from 5 feet to infinity will be sharp.

The depth-of- field scale on a 50mm lens with the infinity mark set at f/32. Everything from infinity to seven feet will be in focus.

Wide-angle lenses ranging from 28mm to fish-eye are the best choice to maximize depth of field and accomplish the expansion technique in wildflower photography. To attain this maximum depth of field, the photographer needs to stop the lens down to its minimum aperture and set the focus point on the lens at its hyperfocal distance. For instance, a 28mm lens set at f/22, with the infinity mark set at f/22 on the depth-of-field scale, will sharply render the scene from approximately 28 inches to infinity. A 15mm fish-eye lens with aperture and depth of field set at f/22 will attain sharpness from approximately ten inches to infinity. Settings and sharpness ranges for the other wide-angles will fall within these extremes.

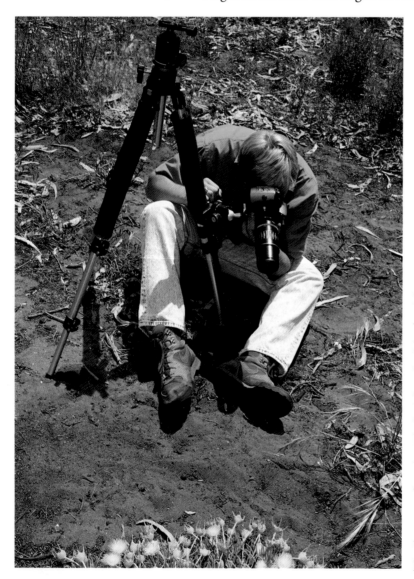

To bring the camera low to the ground, use the Bogen Super Clamp to attach a ball head to an extended tripod leg.

Wide-angle zooms such as 20 to 35mm and 24 to 50mm also work very well, but precise setting of the hyperfocal distance is more difficult. Because wide-angle zooms do not have a depth-of-field scale, you must use a hyperfocal distance chart to obtain maximum depth of field.

You'll need a tripod for success with the expansion technique because of the slower shutter speeds resulting from the minimum aperture and the slower ISO quality films you will be using for flower photography. Another handy tool to facilitate the use of your tripod in flower photography is a leg clamp. Instead of standing on your head, digging holes to get low enough, or reversing a tripod center post, you just clamp a ball head to the lower end of an extended tripod leg and work at ground level with complete freedom.

When you need a faster shutter speed due to windy conditions, a wide-angle tilt/shift lens, a lens which may be tilted on its axis, may solve the problem. The tilted lens more efficiently uses the available depth of field by angling the band of focus without changing the perspective of the scene. This allows you to use a larger aperture with a faster shutter speed.

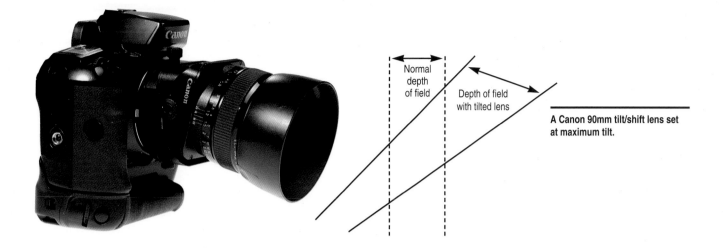

Normal
depth
of field

Depth of field
with tilted lens

A Canon 90mm tilt/shift lens set
at maximum tilt.

As you approach the scene and select your perspectives, keep in mind the minimum distance of the depth of field determined by the hyperfocal setting on your lens. A low camera angle to the field will enable you to show the foreground flowers as well as those in the distance. A higher perspective will cut off the flowers at the top of the frame and leave infinity to the viewer's interpretation.

A lower perspective leaves infinity to the viewer's interpretation and allows the foreground to be closer. 24mm tilt/shift lens; 50 ISO film.

A higher perspective with a 24mm tilt/shift lens showing sky to reasonably close foreground. 50 ISO film.

The unique perspective from below taller flowers must be accomplished using a wide-angle lens of at least 24mm. A right-angle viewfinder can be of great help.

Bug's-Eye View

A unique view can be achieved by photographing taller flowers from as close to the ground as possible. It's best to use at least a 24 mm lens, and the wider-angle the lens the better. Best of all, of course, is a fish-eye. Again, set the lens at its minimum aperture and the focus at its closest point. You also may need a right-angle finder for the viewfinder to help achieve that low position and still compose the image.

Get down really low, and look through the viewfinder for interesting compositions where the light comes through the flowers. Or with a fish-eye lens, which sees 180 degrees, lay the camera beneath the flowers and arrange the composition around and above it. Set a ten-second self-timer to allow yourself time to get out of the lens's field of view. Try a number of different compositions, of course, since you won't have much idea what you've got until the images are processed.

The sun can be an integral part of these images—a sunburst surrounded by flowers, or placed behind a strategic petal. The sunburst is a natural phenomenon with wide-angle lenses used at minimum apertures. You do not need a star/sunburst filter to achieve this effect. When the sun is within the open sky of the frame, the exposure for that image should be bracketed in half stops from a normal sunny

A fisheye lens from beneath taller flowers such as these shooting stars will distort the stems and take in a large portion of the sky; probably, the sun will also be included. 15mm fisheye lens; 1/125 second at f/16 on 50 ISO film.

f/16 to two stops underexposed. You can choose the best rendition later on the light table. Be sure not to look directly at the sun through your viewfinder; note its position, and concentrate on other aspects of your frame.

When a petal or flower eclipses the sunburst, careful attention must be paid to the exposure. Underexposing for the sunburst is no longer the focal point, so a combination of exposures, both over- and under-, will change the emphasis from the sky to details on the petal. This will give you a series from which to choose when you sort the slides later.

Extra-Close Closeups

With macro photography, it is possible to explore intimately the colors, structures, and design elements found within a single flower. The flower itself, separated from its external identity into integral parts, becomes anonymous, except to the experts. The resulting unique images pique interest in most viewers, with some of the most compelling composition, texture, and color found in natural subjects. For the photographer, working in this unusual area where the very small becomes very large presents a great challenge to artistic and composition abilities.

Image magnification of at least 1X (life-size on the film) is necessary to fill the frame completely with a small part of a medium-sized flower, such as a daisy or iris. It is even more desirable to work at higher magnifications such as 2, 3, or 4X if possible. The use of electronic flash is necessary at these magnifications to achieve any depth of field and to bring out the often delicate colors of the flower's interior. Even if flash and minimum apertures are used, the limited depth of field will tend to give an isolation effect on structural parts. Some design elements, particularly those which flow across the entire image, should be approached parallel to the plane to retain sharpness from edge to edge.

A complete discussion of high-magnification field techniques and the equipment needed to accomplish them is presented in the second through fourth chapters of this volume.

The full identity of the flower becomes less important as macro techniques reduce the subject to forms, shapes, and designs. This is not as much a picture of a rhododendron as it is of the shapes within it. 105mm macro lens with two hotshoe flashes on a Macro Bracket; 1/250 second at f/16 on 64 ISO film.

Special Effects

Special effects actually alter the image of the flower or flowers, and the resulting views, used sparingly, add diversity and interest to your photographic presentations. Skillful use of special effects tools can convey the photographer's mood, grant personality to the subjects, create a fantasy, or exaggerate a particular element through repetitive placement.

Special soft-focus lenses designed for portraits work well on flowers to convey a gentle, ethereal mood. The flower remains sharp, but the structure of the lens imparts a halo to the outlines. The effect is heightened in areas that are highlighted or in direct sun.

The Canon EF soft-focus 135 mm f/2.8 lens has three settings: one for extremely soft focus, one with medium effect, and a setting for regular sharpness. This lens and others like it need to be used at their widest apertures for full effect. Older, large-format soft-focus portrait lenses can be modified to fit modern cameras for flower work, but you must operate them manually. This should not be a great problem, since you would normally be using them with a wide-open aperture.

Each filter manufacturer seems to have a different idea about how to achieve the soft-focus effect. For example, Cokin has both a white-dot and a black-dot version of the soft-focus filter. The white-dot gives a halo effect, and the black tends to soften the overall image. Other manufacturers manipulate the outer area of the filter and leave the center clear, which gives a combination of softness and sharpness within the image. Each of these filter systems is different, but they all accomplish the same ends, and it is up to you to experiment to find the subtle effect that pleases you most.

There are two inexpensive softening methods you might try, although the results may be less consistent than those achieved by equipment specifically designed for this effect. On your lens-protection filter, either a UV or a skylight, apply a film of petroleum jelly, but leave a central area uncoated. The size of the uncoated area will control the ratio between the sharp and soft areas of the image, and the thickness of the application will determine the intensity of the softening effect.

In the early mornings, when the air and your camera are cool, you can try fogging the lens by breathing on the front element or attached filter. The condensation will vary according to the conditions and will fade quickly, so the technique is highly unpredictable and difficult to repeat.

When you use the multiple exposure feature, a combination of a sharp image and an out-of-focus image on the same frame will render another soft-focus effect quite different from those achieved by lenses and filters. The percentage of the exposure dedicated to the sharp or out-of-focus part of the total image will vary the effect considerably. For example, a 75% sharp, 25% out-of-focus exposure will give a minimal softening effect, while the reverse percentage will be a mostly soft photograph. The key to gaining competence and confidence in this technique is to experiment and to take notes so that you can repeat successful examples.

The soft haloes on these poppy blossoms are in fact double exposures. The first exposure was accomplished in sharp focus for 1/500 second at f/8, and the second was intentionally shot slightly out of focus, also for 1/500 second at f/8. 100-300mm zoom lens; 50 ISO film.

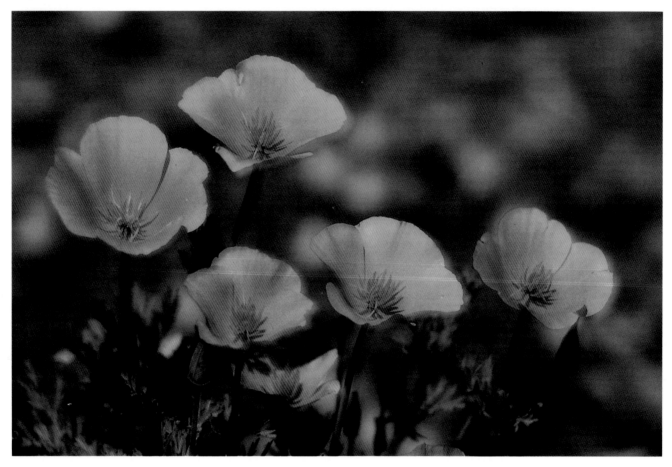

A crisp, lively, staccato effect is achieved by in-focus multiple exposures. This is a tricky and imprecise technique, because you must stop down your camera's aperture and increase the shutter speeds to prevent a final image that is grossly overexposed. All of the shorter exposures must add up to one properly exposed final photograph. The process is further complicated because you will have no conception of the final image until you see it. This technique is pure experiment that at times can be very beautiful and at times can hit the trash can on the first bounce.

To attempt the multiple-exposure effect, first decide how many exposures you want to use to compose one final image. Estimate the individual aperture settings and shutter speeds which may add up to a proper exposure. Simple division will not yield the correct answer, however. Choose settings that add up to slightly more than the proper exposure you seek. Bracket, and then hand-hold the camera during the many exposures. Each individual image will be slightly out of register.

Apply Flower Techniques to Other Subjects

The several techniques for flowers presented in this chapter are transferable to many other nature subjects. Expansion and isolation are useful landscape methods. Use high-magnification optical equipment and multiple TTL electronic flash to get close to, enlarge, and light any small plant, insect, mineral, or mollusk in the field. Always remember your duty to leave a natural area as you found it. Intimate encounters and rare portrayals will delight the creative nature photographer and intrigue viewers of the resulting images. Who could ask for more?

The camera's multiple exposure provision allowed nine exposures on one frame. The hand-held camera was moved slightly between exposures, rendering nine marginally out-of-register images which created a unique floral pattern. 100-300mm zoom lens; 1/1000 second at f/11 for each exposure; 50 ISO film.

AUTOFOCUS AS A TOOL

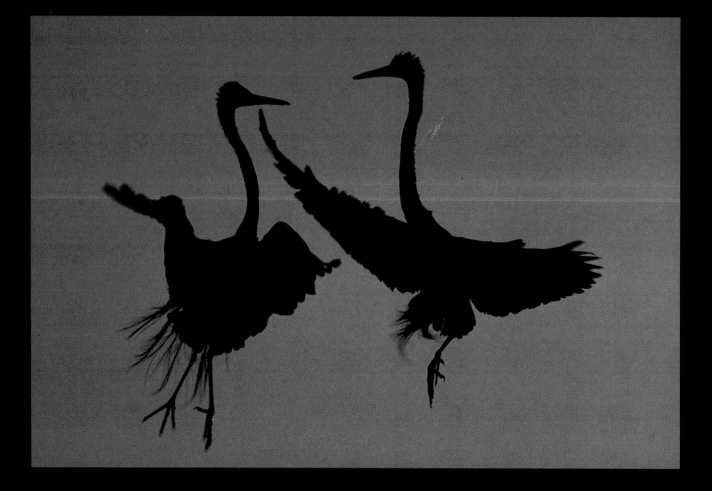

Feathered Fandango

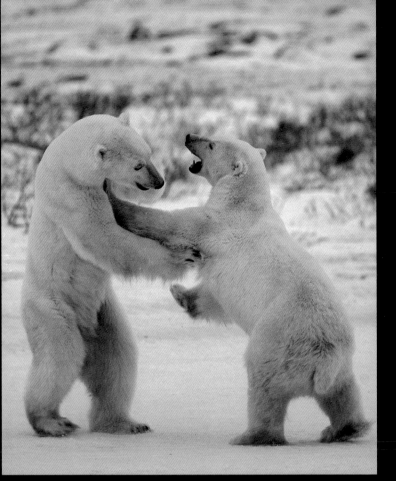

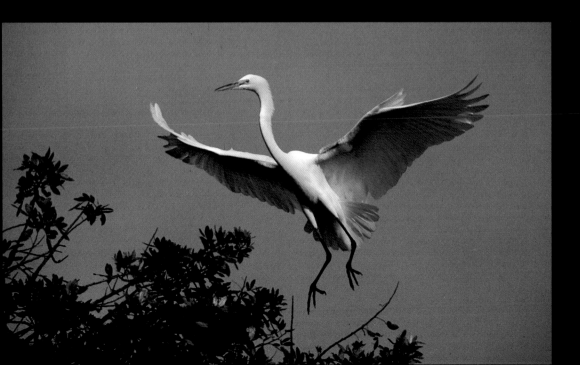

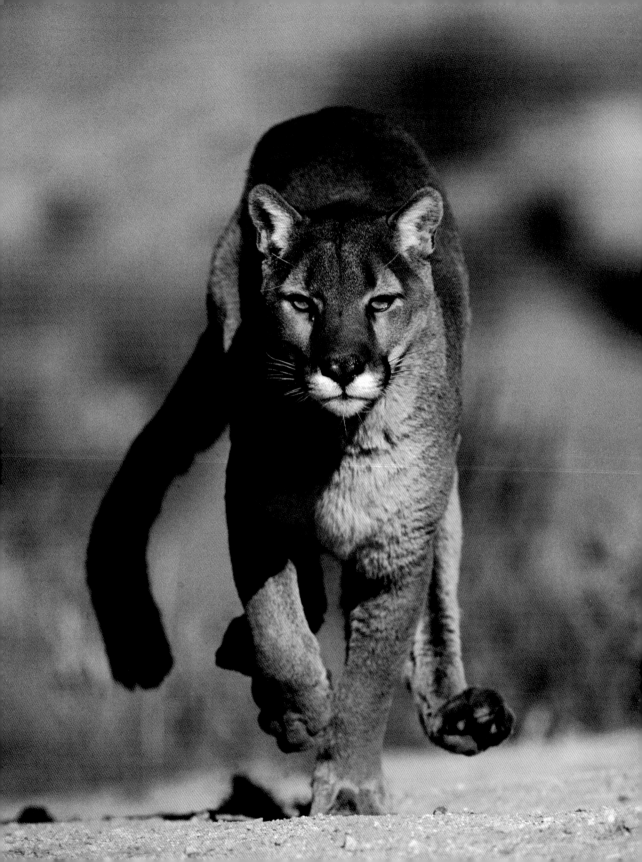

Feathered Fandango

Autofocus saved the final shoot of the day. My colleagues packed up their manual-focus equipment just after sundown, but my auto-focus equipment was still capable of capturing a pair of great egrets engaged in a territorial spat above the rookery. Autofocus 600mm lens; 1/250 second at f/4 on 100 ISO film.

Bear-Fisted Brawl

Fast-moving polar bears are hard to photograph from a bouncing tundra buggy. Both camera and subject are changing position all the time. Using predictive autofo-cus increases the chances of placing the shallow depth of field correctly within the image of the play-fighting bears. Autofocus 300mm lens; 1/250 at f/5.6 on 100 ISO film pushed to 200 ISO.

Great Egret in Flight

Predictive autofocus can increase your percentage of sharp images when photographing fast-moving animals like this about-to-land great egret at a rookery in western Florida. Autofocus 600mm lens with 2X tele-extender; 1/500 second at f/5.6 on 50 ISO film.

Here, Kitty

This trained cougar is headed directly towards the camera. I'm lying next to the handler, who is holding the cat's dinner. The cougar was willing to repeat the charge six times in succession. Each time, I would try to maintain the autofocus sensor on the cat's face. The predictive auto-focus tracked the animal throughout each run, giving me more sharp images than ever could have been possible using manual focus. Even with every-thing working perfectly and three cougars charging for their dinner two days in a row, only a handful of the images had feet, tail, and composition just right. Autofocus 600mm lens; 1/850 second at f/5.6 on 100 ISO film.

\mathcal{A}UTOFOCUS AS A TOOL

The advent of autofocus changed the way many photographers worked. Embraced by amateurs and advanced amateurs, and especially older photographers losing their ability for critical focus, autofocus was applied to virtually every photographic situation. It worked better in some areas than others, particularly as an electronic viewfinder for stationary subjects and as a method to confirm focus in difficult lighting situations. Early autofocus cameras did not solve the problems of capturing fast-moving subjects, and many skilled photographers considered autofocus to be a fad, too imprecise for nature photography.

Even the first autofocus cameras could be used as worthwhile tools for wildlife subjects if not pressed beyond their limitations. For example, I used a Minolta Maxxum 9000 in 1987 to solve the problem of photographing breaching or spy-hopping whales in the waters off Baja California. In previous years, I had been frustrated by my inability to quickly capture both framing and critical focus on activities that lasted for only seconds. Most often I would frame the animal during a jump, but find that the focus was just in front of or slightly behind the whale.

The autofocus, with its ability to immediately lock focus on the critical subject centered in the frame, worked well on animals that were moving past, rather than toward or away from, the lens. The result was an immediate improvement in the percentage of properly framed images perfectly focused on the whale's eye.

However, nature photographers were not satisfied with the first generation of autofocus cameras. Autofocus did not solve every problem it seemed it should have solved, and the manual controls remaining on the lenses were sometimes inadequate. Canon, Minolta, and Nikon brought forth the second generation of autofocus with cameras that could capture birds in flight, track animals running directly towards the camera, and help with focus in extremely low light conditions. At this point, some of the pros opted for autofocus. Many found that to compete in sports photography and some areas of action wildlife photography, they had to embrace the new technologies.

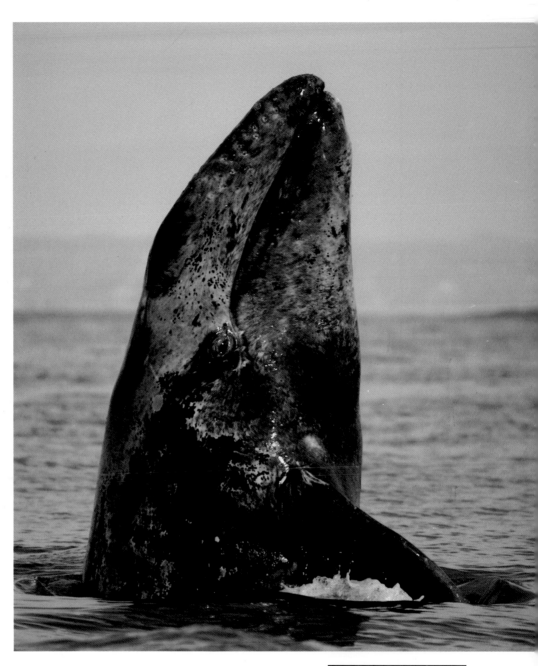

Even the first generation of auto-focus cameras could be useful for wildlife photography. This young gray whale spy-hopped in front of the camera off the coast of Baja California Sur. With only one shot autofocus available in the Minolta Maxxum 9000, the camera still quickly locked onto the large subject in the center of the frame. All I had to do was frame the subject with a 100-300mm zoom lens. 64 ISO film.

Autofocus still isn't perfect, and may never be, but it has matured into an extremely useful and effective tool for nature photographers. Even though autofocus enables more consistent results for many applications, it is not magic. As with any new technology, practice, new methods, and even different perspectives are essential to maximize the results.

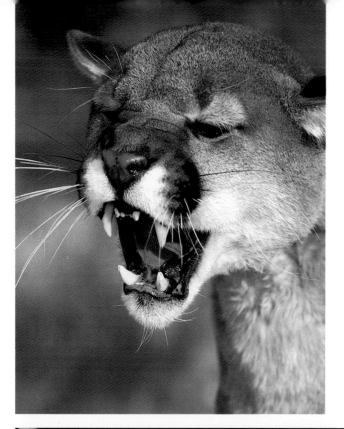

Types of Autofocus

One-shot or single frame. The simplest form of autofocus, one-shot or single frame, allows the photographer to lock the focus onto a particular element of the frame, reframe the image if necessary, and maintain the focal point until the focus is reactivated. This works well for stationary subjects, for macro and portraits, and in low-light conditions. With the addition of multiple focusing points and greatly enlarged focusing sensors within the viewfinder, one-shot autofocusing has become quicker and more accurate.

Predictive or continuous autofocus. This sophisticated feature, also called AI servo mode, is made possible by computer technology that determines the speed of a moving subject whether it is moving past, towards, or away from the camera. The camera continuously adjusts the focus on that portion of the subject which the photographer places in the autofocus sensor area of the viewfinder. Even while exposing film at a high rate of frames per second, the camera samples the movement within the sensor up to three times between frames.

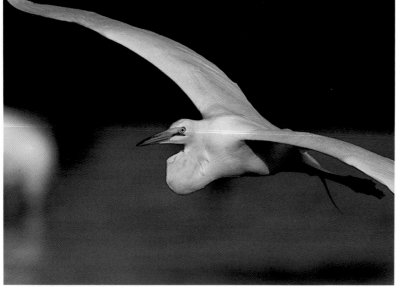

Above top: One-shot, or single-frame autofocus is a useful tool for portraits of stationary subjects. I was able to keep this trained growling cougar in focus and framed while waiting for the peak action. Autofocus 100-300mm lens with TTL hotshoe flash set for two-stop underexposure fill flash. 1/250 second at f/8 on 50 ISO film.

Above bottom: Even a bird flying towards the camera can be tracked with predictive autofocus. I kept the body of this great egret centered in the viewfinder throughout the series of photographs. Autofocus 300mm lens with a 2X autofocus tele-extender (600mm) on a gunstock; 1/500 second at f/8 on 100 ISO film.

Once the camera has determined the speed and direction, it predicts the correct focus for the position the subject will attain at the exact moment of exposure and places the focus at that point. This is extremely important with a fast-moving mammal or bird, which can progress a number of feet during the 120-millisecond interval between the shutter release and the actual moment of exposure.

Techniques to Maximize Autofocus

One shot. With improvements in the size and placement of the autofocus sensor and the addition of sensors in various sections of the viewfinder, it has become easier to lock one-shot autofocus on the subject to suit the photographer's tastes without the need to recompose the image frequently. One-shot autofocus will not work, however, with subjects that are constantly moving in and out of the focus plane, a situation that calls for AI servo or continuous autofocus mode.

With those cameras that have multiple focus sensors in the viewfinder, the photographer needs to predetermine the part of the frame in which the subject will be placed and activate a sensor in that area. At a recent tennis match, I activated an upper sensor with the camera set at vertical to keep the camera from focusing on the low net separating me from the subject.

On some of Nikon's "D" series lenses a focus activation button is located near the front of the lens barrel. This gives the photographer immediate control over when the autofocus is activated.

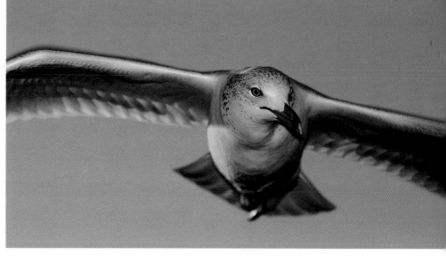

Canon has addressed the activation of the autofocus by enabling the photographer to select a custom function that converts one of the buttons on the back of the camera into a switch between manual focus, one-shot autofocus, and continuous predictive autofocus.

Predictive autofocus (AI servo). The secret to maximizing use of predictive autofocus is locking the autofocus sensor on the moving subject prior to the time that the exposure will be taken and meticulously maintaining the subject's position in the autofocus sensor portion of the viewfinder throughout the sequence.

Predictive autofocus frees the photographer to concentrate on framing a moving subject as it approaches. Projected electronic flash on the camera combined with early morning light provided the lighting for this in-flight closeup of a ring-billed gull. 300mm f/2.8 lens; 100 ISO film.

For example, in photographing an approaching flock of geese, identify from a distance the bird on which you will concentrate. 'Lock' the autofocus sensor on that bird well before it is in photographic range, and be careful to keep it within the confines of the sensor at all times. When the bird is close enough, continue to frame and photograph it. Remember that you must consistently maintain at least a part of the bird within the sensor area. As the goose approaches and fills the frame,

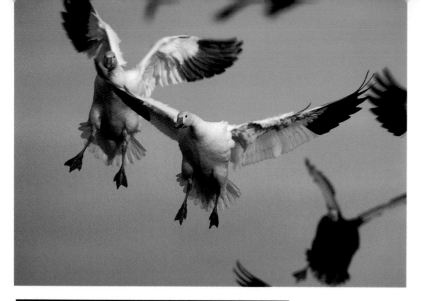

it may become even more critical to keep the sensor on a particular part of the bird, such as the head, because the depth of focus might not encompass the entire body. With practice you can continue the photographic sequence until the bird can no longer be followed, or until it is closer than the lens's minimum focus.

The secret to successful auto-focus photographs of fast-moving subjects is locking the autofocus sensor onto the subject well before the antici-pated exposure. The initial focus in a series takes longer for the camera to accomplish; but minute adjustments are quickly made by the camera as the subject approaches. These snow geese are farther away than I would normally start photographing. Autofocus 300mm lens with autofocus 2X tele-extender (600mm); 1/500 second at f/8 on 100 ISO film.

At times during such a sequence, the photographer may inadvertently lose the subject from the sensor, and the lens will immediately seek a new point of focus, ranging repeatedly from macro to infinity. To shorten recovery time from such a mishap, immediately refocus on a stationary object (such as a stand of trees) at the same distant focus plane as you might find a new flying bird subject. This serves two purposes: It will stop the lens's search for a new subject and reset the focus close enough to be able to identify and frame a new target with minimal additional focal adjustment.

In general, users of predictive autofocus expect to be able to jump immediately onto any subject and to attain instant, accurate focus on whatever is within the sensor. In fact, while the autofocus swiftly accomplishes the minute adjustments necessary in a photographic sequence, it takes longer to gather sufficient information for the first focus.

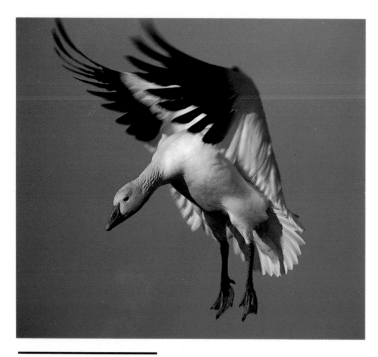

During an autofocus series, keep the bird centered in the frame, and shoot whenever the image is properly composed. This snow goose was followed for quite a distance; the best frame occurred when it passed directly in front of me. Autofocus 300mm lens with autofocus 2X tele-extender (600mm); 1/500 second at f/8 on 100 ISO film.

The most important advantage of predictive auto-focus is that it allows the photographer a much greater range of artistic expression by increasing the percentage of usable photographs resulting from an action sequence. In the past, the photographer with manual-focusing equipment would produce many images from such a sequence, with the hope of achieving a few in critical focus.

With manual focus, the percentages did not favor the best composition appearing in the focused series. With predictive autofocus skillfully used, the photographer still needs to produce lots of choices, but the percentage of usable images will be increased, and chances of the peak action being within the critically focused options are greatly enhanced.

It takes practice to become really proficient at photographing fast-moving subjects like running mammals and flying birds. Find a location that has many subjects like sea gulls or pigeons. These subjects may not merit a lot of exposures, so use them for practice without film. It's the accurate tracking that needs to be perfected as well as concentration on where the autofocus sensor is relative to the composition of the frame.

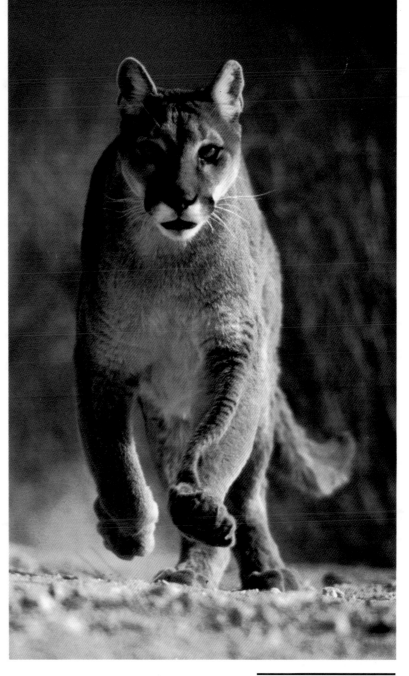

Another example of the possibilities offered by predictive autofocus. Autofocus 600mm lens; 1/850 second at f/5.6 on 100 ISO film.

What's a Photographer to Do?

To those who say the automatic features of today's cameras take all the challenge out of photography, I reply that the mechanics are not the essence of photography. The real challenge is to capture events that the eye can see hardly long enough to understand. The creative aspects of photography have little to do with the functions of the equipment; the gear exists to make it easier to record the photographer's vision.

Autofocus may take away some of the worry about getting sharp focus, but there's still plenty the photographer must do to achieve significant photographs. Autofocus by itself will not create great photographs. A boring image in perfect focus is still…boring.

PROJECTED FLASH

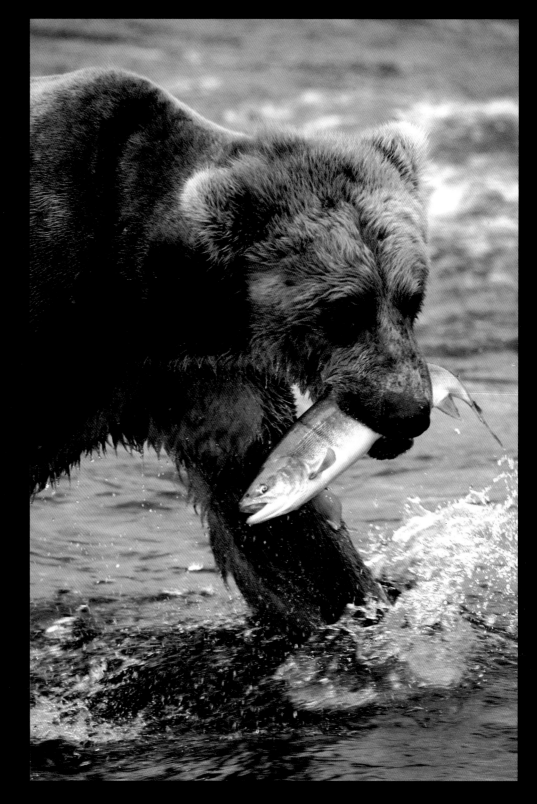

Grizzly Bear
with Salmon

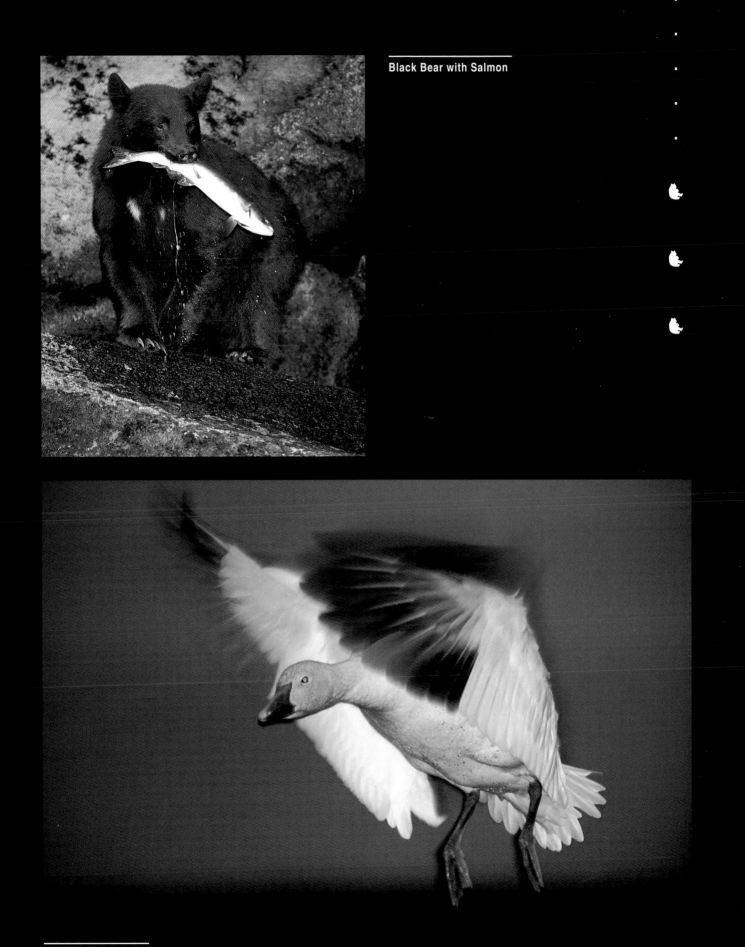

Black Bear with Salmon

The Goose from Hell

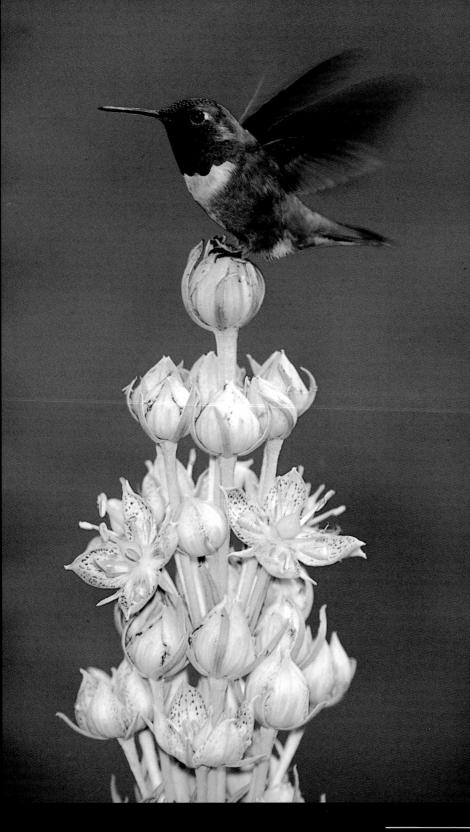

Hummingbird in
a Crow's Nest

Grizzly Bear with Salmon

Sometimes you add projected flash even when you're not sure it will make a difference. The wet grizzly bear was quite dark, and at forty feet the projected flash was just enough to open the deeper shadows and put highlights on the fish and some of the splashing water. The end result is a much better image than those taken without the flash added. 600mm lens with 1.4X tele-extender (840mm); 1/125 second at f/5.6 on 100 ISO film pushed to 200 ISO.

Black Bear with Salmon

Normally a black bear in dark shadows is impossible to photograph. By matching the ambient light, the single projected flash lightens the shadows and adds a highlight to the bear's eyes, yet it maintains the natural look of the scene. 600mm lens; 1/125 second at f/4 on 100 ISO film pushed to 200 ISO.

The Goose from Hell

I sat in near-freezing rain for three days and "available" light was never available. On a particularly dark morning I used projected flash to light this snow goose as it came into range. Due to the low light and enlarged pupil of the bird's eye, the flash reflected off the retina, which resulted in eye-shine of a particularly devilish sort. Autofocus 300mm lens with a 2X autofocus tele-extender (600mm); 1/125 second at f/5.6 on 100 ISO film.

Hummingbird in a Crow's Nest

To bring out colors in the bird's reflective feathers, I used a projected flash set to match the ambient light. The result is an overall improvement in color and two images of the hummingbird's beating wings: one set from the flash, and another recorded image from the ambient light. 300mm lens with 2X tele-extender (600mm); 1/250 second at f/5.6 on 50 ISO film.

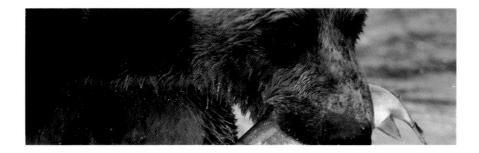

PROJECTED FLASH

Nature photographers always want to reach out farther to bring small birds and wary mammals closer. At the same time that we ask for longer and longer lenses, we seek to manage the conditions under which our subjects are photographed in order to maximize detail and control contrast. From a distance of twenty or more feet, this represents a significant challenge.

Directional shooting, angle of light, and use of lower-contrast films that still yield fine detail are variables which may work serendipitously; but most often in natural settings there are few sure choices. We must work from a certain direction, under low-light conditions, and with high-definition films which are typically higher in contrast. In my opinion, the most controllable, and thus reliable, solutions involve electronic flash.

Even from long distances, projected electronic flash can completely light the subject, augment the available light to fill in the shadows and lower the contrast, as well as create enough usable light to accommodate the higher-definition films. In projected flash, a special Fresnel lens (a flat sheet of plastic with concentric lens facets engraved on its surface) modifies the angle of the flash output, and concentrates the available electronic light where the camera lens is aimed.

Most of today's electronic flashes already have small Fresnel lenses built into the front of the unit. The lens is either manually or automatically positioned in front of the flash reflector to change the angle of the light emanating from the flash tube. Bringing the Fresnel closer to the reflector spreads the light for wide-angle lenses, and moving the Fresnel out to its focal length narrows the light angle and improves its efficiency.

For example, most medium-power flashes with built-in Fresnel can be concentrated to match an 85mm lens with a gain of approximately 3/4 of an f/stop. But 300mm and longer lenses can make use of an even narrower concentration. The same medium-power flash, with an additional Fresnel approximately 5 x 6 inches in size, will narrow the angle even further, and concentrate the light to gain up to three stops of usable exposure—a tremendous increase in power at little additional cost or weight. Equivalent power without the Fresnel would require a prohibitively hefty and pricey unit not suited for field use.

You can use the extra light to extend the flash range if your subject is distant, to allow a smaller f/stop for additional depth of field if your subject is closer, or to decrease flash recycle time and shorten the flash duration, even stopping a hummingbird's beating wings. Each of these techniques requires careful attention to achieve desired results.

Most of today's larger hotshoe flashes have a built-in Fresnel lens which effectively works as a projected flash. Unfortunately, the usual gain is only approximately one stop of light. Accessory projected flashes can increase the usable light by as much as four f/stops. Shown is a Nikon SB-25 electronic flash with built-in Fresnel.

Equipment for Projected Flash

Extended flash range is dependent upon the power of the strobe, the low-light capabilities of the lens, and the speed of the film. A range of 100 feet is possible if you have a powerful flash, an f/2.8 telephoto (fast) lens, and a film ISO of 200 or more. But more realistically, a medium-powered TTL hotshoe flash, an f/4 or f/5.6 lens, and a film of ISO 100 are usually available to us in the field. With this combination, a range of approximately 40 feet is attainable. This limit does not present a problem, however, because likely uses of the technique are for small birds from 12 to 20 feet away and for flash fill of larger animals at greater distance, but where less light is needed.

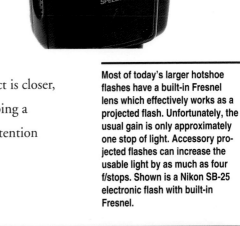

While telephoto lenses normally don't give much depth of field with available light, using the projected flash on closer subjects gives the option of stopping down to f/8 or f/11, which gains enough depth of field to sharply encompass an entire small subject, such as a bird from beak to tail.

Stopping down the lens results in longer flash recycle and flash duration. If shortening either of these is needed for a particular subject, use the lens wide-open. This will result in short flash duration and will allow quick recycling time. The short flash duration also can be put to use to stop action. A group of projected flashes

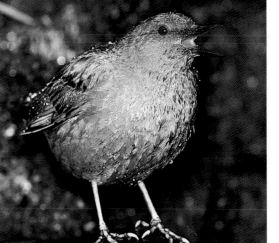

Dippers are usually found along shady streams, and ambient light is never sufficient to accomplish a reasonable photograph. A projected flash at a frame-filling distance can generate enough light to use f/8 or even f/11 to bring nearly the whole bird into sharp focus. 300mm lens with 2X tele-extender (600mm) on a gunstock with a projected hotshoe flash with guide number of 116 with 100 ISO; 1/250 second at f/11 on 100 ISO film.

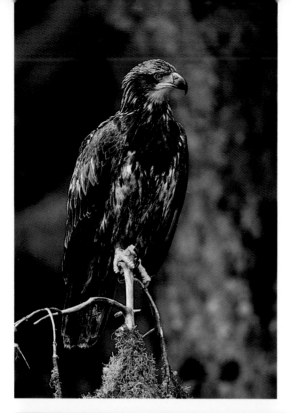

can be used to create sufficient light for adequate depth of field while still maintaining the short duration needed to stop fast-beating wings of birds or insects in flight—up to 1/30,000 second.

Projected flash can provoke occasional unwanted eye-shine from animals in low-light situations due to the close axis of the flash to the lens. This is also known as 'red-eye' and is prevalent in owls, cats, and other nocturnal animals. The only solution to this problem is to engage an assistant to hold the projected flash away from the camera and lens. The light should be directed toward the subject from a divergent angle. If the projected flash is the only light source, the result can be harsh since there is no additional fill. If possible, I prefer to use projected flash in combination with ambient light.

Projected flash techniques require a bracket assembly to position a flash above the camera and center a Fresnel above the camera lens. The assembly can be attached either to a hand-held gunstock or tripod-mounted lens. This position aids in the alignment of the unit to coordinate the concentration of the beam of light with the lens's field of view.

Above top: Nocturnal animals and some animals with exceptionally keen eyesight have a tendency to show eyeshine with projected flash. Photographed in full daylight, this immature eagle in southeast Alaska showed unnatural eyeshine in every frame. 600mm lens with projected hotshoe flash with guide number of 116 with 100 ISO; 1/25 second at f/5.6 on 100 ISO film.

Above bottom: Jack Wilburn, manufacturer of projected flash systems, demonstrates a system mounted on a gunstock. The attached camera/lens combination is a Nikon 8008 with AF 300mm f/4 and 1.4X tele-extender (420mm). The flash being projected is a Nikon SB-24.

Flashes useful for projection are medium-to high-powered TTL units with a guide number of at least 100 for ISO 100 film. Those designed to attach to the hotshoe are generally preferred over the detached, "potato-masher" variety, due to the latter's unwieldy size and weight. When the hotshoe flash is relocated from the camera to the projected flash assembly, a special flash cord is required to carry the TTL signals between the units. Check with the manufacturer of your particular camera system to determine the correct cord.

Determining Exposure for Projected Flash

Depending upon the type of equipment you are using, projected flash exposure is determined in different ways.

TTL exposure. Even though the subject is at a distance, the flash exposure receptors within the camera will determine the correct exposure based upon the reflectance of the subject in the center of the frame. The photographer must take care to have the subject large enough in the frame for the sensors to register it; otherwise the background will guide the exposure and undoubtedly overexpose the closer subject. Conversely, if leaves or other material are between you and the subject, the sensor may read the exposure on the foreground and underexpose the subject. Finally, if the foreground appears in the frame, but the camera reads the exposure for the subject, the closer areas may be grossly overexposed. When using TTL projected flash, it is recommended that you maintain a clear path between the photographer and the subject.

Manual exposure for projected flash. Either a flash exposure meter or calculating dial on the flash is necessary to determine proper exposure with non-TTL flash units. Position a flash meter at various distances, take careful readings, and record them on a chart to attach to your flash unit. When working in the field, simply check the distance against the chart, and set the exposure accordingly. Make adjustments in consideration of the reflectance of the subject and coordination of the exposure with ambient light.

A less accurate method employs the flash calculator on the back of most flashes. First determine the f/stop by the subject's distance, then adjust the exposure for the approximate gain in f/stops contributed by the Fresnel. It would be wise to conduct a series of tests before taking the system into the field.

Using Projected Flash

At the beginning of each field session, the assembly should be tuned. Align the flash and the camera's field of view by aiming the lens at a point in a darkened area, maintain that position, look over the top of the lens, and fire the projected flash by using the 'open flash' button. The area of light concentration should be visible and oriented to cover the same area as the lens field of view.

As a main light source. When the projected flash will be the main light source, the exposure must be equal to or greater than the ambient light falling upon the subject.

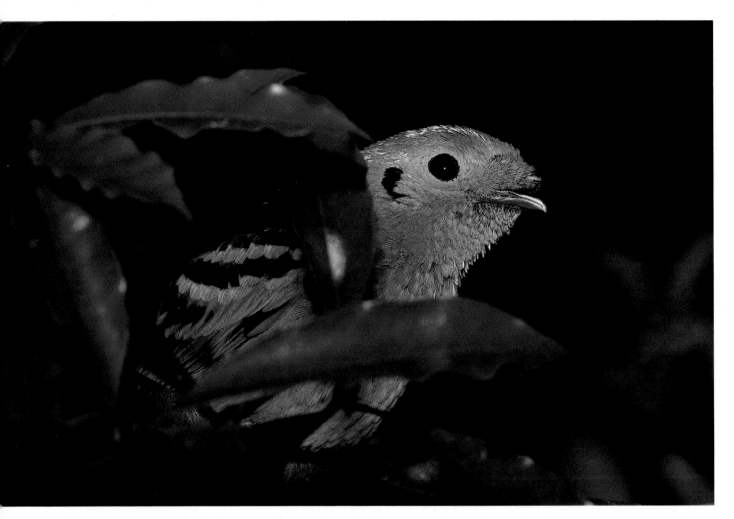

Projected flash was used as the main light source for this greater green broadbill photographed in a walk-through aviary at the San Diego Zoo. 400mm lens and projected hotshoe flash with guide number of 157 with 100 ISO; 1/250 second at f/5.6 on 64 ISO film.

At the same time, consider any background or reflected light, and alter shutter speed and/or f/stop as necessary. If it's possible to maintain the projected flash exposure within one to two stops of the ambient light, the ambient light will provide a very natural fill. This becomes difficult, however, in low-light situations where the projected flash must be many times greater than the natural light in order to stop action or gain depth of field.

Used as fill. When the projected flash will be used as fill, first set the exposure for the ambient light falling on the subject. The projected flash needs to produce an exposure which is one to two f/stops less than the ambient light exposure. This can be accomplished either through manipulation of the electronic flash ratio settings, adjustment

of the exposure compensation on the camera, or changing the film ISO rating.

With cameras having a flash sync speed of 1/250 second and slower ISO films, projected flash as a fill light source can be useful on distant subjects. For example, with 50 ISO film a sunlit exposure for 1/250 second is approximately f/8. A two-stop fill exposure would need to be only f/4. The distance at which f/4 could still be attained might be as much as fifty feet.

Cast Your Light Farther and Brighter

Projected flash, then, provides an important tool for nature photographers who need to light distant subjects properly. Whether used for fill, as a main light source, to control contrast, or to stop movement, projected flash can significantly increase the quality of your long-lens photography.

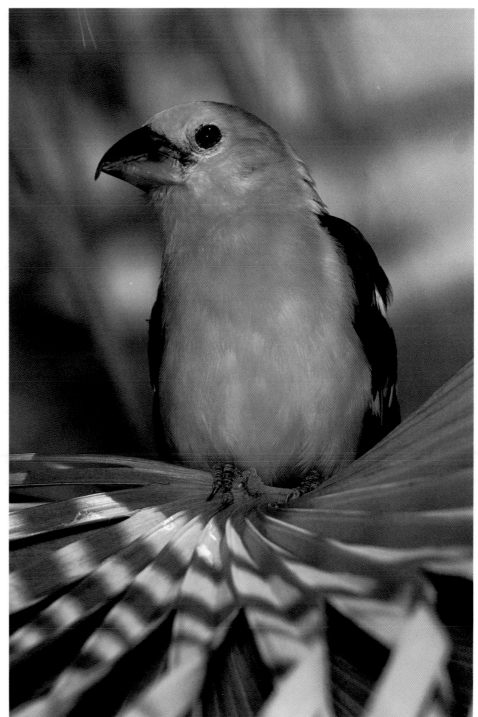

The sunlight is one stop brighter than the projected flash used to flash-fill this yellow grossbeak, photographed in a walk-through aviary at the Sonora Desert Museum near Tucson, Arizona. 300mm lens with 2X tele-extender (600mm) and projected hotshoe flash with guide number of 116 with 100 ISO; 1/250 second at f/8 on 100 ISO film.

PHOTOGRAPHING BIRDS AT THE NEST

Allen's Hummingbird
Feeding Young

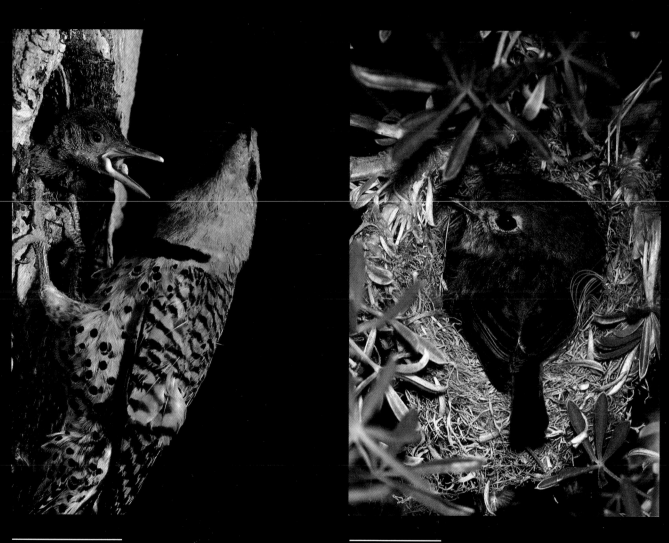

Flickers' Lunchtime

Hutton's Vireo
Brooding Young

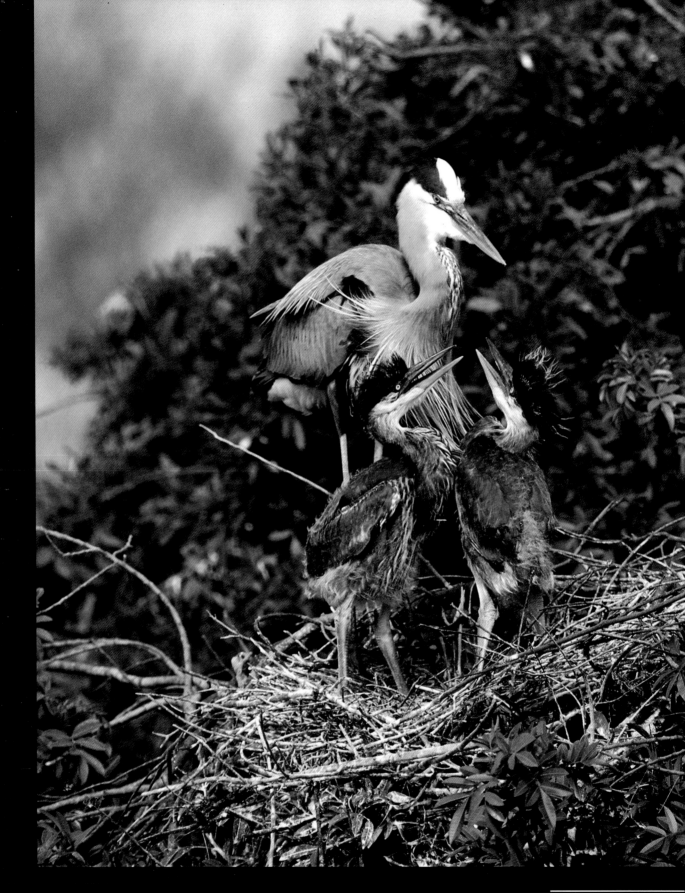

**Young Great Blue Herons
Anticipating Dinner**

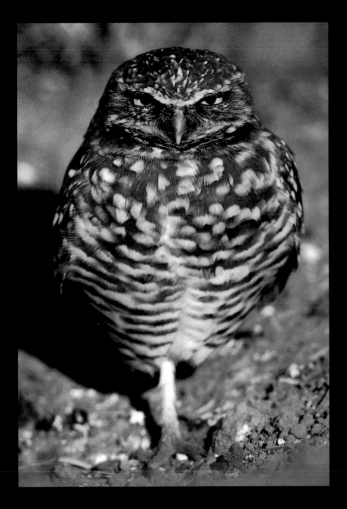

**Two-Legged Burrowing
Owl on One Leg**

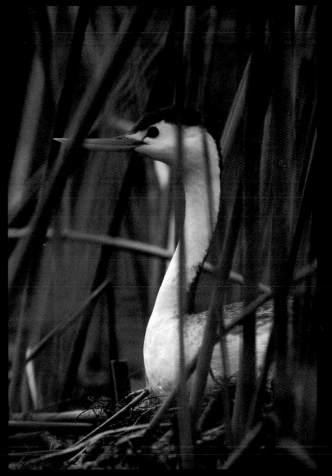

**Clark's Grebe on a
Floating Nest**

*A*llen's Hummingbird
Feeding Young

A female Allen's hummingbird feeds her two young in a nest situated three feet from the ground in a cypress tree. Hummingbirds often nest near the ground, which makes photography from a blind considerably easier. Every individual in each species reacts differently to a photographer's presence, and this female's intolerance necessitated use of a blind. Two flash units on stands between the camera and blind furnished the lighting. A 300mm lens with 1.4X tele-extender (420mm) was used because of the combination's close focusing ability. 100 ISO film.

*F*lickers' Lunchtime

A female flicker clings to the side of an aspen tree to feed her youngsters. Flickers typically enlarge the excavated tree cavities created by woodpeckers; they may use the same hole for many years. The only other birds that will use a cavity this large are starlings and house wrens; the latter will fill the hole with sticks to make it smaller and to keep other birds from using it. The best photographs of cavity nesters are possible when the young are well along in development and come to the opening to greet the adult bringing the food. A 500mm lens was used with lighting from two flash units on stands between my blind and the nest. 100 ISO film.

*H*utton's Vireo
Brooding Young

This particular bird stayed fast on the nest despite my close approach. I used a 200mm macro lens set up with a Macro Bracket; its two lights enabled the use of 50 ISO film and a small f/stop for extended depth of field. Even when an adult bird appears to ignore your presence at the nest, get your photographs quickly and leave it to tend its young. The longer the photographer stays in proximity, the more stress is put on the bird and the greater disruption to its normal feeding schedule.

*Y*oung Great Blue Herons
Anticipating Dinner

A small heron rookery near Venice, Florida offers an unobstructed view of several nests. A moat populated by alligators keeps dogs, cats, and people from disturbing the nesting birds. Photography can be accomplished only from a distance that requires at least a 400mm lens to document what happens in the nests. When the subject's behavior is the basis for the photograph, give yourself plenty of time to watch for the right moment, and be ready. Naps are not allowed. Photographed with a 600mm lens on 100 ISO film.

*T*wo-Legged Burrowing
Owl on One Leg

Expecting to get great head shots, I approached this burrowing owl nest with an 800mm lens and 1.4X tele-extender (1120mm). But the super-long lenses are limited by their minimum focusing distance. Even with extension tubes I couldn't focus any closer than 30 feet, although the bird allowed a closer approach. The best combination turned out to be a 300mm f/2.8 lens with 2X tele-extender (600mm); the combination focuses to nine feet. I was able to take the photographs at close proximity and back away without provoking the bird to change position. Too often, photographers cannot resist continuing to approach a natural subject until the animal is forced to flee. Your goal should be low-impact nature photography: Try to advance, photograph, and retreat without displacing the subject.

*C*lark's Grebe on a
Floating Nest

Photographing from a reed-covered floating blind is the only way to capture these nesting birds. It's nerve-racking to trust your equipment to a blind constructed of a piece of plywood and an inner tube, but observing and documenting a bird species by becoming an indistinguishable part of its environment is truly satisfying. A 300mm f/2.8 lens with 1.4X and 2X tele-extenders were used to photograph from the floating blind. The fastest shutter speed at f/5.6 was used with 100 ISO film.

PHOTOGRAPHING BIRDS AT THE NEST

Photographing birds at the nest has many advantages. First, nesting is the easiest time to photograph most birds; they are limited to a particular area and will consistently return to the nesting site. The birds' tolerance of encroachment by photographers is high as soon as the young hatch. For several days after fledging the adult may tend young who are slow to leave the area. This offers opportunities for photographs of feeding away from the nest. Adults are typically in their prime and adorned with breeding plumage when nesting commences. Nest-building behavior and raising of young are interesting interactions to document; and spring weather and foliage provide pleasant backdrops.

But keep in mind that nesting birds are vulnerable; you must do nothing inadvertently to cause a bird to abandon its nesting efforts. The most critical time is, in fact, at nest-building. Remember that the birds have carefully chosen the nesting location, and your sudden and sustained presence may cause them to reconsider their decision. If they abandon the site, they may not find a suitable location in time to start another nest. So watch from a distance and be patient. Plan your strategies for photography to begin after the nest is completed.

Once the eggs are laid, you can get closer, but only for very short periods of time when the adult is off the nest of its own volition. The eggs must be kept at a relatively constant temperature, and the parent's egg-sitting is meant not only to keep them warm, but also to protect them from overheating. Allowing the eggs to cool will delay their hatching; but heat can kill them. So be particularly careful not to force the adult off the nest when it is in full sun.

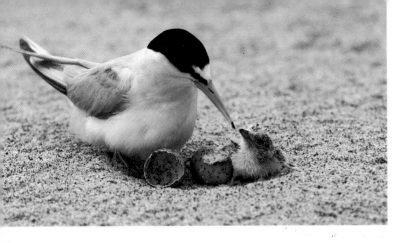

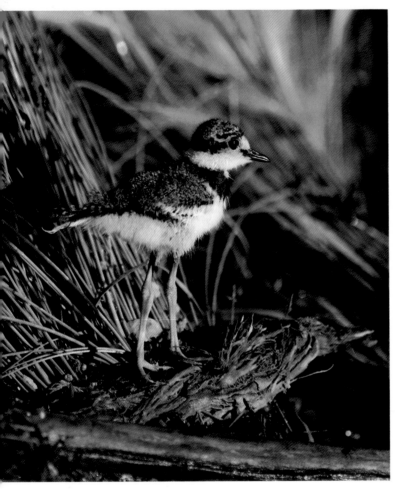

There are two types of nestlings. The down-covered chick is active soon after hatching, even able to leave the nest area if necessary. An example of these precocial birds is the killdeer. The chicks of altricial species, such as songbirds, are naked, blind, and helpless at hatching and totally dependent on the parents.

If the photographer isn't at the nest site when precocial young hatch, the chances of photographing them are slight. The young usually will stay in the nest for only a short time as they dry their feathers. If undisturbed, the young may stay in the nest for a day or two, until all the eggs have hatched. If the photographer has kept track of the exact time the eggs were laid, positioning a blind for the moment of hatching is possible. A good reference book on bird nests, such as the *Field Guide to the Nesting, Eggs and Nestlings of North American Birds* by Colin Harrison, will provide the number of days of incubation for a particular species. Expect to spend a lot of time in the blind waiting for that moment when the egg breaks and a wet chick peeks into a new world.

For altricial birds, the temperature remains a critical factor for a day or two after hatching when the adult must still brood the youngsters. When the parents begin to leave the nestlings for longer periods of time to search for food, it indicates that the young have attained sufficient maturity to maintain their own body temperatures.

Above top: Moments after hatching, this California least tern was caught drying out; shortly thereafter it raced around in the sand. This newly hatched tern was photographed from a moveable blind using a 400mm lens and 100 ISO film.

Above bottom: This long-legged killdeer chick, another example of a precocial bird, is only a couple of days old, but already running around gathering food. A tripod-mounted 500mm lens was used to capture this chick along the shore of Mono Lake, east of Yosemite National Park. 100 ISO film.

The best time to begin serious nest photography is at least two days after *all* the eggs have hatched. The parent will leave the nest at predictable intervals, and will return on schedule to feed the babies. Watch this process until you are certain you understand the pattern and timing, then begin your photography. At this point the parents' bonding with the young is very strong, and it is likely that they will continue feeding even with you in photographic range. If a parent, carrying food but not entering the nest, moves about nervously nearby, your presence is interrupting the feeding schedule. Pull back; the adult will tell you when you've reached an acceptable distance by resuming its visits to the nest.

For many birds, a blind should be moved towards the nest in stages. Start with the blind at a distance that is readily acceptable to the bird. After observing that the feeding has continued with no interruptions, move the assembly closer and observe again. There will be a point from which the blind should not be advanced any farther, as it will be a constant disturbance. It is up to the photographer to identify and stay behind the bird's point of intolerance.

The assemblage of tripods, light stands, blind, and photographer can become so enormous that natural pathways to the nest are obstructed. The problem is usually a second or third light that completes the circle around the nest. If you've observed the feeding patterns carefully, you'll know the routes the adult birds are using to reach the nest. Position your photographic equipment so as not to block these paths.

A third critical period in the nesting cycle for some birds, especially those in cup nests, is just before fledging. In the days before leaving, the young, flexing their wings and attempting flight, become very active in the crowded nest, even though it is not yet time to leave the nest's protection and they still require a parent's care. This is the time when your quick or close movements may cause the young to leave prematurely, which *significantly* reduces their chances of survival.

From even before the moment the first egg is laid, your presence near the nesting activity can draw attention of other birds, animals, and humans. Jays and mockingbirds, in particular, have been known to locate nests by observing photographic activities. They may consume the eggs or young after the photographer leaves. Keep a watchful eye for these predators and cease photography if they stay nearby. A blind to hide from the predator is a safer photographic strategy in these situations, even if the subject doesn't require it.

If you are working in a high-traffic area, other people may be attracted to the nest by your activity. The negative effects of continued human disturbance are cumulative. It may be necessary to concede the opportunity to photograph where you would draw excessive attention to the nest's location.

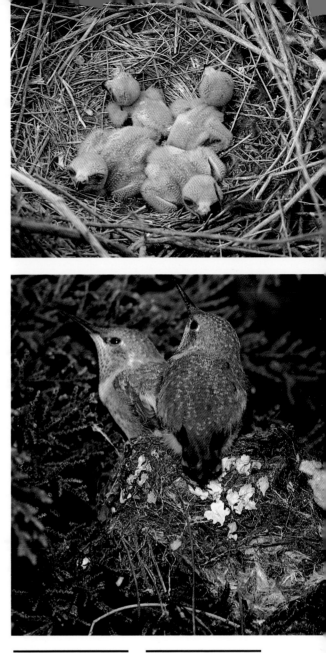

Above top: Altricial birds are naked and helpless when they hatch. This group of black-shouldered kites demonstrates size differentiation between the first and last hatched. Most of the photography on this nest was accomplished with a 500mm lens from a blind on a platform eight feet off the ground. From a ladder, closer shots documenting the nestlings were done with a 55mm macro lens. All photography was supervised by a biologist studying the kites. 25 ISO film.

Above bottom: A very critical time for photographing near a nest is just before the young are ready to fledge. As the young get larger and more active, like this pair of Allen's hummingbirds, it is imperative for the photographer to avoid sudden movements or too-close approach. Premature departure of even one day seriously reduces the bird's chance of survival. In this case, a 400mm lens and attached hotshoe electronic flash allowed a large photographic image from a safe distance. 64 ISO film.

It is essential that you avoid leaving your scent on foliage near the nest, at the base, or on the limbs of the tree or bush, because this will attract feral animals to the site. Remember too that the nest location may have been chosen in part because of available camouflage. If you must adjust foliage to clear a path for your lens, use gloves and tie back, rather than break, obstructing branches. Always return the surrounding vegetation to its original position before you leave the area, even if for short durations.

Even without human presence, many nests do not come to term. If a nest you are photographing is aborted, abandoned, or destroyed between photographic sessions, try to learn the cause. It can be very useful to discuss the incident with other photographers or naturalists in the area, because doing so may contribute to better information about factors affecting the local bird population. For example, I once was distressed by sudden parental abandonment of a mountain bluebird nest with young which I was photographing. When I learned that the nests in the area were particularly vulnerable that year to a fungus, I discontinued adding further stress to the population with my photography and at least understood that my photographic activities probably were not the cause of the nest's demise. Be aware that your presence may have contributed to the loss of a nest; but if you have practiced meticulous precautions in your photographic activity, you can be reasonably sure that your intervention was minimal.

Interacting with a nest puts a certain responsibility on you; once you photograph it, it is incumbent upon you to continually check the nest until you are assured that the babies have fledged. If your methods are in fact causing nest destruction, you won't know it unless you continue to observe the nests you photograph. And don't tell anyone else about nest locations unless you are certain they will maintain your standards of photographic behavior. Don't forget that continuing disturbance has cumulative effects.

Finally, an important note about endangered and protected bird species: Nesting behavior of endangered birds should not be photographed in the wild; the risk of an unsuccessful nest is too great, and the implications too profound. Not all endangered bird species are as well-publicized as, for example, the California condor, but many natural areas will carry posted information if they harbor such birds. If you have questions, check the local Audubon Society, fish and game departments, biology departments at local universities, and natural history museums for information about the species at risk which may be found in the area you are about to photograph,

and know how to recognize such birds if you are fortunate enough to see them. During breeding and nesting, be sure to give endangered birds plenty of space, and keep the information about their location a venerable secret between you and them.

Some species are protected in certain areas, although they may not yet officially be termed endangered. Be absolutely sure that you know all of the federal, state, and local regulations before considering the photography of protected species. I strongly recommend that any photography of such birds, particularly at nesting, be done only in conjunction with a biologist with firsthand knowledge of the species in the area.

Finding Birds' Nests

Know where and when to look. Do your homework before you set out to look for a particular species. Check to see what to expect in the area you plan to explore. Sources can be books, area bird checklists, local members of the Audubon Society, or biologists at nearby colleges and universities. These sources will also be able to tell you the times of the year that the birds will be nesting. Good references on nesting birds for serious bird photographers include the following volumes:

A Field Guide to the Nests, Eggs and Nestlings of North American Birds,
by Colin Harrison, published by Collins.

Peterson Field Guides, Western Birds' Nests,
by Hal H. Harrison, published by Houghton Mifflin Company.

Peterson Field Guide to Birds' Nests
(found east of the Mississippi River), by Hal H. Harrison,
published by Houghton Mifflin Company.

Life Histories of North American Birds,
by Arthur Cleveland Bent, published by Dover Publications.

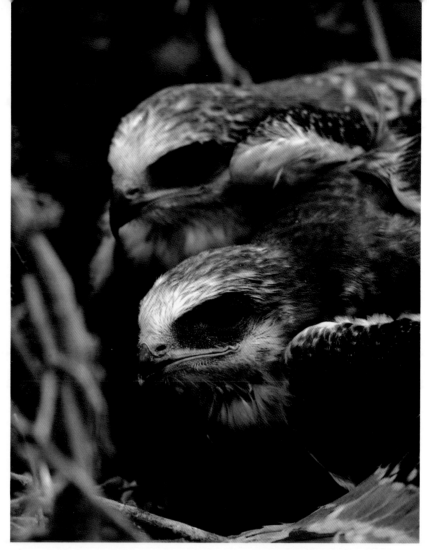

These black-shouldered kites are starting to react to me as I photograph them with a macro lens close to the nest. The biologist who was studying the kites regulated how often and how long I was able to take closeup photographs. Most of the documentation was accomplished from a blind. Whenever you plan an in-depth photographic study of a species, it is important first to do your homework about the animal's expected behavior. This information will help you both to understand what you're photographing and to ensure the safety of the subject. Biologists have been instrumental in the success I've had in photographing many species of birds and mammals. The young kites were photographed with a 55mm macro lens; 25 ISO film.

Tools for finding nests. Binoculars are a necessary tool, along with a mini high-power flashlight and a small mirror on the end of a telescoping handle (available from auto parts stores). The binoculars, of course, are for watching the movements of birds from a distance; for this purpose, 8X to 10X magnifications are the best choices. My favorite binoculars are the 10x40 roof prism type. They are small in size, powerful enough to obtain details of small birds, focus close, and are efficient enough in light-gathering power to be used in low light.

The mini flashlight with krypton bulb is used for looking into tree cavities; in conjunction with the small mirror, you will be able to search both cavities and cup nests above your head without climbing the tree or disturbing its foliage and occupants. Position the mirror, and if more light is needed shine the flashlight directly into the glass to illuminate the dark recesses of the cavity. Be prepared for the occasional piercing stare returned by an adult sitting on eggs, or, even more unsettling, the quick exit of the adult inches from your face.

The tools of a bird photographer go beyond cameras and long lenses. Books are important to provide information on the various stages of development of particular species. Binoculars extend the photographer's ability to carefully study the subject prior to photography. The mirror and flashlight are tools that help to view high or recessed nests. Being a basic biologist is an important component of successful nature photography.

Checking a new area. In your search for nests, move very slowly, listen for bird sounds, and observe any bird movements. This is the most effective and least intrusive method. Sitting down in a likely area and just observing the activity around you can be rewarding in nest location.

Bird sounds will draw your attention to the bird to start your observation. A scolding bird is probably protecting the nest; a shorebird flying close overhead may be trying to distract you from the nest; and a chorus of high-pitched cheeps can be youngsters reminding their parents that they're hungry.

A moving bird could be carrying nesting material to the nest site or going to the nest to brood or feed its young. Items in the bird's beak will give you a clue. Dry materials such as twigs, string, or feathers, mean nest-building; carried food often means that there is a nest with young close by. If the bird is not feeding young, it usually will eat an insect on the spot. A beak full of food is a giveaway that the nest is active with youngsters, or a mate is being fed at the nest while incubating eggs or

brooding young. Watch the bird from a distance with binoculars and try to ascertain where it is going. Be patient; if nesting is going on, the bird is likely to reappear quickly, and sometimes it will take several different sightings to identify even the general location of a particular nest. As you approach, a quick movement by the bird from a tree, bush, the ground, or a cavity can be the clue that pinpoints the location of the nest.

Ground nests in open areas pose special problems. The nest, adult, and eggs all blend into the ground cover. Watch where you walk or you might step directly on the nest. Some birds won't leave the nest until you get very close, but usually an adult will be flying around scolding at you as you approach. The nest will still be hard to find. Back out of the area and watch from a distance with binoculars. The birds will soon return to the nest and give the location away.

Photographic Strategies for Types of Nests

Ground nests in vegetation are hidden from view under leaves, bushes, or in a clump of grasses. Species using such nests include ducks, quail, towhees, and some warblers. Few ground nests can be safely photographed; uncovering them will almost always jeopardize the construction or safety of the nest. Your scent in the area will attract predators, and no photograph is worth endangering the nest.

In the event that you find a nest where the covering can be safely propped to the side and returned to its original position without damaging the nest, macro photographs can be taken to document the stages of the young's development. A bracket system with two flashes set close to the lens will help to evenly light the tight confines of most nests.

Placing a blind near the entrance to the nest can be rewarded with natural shots of the adults as they scurry back and forth during feeding. There is a tendency for birds to use the same perches near a nest as they come and go. Keying on the perch rather than the vulnerable nest can be the best choice for photography. Two electronic flashes lighting the area at the entrance of the nest itself are usually ideal and not unduly disruptive. A single flash on axis with the lens is sometimes needed for nests that are set back into a cavity.

Ground-nesting birds are particularly vulnerable to predation, and the conscientious nature photographer will be extra careful or leave ground nests alone. This junco nest was covered by a branch to protect the young from view and the elements. I carefully propped up the branch just far enough to photograph the young. (Note the two big chicks a cowbird had added to the clutch for the junco to raise!) After shooting was completed, the branch was returned to its original position. I was careful not to leave any human scent around the nest for mammal predators to detect. Two flashes and a 400mm lens with an extension tube were used; 64 ISO film.

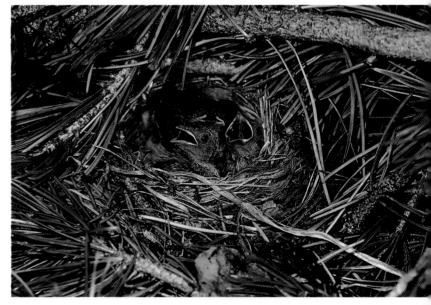

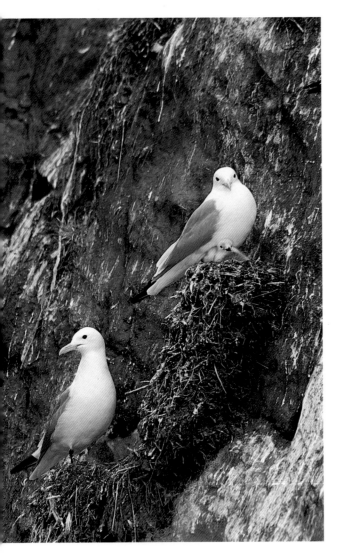

These black-legged kittiwakes nest in colonies at the edge of a glacier near Valdez, Alaska; they can be photographed only from a small boat. With chicks this small it would not be wise to force the adults off the nest; the young are vulnerable to predation and the elements. Any time a colony of birds or mammals is photographed, it is better to photograph from the edge of the group than to wade into the middle of the flock. In this case, a telestock was used to steady the camera in the small boat. A 300mm f/2.8 autofocus lens and 100 ISO film helped me attain a faster shutter speed to eliminate effects of the boat's movement.

Ground nests in the open are often just a simple scrape on a rocky area or sandy beach. The type is typical of shorebirds, gulls, and colonies of nesting sea birds. Observation of the adults at nesting time is necessary to determine when the eggs are laid so that, using a book on nests as your reference, you can calculate the likely hatching dates. Most of the young of these species of birds will leave the nest very soon after hatching. You might be able to photograph the adult on the nest, but be especially careful that your activity doesn't keep the bird off the nest, which exposes the eggs to the hot sun.

A blind often is necessary to photograph open ground nests since no natural cover will be available to hide the human form. To photograph some tern nests, for example, I have used a moveable blind and have slowly moved it closer into position after the bird has settled onto the nest. Ambient light, or sometimes only a single flash for fill, will generally be sufficient for photography. Adjust your angle of approach to the nest to make sure the light falls on the subject from the right direction. Some colonies of nesting birds lack fear of humans and may tolerate an open and direct approach. Again, adjust your direction of approach to the light source and consider flash as a fill, but if the flash disturbs the subjects, discontinue its use. It is generally best to work along the edges of the colony rather than wading into its midst.

Cavity nests in trees are some of the safest for photography. They are relatively easy to find and not as susceptible to predation. The entrance to the nest is often clear of branches, which allows a clear view of the opening, and the parents will consistently approach the nest from the same direction. These conditions make photography more predictable. The young birds stay in the nest for a fairly long time, and in some species the young eagerly meet the parents at the hole for feeding during the latter stages of development, which makes for interesting photos. The variety of cavity nesters includes both woodpeckers, who start the nest cavities with their excavation, and bluebirds, who use the holes at a later time. Other cavity nesters are wrens, wood ducks, flickers, and tree swallows. I once photographed a single tree which housed the nests of a flicker, house wren, violet-green swallow, tree swallow, and a red-breasted sapsucker, all within ten feet of the ground, and all in progress at the same time.

Most tree-cavity nesters will ignore a photographer standing with a telephoto lens in the open within twenty feet of the nest. If at this distance the birds demonstrate intolerance, a blind will be necessary.

Ground-cavity nesters include kingfishers, dippers, and swallows (which make their own cavities with mud). Ground-cavity nests may be as simple as a hole burrowed into a bank, cliff, or directly into the ground. Burrowing owls use abandoned holes left by ground squirrels.

Some ground cavity nesters are extremely wary and their nests are often in precarious locations, as is the case with kingfishers and dippers. Long telephotos from adjacent banks, or even photography from an anchored boat below the bank housing the nest, may be necessary with these birds. Some other species may allow a slow approach into photographic position. It may not be necessary to use extreme telephotos when it is safe to set up within 20 feet of a nest's entrance. I tried to photograph burrowing owls with an 800mm lens with mixed results. With a little effort I was able to continue my approach to within 15 feet and use a 300mm f/2.8 and 1.4X tele-extender with much better results. Being able to back away slowly from the nest without disturbing the owl family was a satisfying conclusion. To complete a photographic session without ever disturbing the subject is a worthwhile goal as important as the final photographs.

In the case of cliff swallows or any other bird that has nesting colonies, it is important that your proximity to the nests doesn't keep them from continuing their routine, whether it be building nests or feeding young.

Cup nests are the most common type and are used by many interesting and colorful birds including hummingbirds and robins. Found in trees and bushes, sometimes close to the ground, these nests are especially vulnerable to predators. The photographer must be careful to avoid leaving a trail of scent to the nest, thus pointing the direction for raccoons, foxes, possum, feral cats, and other predators. Cup nest locations are chosen by

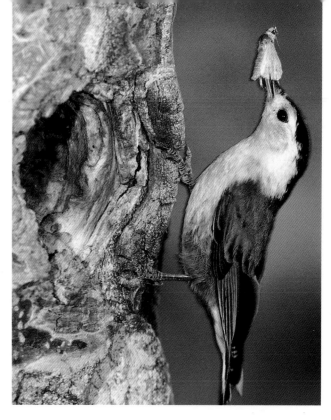

Cavity nesters are usually tolerant of equipment set up close to the nest; they're predictable in their feeding timetable, and the habits they exhibit are interesting. A close-focusing 300mm or 400mm lens is usually ideal for these nests. This white-breasted nuthatch was photographed on 100 ISO film with a 300mm f/2.8 lens, 1.4X tele-extender (420mm), and a pair of flashes.

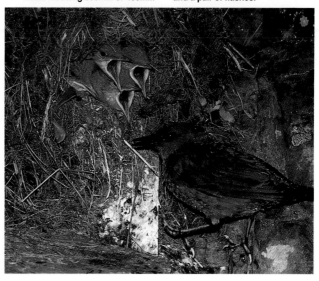

Birds that build their nests in ground cavities or with mud often are hard to photograph because of their placement of the nests where predators can't get to them. This dipper was an exception; its nest was next to a waterfall in the San Juan Mountains of Colorado. A 300mm f/2.8 lens with a 1.4X tele-extender (420mm) attached was more than adequate for this photograph. A projected flash was used for lighting on the 100 ISO film.

Cup nests often are located in the foliage of a bush or tree. Here my colleague, Rich Hansen, ties back a branch that hid a tolerant Hutton's vireo adult on its nest. (See the portfolio photograph, page 101.) By tying the branch back and returning it to its original position after photography, the photographer minimizes chances of predation.

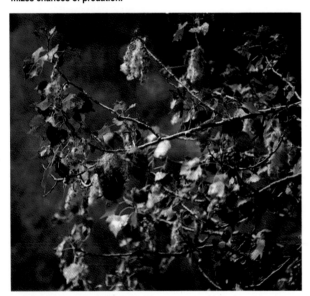

If you think cup nests are difficult to find and photograph, you haven't tried to photograph a hanging nest. These nests are usually located high in a tree, and the opening is situated in such a way that the bird flies directly in and out of the nest without stopping to pose for photographs. This oriole nest is a good example of a hanging nest that was out of the reach of serious photography.

the parents to maximize the natural camouflage of foliage. You must never remove or break branches to photograph the nest. If you cannot safely tie back obstructing foliage and replace it as soon as you are finished photographing, leave the nest alone.

Watch for favorite perches nearby that the adults will consistently use as they enter and exit the nest. If your presence around the nest disturbs its occupants, use a blind. Start at a distance and slowly move closer until you are within photographic range. Always move back if your activity causes a change in the brooding or feeding behavior of your subjects. If you can't stay close to the nest, remote cameras are an option; but it's better to continue to watch through the camera for the precise photographic moment than to be removed from the camera and unable to monitor camera focus and the subjects' behavior.

Hanging nests are similar to cup nests, but are more completely constructed so that the bird enters through a cavity. They are used by birds such as titmice and orioles. Often hanging nests are located high in a tree, which limits the photographic possibilities to activity around the entrance. The young can be photographed only at fledging when they leave the nest but are still being fed by their parents.

The inaccessibility of many hanging nests is a problem, but you can photograph the adults as they enter and exit if the nest is positioned low enough. Look for favorite nearby perching positions and concentrate on the adults until the young have fledged.

Raptors, such as hawks and owls, often build nests in precarious locations such as cliffs and in high trees, so the photographer must pay particular attention to his or her own safety. Some raptors will vigorously defend their nests and attack intruders; therefore some photographers have resorted to wearing protective gear such as helmets. But in my opinion, if a photographer is provoking aggressive behavior in the subject, the photographer should leave. It is safer to photograph with long lenses from nearby cliffs or adjacent trees, from blinds or scaffolding, or with remote cameras. Raptors have the keenest eyesight of all birds, and your approach or blind must be better than with most species.

Protective state and federal regulations are likely to apply to raptor species, despite their challenging behavior. Be sure to do your research before attempting photography.

Aquatic nests are a special challenge due to the added water hazard. My own experience has been with nests in reeds growing in water about three to four feet deep. A floating blind can be constructed using a plywood platform with a hole cut in the center. This platform is then strapped over a truck tire inner-tube. The photographer sits in the middle of the tube. A suspension system adjusts the seat to the right height to align the photographer with a camera/lens combination mounted on the platform. The assembly is crowned with a blind constructed of mesh screen over a frame, liberally adorned with fresh reeds selected from an area away from the nesting sites. The photographer propels the craft (which looks somewhat like a muskrat house) by walking on the lake bottom. Disguised as the local flora and moving very slowly, a photographer can closely approach nesting birds such as grebes. Use of such a blind is limited, of course, by the depth of the water around the nests, wind and rough water conditions, and your patience.

Electronic Flash at the Nest

I have experienced few problems with flash affecting birds on the nest; they sometimes react initially, but adjust quickly. Multiple lights are ideal—one main and one fill, plus a back light. But it's that third light that often causes a problem by blocking the adults' access to the nest. If flashes are distressing your subjects, pull back to just flashes at the camera or use projected flash from a distance. The result with projected flash can be contrasty unless it is used in conjunction with ambient light.

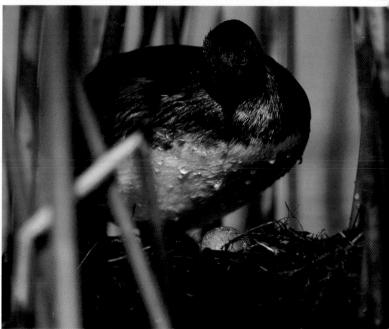

Above top: About midway along the coast of Baja California on the small island of San Benitos, you'll find osprey nests situated on the ground. The lack of predators on the island allows the land-based position of this fish-eating raptor's nest. A long lens was used in order to avoid displacing the adult, who was incubating eggs. I would have liked to stay to wait for the other adult to return to the nest with a fish. But if I had lingered, I'd have missed the boat. A 600mm f/4 lens was used for the photograph on 64 ISO film.

Above bottom: Grebes minimize predation by building floating nests in clumps of reeds. The best method of photography for aquatic nests is a floating blind, which offers low profile, slow movement, and camouflage. A 300mm f/2.8 lens was used with a 2X tele-extender (600mm); the small size and close focus of the combination makes it an excellent tool for many types of bird photography. 100 ISO film.

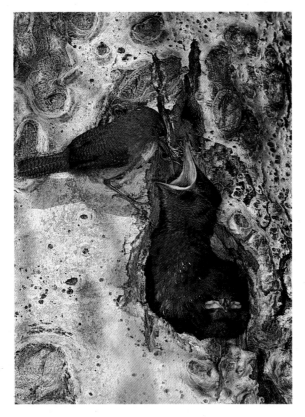

A house wren feeds a pair of starling chicks at a nest located just below its own nest hole. The wren's own nestlings already had fledged, but the instinct to feed drove the bird to fill the "monster" mouths for several days. The behavior at the nest was photo - graphed using a 500mm lens with a projected flash to match the ambient light. 100 ISO film.

Both slave and TTL flash units pose advantages and problems in flash photography at nests. Often a single flash on the camera, coupled with ambient light, will solve lighting problems. But two lights combined with ambient background light can add a more natural look in the daytime. Slow the shutter speed if the bird is in a dark area with a light background in order to match the ambient exposure behind the nest. You must match or slightly underexpose any sunlight falling on the nest. The camera's TTL system will make sure the exposure from the flash will be correct for whatever f/stop is chosen.

If non-TTL flashes are used around a nest by either using sync cords or slaves, the exposure from each source must be considered, and a hand-held flash meter is essential. The result should be the same—a simulation of ambient light.

Do It for the Birds

Bird photography's extreme popularity is easy to understand. The surroundings are natural, the subjects appealing and challenging, and the resulting photographs call forth interested responses from most viewers. The more observant you are, the more you will learn about your subjects and their environments. The watchful photographer will find great satisfaction in images documenting a successful nest.

Zoo Photography

Flamingo Nap

Gorilla with an Attitude

Flamingo Nap

One technique for exceptional zoo photographs is framing the subject tightly with a telephoto lens. This eliminates distracting or unnatural backgrounds and allows up close and personal portraits that convey the essence of the subject's personality. Use the direction, intensity, and quality of the light to enhance the subject. This flamingo was sitting in a shaft of light that came through the vegetation in a walk-through aviary at the San Diego Zoo. A 400mm lens on a telestock was used; 64 ISO film.

Gorilla with an Attitude

It's next to impossible to get information on the film when the subject has black fur and is in the shade. The only thing worse is black fur in *both* sun and shade. My solution to these lighting problems is projected flash. By placing a Fresnel lens in front of a moderately powerful flash to concentrate the flash output on the subject, up to three f/stops of light can be gained. The extra light revealed the mood of this male gorilla at the Miami Zoo. 500mm f/4.5 lens with 1.4X tele-extender (700mm); 1/125 second at f/8 on 100 ISO film.

Piranha

Aquaria offer unusual photographic opportunities for land-based photographers. Even if I did a great deal of underwater photography, I'd prefer to photograph piranhas from outside a tank. Approach smaller tanks as macro studios. Pay extra attention to reflections, and make sure the camera lens stays close against and perpendicular to the glass. Use flash on a bracket, or hold it to the side and away from the camera to keep reflections from entering the lens. It may be difficult to get adequate light to any subject deep in a tank. This is a perfect place to use TTL flash. The piranha was photographed with a 55mm macro lens and two TTL medium-power hotshoe flashes on a Macro Bracket. 64 ISO film.

Red Brock Deer in a Zoo Rainforest

This small South American deer was photographed in a very natural setting, the walk-through bird aviary where it was housed at the San Diego Zoo. An 80-200mm zoom lens was used with ambient light; 64 ISO film.

A Roar or a Yawn?

Sometimes you just have to wait. From another part of the Albuquerque Zoo, I heard this male lion roaring several times. Certain he'd do it again, I watched for an hour. When he opened that mouth I was ready with projected flash to light the cavern. Interesting behavior strengthens zoo photographs. Starting your zoo safari early in the day or staying into the evening will give you the best chance to photograph the animals while they are active. Many animals reserve midday for naps. 300mm f/2.8 lens with a 2X tele-extender (600mm); 100 ISO film.

ZOO PHOTOGRAPHY

While some may think that nature photography, being "natural," has no place at the zoo, captive animals can provide you with some of your greatest opportunities for closeups or portraits that would never be possible in the wild. Zoos provide a great place to practice techniques for animal photography that later can be applied effectively in the field. At the zoo, you can test your equipment and your skills and make sure you have all you need before undertaking that expensive photo safari.

Zoo photography often is perceived to be of low prestige because the subjects are usually confined, which removes some of the sport from the photographic chase. But in fact, some significant and satisfying photography can be accomplished in the zoo environment. One need look no further than zoo publications themselves, such as *Zoonooz* from the San Diego Zoo, to discover the exciting images that dedicated zoo photographers can produce. Anyone can encounter the animals at the zoo, but, as in the field, unique and compelling photographs will result only from patient observation, understanding the subject, predicting behavior, and presenting the subject in unique ways.

These days, our perceptions of zoos are caught up in serious philosophical and environmental issues ranging from animal rights to protection of endangered species. Modern zoos are both preserves and educational centers. Zoos harbor viable gene pools of endangered species and sustain unparalleled opportunities for research in species preservation and propagation. They provide a protected area where humans can appreciate the diversity of the animal world. Open ponds and foliage give refuge to native birds and animals. In the most sophisticated zoos and aquaria, shows featuring animal residents increasingly are designed to demonstrate how the

animals relate to their natural environments in the wild. For example, the animals are "trained" to demonstrate natural behavior rather than to perform tricks of human devising. Such entertainment allows the human audience much greater appreciation of the represented species' true role in nature.

Every zoo is different, and some are much more amenable to photographers than others. Well endowed zoos have expansive enclosures with carefully reproduced habitats; healthy, active animals; accessible professionals and information programs; animal nurseries; and plenty of attractions for local birds and animals in open areas. Poorer and sometimes older facilities have animals in cages; these are hard on the animals and render photography nearly impossible.

Some zoos, such as the National Zoo with its collection of rare small mammals, focus on particular species. These are housed in glass enclosures, which pose a whole new set of challenges for the photographer. Others specialize in local animals; two notable regional specialists are Washington's Northwest Trek, which houses only animals of the Northwest, and the Sonora Desert Museum near Tucson, Arizona, which specializes in desert creatures. Insect collections (such as Butterfly World in Florida), aquaria, bird and animal refuges, and controlled animal facilities offer a world of different subjects to the photographer—subjects your camera would never encounter in the wild, no matter how far or how long you travel.

For example, a resident of one of the San Diego Zoo's aviaries was the rare white-bearded manakin, a native of Central and South American tropical rain forests. The bird's presence at the zoo enabled photographers to document its characteristics. The resulting photographs probably could not have been accomplished in the manakin's natural habitat at any price.

For satisfying photographic expeditions, choose a zoo that provides access to healthy animals that are interesting to you, houses them in enclosures that facilitate photography, and contains natural-looking habitats that will provide appropriate backgrounds to your images. A good zoo will provide information about the animals to assist in your documentation; abundant and knowledgeable staff who will discuss the animals and advise you as to feeding schedules and active times; and generous operating hours that allow you to schedule your photography at times of optimal lighting, highest animal activity, and fewest other visitors—typically early morning and late evening hours. Some facilities may provide special access to photographers upon request and at additional cost, such as the zoo safaris offered by the San Diego Wild Animal Park and Northwest Trek in Washington.

A white-bearded manikin would be hard to find in the wild, and even harder to photograph. But this photographic portrait was possible in a walk-through aviary; the documentation is significant because few manikins are in captivity. A simple 200mm medium telephoto lens was used with a hotshoe flash on the camera. 64 ISO film.

Stay tight and watch the light. A 500mm f/4.5 telephoto lens used wide-open through the mesh of the gerenuk antelope's enclosure kept the background out of focus and the viewer's interest focused on the head in this photograph. The lens's large aperture (f/4.5) and close proximity to the mesh erased the fence barrier from the image by putting it completely out of focus. This was another case of waiting around at the ready; eventually the animal presented itself in the best light. When it looked over a bush, a framing element was added to the photograph. 64 ISO film.

There are certain zoo conditions which make photography impossible, and before you travel a long distance for serious zoo photography you should check to see if any of the following configurations are commonly used in the zoo to restrain visitors and animals: double glass panels (which multiply reflections as well as render sharp focus impossible); railings set back from glass panels (which prevent you from getting your lens close enough to the glass to shoot through it without reflections); cement and bar cages (environmentally unacceptable backgrounds); dirty and scratched Plexiglas viewing areas; or double chain-link fences (it is possible to deal with one, but not two).

Zoo Etiquette

Good manners at the zoo take into consideration the animals, the staff of the zoo, and other visitors. Most animals become sensitized to continued attempts to attract their direct attention, and no amount of whistling, calling, clapping, or finger-snapping will be effective. While most completely ignore flash, even projected flash, there are some individual animals that don't like it. Observe the animal's reaction to your first flash, and if it turns away, don't use it again or the animal is likely to show you its back or even leave the open area of the compound to get away from you. In aviaries move slowly and deliberately; use field tactics even though these birds can't get too far away.

Remember that when you are in a busy public area like a zoo, everything you do reflects on all nature photographers because your sophisticated camera equipment identifies you as one of us. Your thoughtful behavior will set a strong example for beginners who are watching you work.

Usually you will benefit from following the directions and suggestions of zoo staff. If you explain your needs for special access to an area, they may accommodate you. But remember that the first responsibilities of zoo staff are to protect both the animals and the safety of visitors. Respect zoo professionals who are dedicated to these goals.

Be considerate of other zoo visitors. With tripods, bags, and some of your friends along, you could block the best animal viewing areas. You'll need to protect your

own equipment without restricting others' access to viewing areas. And if your flash is driving animals out of the viewing area, you may get a few photos at the expense of others who will be unable to see the animals for several hours following your photography.

Finally, remember that the animals in zoos have become used to interactions with humans and complacent about situations that, in their natural habitats, would provoke interesting, aggressive, or fearful behavior. However, some engaging "natural" behavior will be demonstrated by zoo residents; they remain, after all, representatives of their species. So while the zoo is not the place to document fully the behavioral characteristics of species, it can provide opportunities for compelling and informative portraits.

Techniques and Equipment for Zoo Photography

Large mammals. Most animal enclosures do not simulate the native environment of their occupants. To avoid distracting or unnatural background, use lenses of 200mm and longer to frame the subject tightly. Long lenses and a wide aperture will render background out-of-focus and neutral. The quality and direction of light falling on the subject is extremely important in zoo portraits. Using light coming toward the front of the animal is standard, but don't rule out back lighting. The soft light of overcast days is fine for zoo photography. In full sunlight, consider flash fill to control contrast.

Very dark-colored subjects, such as gorillas and bears, are a particular challenge. Flash will be needed as fill, or even as the main light source, to record facial expressions and to add light to the eyes. For intimate and appealing portraits of primates, use a long lens and wait for interaction among the animals or between them and the watching humans. Primates are very expressive, and patience will reward you with shots seldom possible in the wild.

Low contrast, a ratio of intensity of light to dark of about 1:2 or 1:3, gives a good result for later printing or publication. For example, consider that the subject is 40 feet away. With 100 ISO film and the camera set at the fastest flash sync speed of 1/250 second, the sunlight f/stop with an average gray subject would be between f/8 and f/11. The flash fill at two stops less than the ambient exposure need be only

Most primates, and gorillas in particular, are interesting subjects to photograph at the zoo because we relate to their human-like behavior and facial expressions. Primate portraits are best accomplished with long lenses in the 300mm to 600mm range. With gorillas it often is necessary to use auxiliary lighting in the form of a projected flash to bring out the details in the animals' dark fur. The flash also enlivens the portrait by adding a small highlight in the animal's eye. This female gorilla was photographed at the San Diego Animal Park. 300mm f/2.8 lens and 2X tele-extender (600mm) with a hotshoe-type projected flash; 100 ISO film.

enough to give an f/4 to f/5.6. This is not too difficult for an average power, camera-mounted flash like the Nikon SB-25 or Canon 430EZ. But the projected flash system discussed earlier in this volume is a better technique for portraits of large mammals in full sun.

Small mammals. Smaller mammals are usually contained in small enclosures, so portrait closeups are possible with medium telephotos. In addition, the entire animal or a family grouping can be isolated against a neutral background. Be alert to undesirable background features and incorporate light direction into your composition; use flash liberally. Projected flash is not usually needed at the closer working distances possible with most small mammals.

Mammals in terraria. The National Zoo in Washington, D.C. has a marvelous display of rarely seen ground-dwelling or nocturnal mammals housed in small, elaborate, glass-fronted enclosures. The light in the enclosures is very dim and not anywhere near adequate for photography, even with quality films to 400 ISO. Flash is essential, but its use in such circumstances requires some special techniques. The camera's lens must be placed against the glass and the flash moved away from the close axis of the lens. Two flashes give the best lighting, so an assistant is very helpful to hold one of the

flashes away from the camera. In this situation, a photograph of any subject close to the background will show an unnatural shadow on the wall.

Zoom lenses of varying power are best for this type of photography; they allow the photographer to stay against the glass while varying the magnification of the subject. A short extension tube attached to the zoom is sometimes necessary to allow the closer focus needed with small mammals.

Some zoos with glass-fronted enclosures add a railing to keep people away from the glass. This will render flash photography impossible. Before stepping beyond the barrier, check with the keepers in charge of the area for permission. They may grant access only at low-traffic times, such as early on weekdays.

Above top: Meerkats, with their quizzical attitudes, are fun to watch and photograph. Many zoos display these small mammals from Africa in open enclosures that allow close viewing. Often a 300mm to 400mm lens is sufficient to obtain frame-filling images. 300mm lens using ambient light; 100 ISO film.

Above bottom: At Northwest Trek near Seattle, burrow-like tunnels lead from some animals' enclosures. The burrows are glass-fronted, providing an interesting viewing area but subdued light. These raccoons were photographed by using a Macro Bracket with two flashes to give even lighting. Occasional flashes should not disturb the resting animals, but if you see an adverse reaction, discontinue the use of flash. A 20-35mm zoom lens was placed against the glass to eliminate the chance of reflections. 100 ISO film.

Marine mammals. Some zoos and most large aquaria display marine mammals such as whales, dolphins, seals, and sea lions. If the animals are housed indoors, the main problems in photographing them are the typically low light levels above the display area and the lack of light that can penetrate the depths of large, glass-sided aquaria. A fast film will be necessary even when the animals are at the surface. I've had some good results with the new 400 ISO films, both print and slide.

To penetrate the glass-sided, deeper tanks, a flash of at least medium power is necessary. Even the Nikon SB-25 and Canon 430EZ and other similarly powered flashes can only light a subject a few feet away in the tanks. Keep the camera lens against the tank glass to prevent flash-back into the camera, and use wide-open f/stops.

Where marine mammals are displayed in outdoor tanks, many of the same photographic considerations should be taken as for other large mammals. Watch backgrounds, subject lighting, and contrast (flash fill can be used to advantage), and be aware that a wet, dark mammal absorbs a tremendous amount of light. Bracket exposures to the overexposure side. Action of the animals swimming, jumping, and performing can be photographed successfully using predictive autofocus.

Birds and mammals in cages. In all zoos, some animals are still exhibited behind bars or mesh. These facilities severely limit photographic opportunities. Impossible conditions include a series of barriers, such as two parallel rows of chain-link fence; full sun on the barrier between you and the subject; bars or fences both directly in front of and behind the subject; or a barrier closer to the animal than it is to the camera.

The obstacles posed by most other kinds of bar or mesh barriers can be overcome or minimized as long as direct sunlight is not falling on them. Using a telephoto lens set at its widest aperture will throw the obstruction so far out of focus as to be nonexistent. Center the lens as closely as possible in the opening; portions of the fine mesh or wire bar directly against the lens will have little effect on the image. Do not attempt to use flash from the camera hotshoe to light the subject; the barrier will be overexposed or will lay a shadowed pattern over the subject.

Clear photographs are possible even when animals are displayed behind mesh fencing or bars. First, shoot through a portion of the fence that has no light falling on it. Position yourself so that the camera is closer to the fence than the animal is on the opposite side. The closer the camera is to the fence, the better. Use the widest lens aperture possible. This Bengal tiger was photographed through the bars pictured first above. A 300mm f/2.8 lens with 2X tele-extender (600mm) was used at f/5.6. 100 ISO film.

Some zoos provide an area for viewing protected by large Plexiglas panels. While a great view of the animals is afforded, serious photography is impeded by the typically dirty, scratched, and green-tinted glass.

Fortunately, many zoos are offering elevated and unobstructed observation areas which provide a good perspective for photography. In smaller cages, bars are being replaced by fine black wires which are photographer-friendly.

Birds in walk-through aviaries. This is the closest to the real thing offered by the zoo. The birds are free to fly around, and the lighting is often very natural, albeit low. The real advantage is that the birds can't get very far away, and the photographer has repeated opportunities to get the shot. Aviaries are great places to improve proficiency and technique, because they allow many chances to photograph the same subject, something that doesn't often happen in the wild.

Many walk-through aviaries reproduce the subject's native plants and habitat, which provides very natural backgrounds and exceptional photographs. Hand-holdable lenses of 200mm to 400mm work well because the subjects are relatively close and constantly moving. Apply field techniques to work in the aviary. Watch a particular bird for a while to pinpoint its favorite locations and patterns of movement around the enclosure.

The birds found in walk-through aviaries display habits similar to those they would exhibit in the wild. At the San Diego Zoo this cock-of-the-rock from the jungles of South America regularly comes out of the vegetation to drink from the pool in the enclosureWatching the subject long enough to spot a behavior pattern will help to get better photographs. Most of the birds in the large enclosures have favorite areas that they regularly occupy, even to the extent that they may spend most of their time on a single perch. A telestock with a 400mm f/5.6 lens and projected flash attached provided the mobility needed to follow the bird's movements. 64 ISO film.

Outdoor display. Observe the positions and flight patterns of birds that perform in a show. You can return to later shows knowing exactly where to position yourself for the best chance to capture the bird's flight on film.

Some zoos put birds on display where interested persons can get quite close, which presents an exceptional opportunity for portraits not possible in the wild. You can work completely around a bird on a perch. This makes it possible to take advantage of the best directional light. Flash fill can be used to fine-tune the composition. Medium telephoto lenses are sufficient for this close work, and if there are no crowds you can work from a tripod. Careful consideration for a neutral background is important, and you might ask the trainer to move the display to accom-

modate your desire for a green or sky background. This is an opportunity to strive for the highest quality result by using a fine-grained film and the light to its best advantage.

Always move slowly around a restrained bird. If the subject exhibits unsettled behavior, back away. If it is evident that flash at close range elicits a negative response, discontinue its use. Be considerate of others around you who also wish to view or photograph the bird. Remember that being surrounded generally upsets a restrained animal.

Reptiles and amphibians. Because they are usually housed in glass enclosures, reptiles and amphibians can be difficult to photograph at the zoo. Poisonous species are typically protected by two layers of glass, which compounds the photographic problems to nearly impossible levels.

Closeups of smaller specimens or portraits of heads of larger animals will be most successful. Macro lenses and zooms with two-element closeup lenses attached will enable the photographer to keep the lens close to the glass to minimize reflections. The combination of lens and accessory is determined by the size of the subject, its distance from the glass, and the size of the enclosure. The combination of a macro lens in the 100mm range with two flashes on a Lepp Macro Bracket II is a flexible setup. Be sure the lights on the bracket are positioned away from the camera at a 45 degree angle to the subject. An 80-200mm zoom with a Nikon 5T two-element closeup lens also works well with the bracket in this situation.

Tapping on the glass to catch the animal's attention will usually cause the keeper, rather than the animal, to strike. Any assault on glass enclosures, including scratching them with the front of your lens, could be reason for expulsion from the exhibit.

Large aquaria. Photographing fish in large public aquaria is similar to working with mammals in glass-sided tanks. Remember that ambient light exposures will be too slow and predominantly blue, and that even medium-powered flashes will not penetrate far into the tank. Look for rock or reef formations that are located close to the sides of the tank; fish are likely to visit these areas. It is important to shoot perpendicularly

Above top: During the summer months, Oregon's Portland Zoo provides an informative demonstration program where photographers can get close to tethered birds such as this king vulture. When working with birds secured to perches, it is important to follow the directions of the attending handler in order to minimize any stress on the bird. A medium telephoto lens (200mm to 300mm) gives working distance, and a flash fills in any dark shadows. In this case, a 100-300mm zoom lens was used with a hotshoe-mounted flash for fill lighting. 50 ISO film.

Above bottom: This closeup of a two-headed gopher snake was taken through the glass of a display case at the Los Angeles Zoo. The thick protective glass necessitates the use of flash and a camera angle of 90 degrees to the pane. Any other angle will distort the image and degrade the quality of the photograph. A 100mm macro lens allowed me to focus on the subject from the glass, and two flashes on a Macro Bracket gave even lighting and considerable depth of field. 50 ISO film.

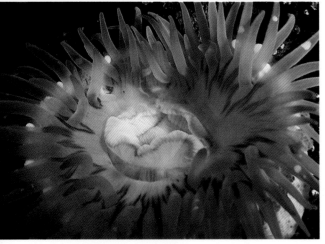

Above top: Large aquaria allow you to take underwater photographs without getting wet, but they also present the same difficulties encountered when photographing below the water's surface. Most underwater photographers use electronic flash to correct loss of light and color in the red and yellow parts of the spectrum, but even then considerable color is lost after the light travels through only a few feet of water. Look for subjects that are relatively close to your viewing area, and stay against the glass of the aquarium (being careful not to scratch it) in order to minimize reflections. 28mm lens with two flashes on a Macro Bracket. 100 ISO film

Above bottom: Small aquaria, whether they be in your home or at a public facility, are excellent macro studios when filled with colorful and exotic subjects that can be photographed with great clarity. Use macro lenses, stay close to the glass, and try to shoot at a 90 degree angle to the pane. This sand-rose anemone was photographed at California's Monterey Bay Aquarium. 50mm macro lens and a Macro Bracket holding two flashes; 50 ISO film.

to the glass. At any other angle, the glass will act like a lens and render every subject out of focus.

Interesting compositions possible at large aquaria include reef areas teeming with fish, schools of fish swimming towards the photographer out of the darkness, or large sharks and salmon swimming directly past the camera. As long as the lens is kept close to the glass, the aquarium photographer can bring home the same kinds of photographs as the diver, without getting wet.

Small aquaria. Subjects in small aquaria are the macro-photographer's delight. A multitude of intricate subjects is available that could never be photographed properly under water. Public aquaria have many small tanks, all with their inhabitants precisely identified. The photographer can visit a large number of little underwater worlds in one day, and come back with a diverse array of fascinating and colorful images.

A Lepp Macro Bracket II with two medium-powered TTL hotshoe flashes and a variety of lenses including 50mm and 100mm macro, medium telephoto zooms with two-element closeup lenses, and an assortment of macro accessories will provide a sufficient variety of photographic approaches for small aquaria subjects. The flash bracket system must position the strobes away from the lens, but must not extend past the edge of the aquarium. As always with glass barriers, keep the lens as perpendicular as possible to the surface to eliminate reflection and ensure maximum sharpness.

Remember the Day at the Zoo

Sessions of zoo photography can be great for practicing new techniques and can provide opportunities you'd never have in the field. You can achieve superb and marketable results. In the case of publication, be sure to remember the zoo — photographic ethics require that you acknowledge that your subject was restrained even though you've strived to eliminate all photographic evidence of the fact.

OPTICAL EXTRACTION FOR LANDSCAPE

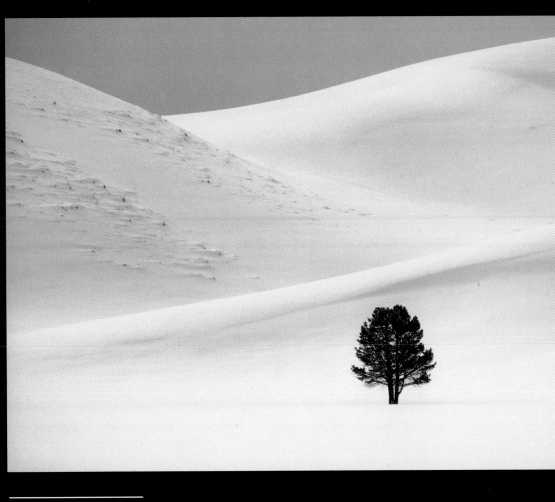

Hayden Valley Lodgepole

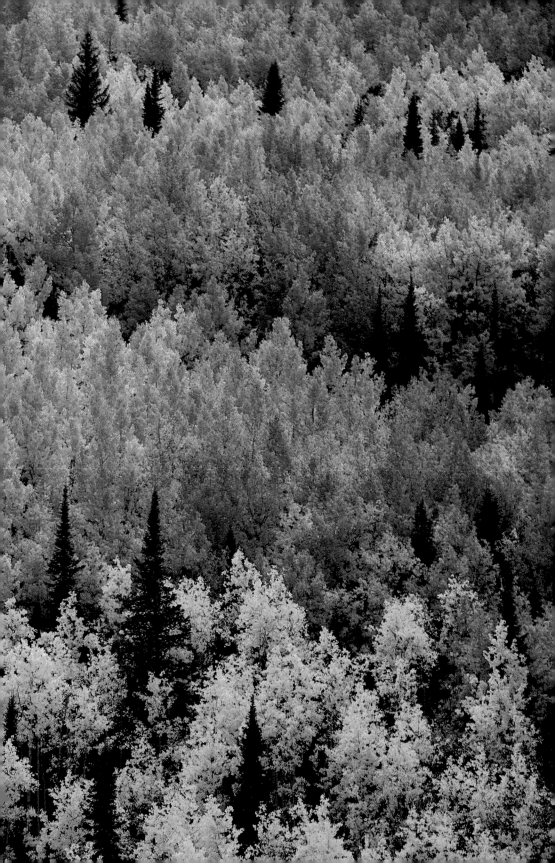

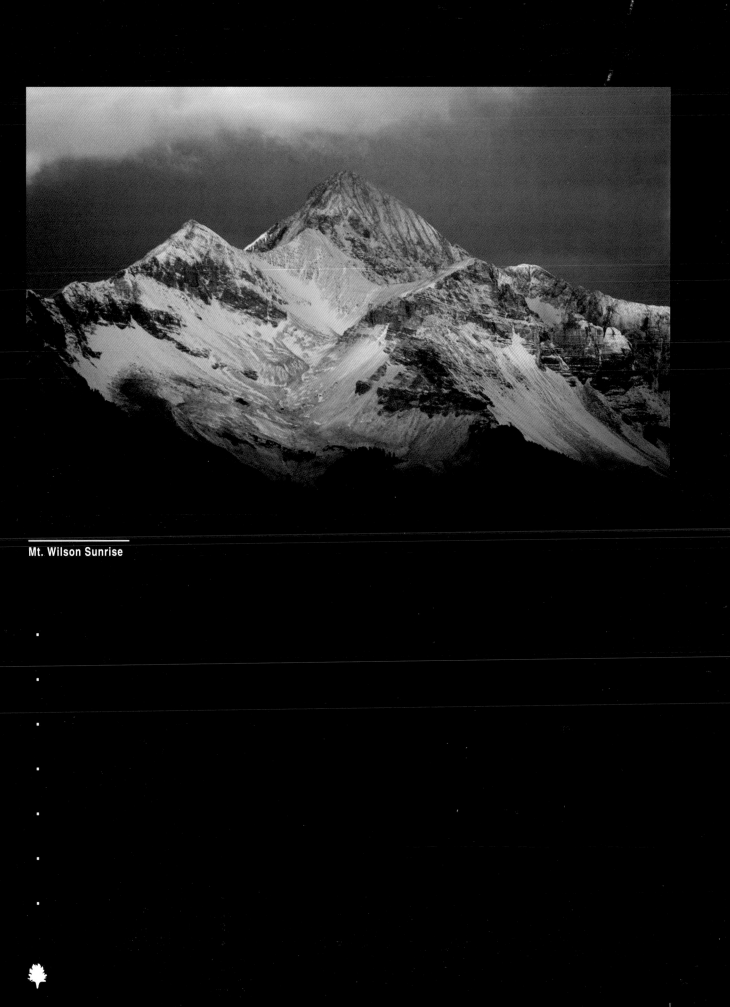

Mt. Wilson Sunrise

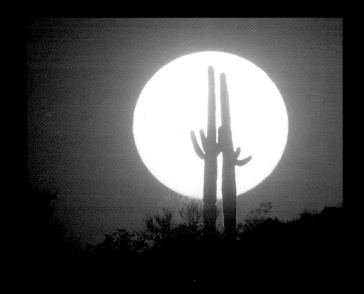

Saguaro Sunset Silhouette

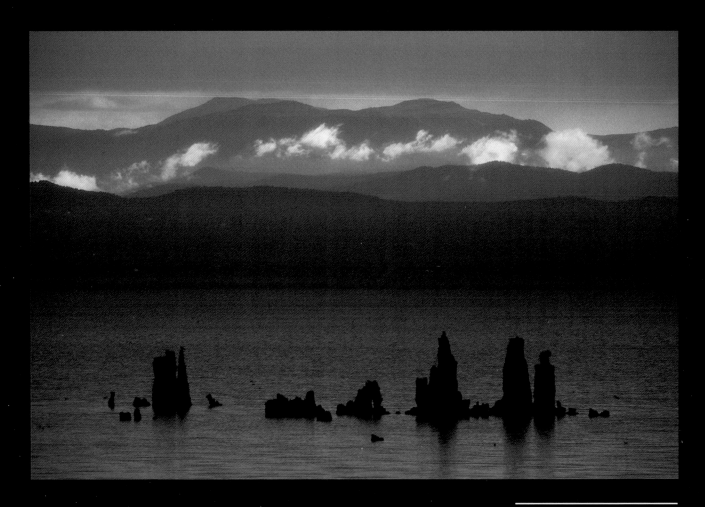

Mono Lake and Distant Clouds

Hayden Valley Lodgepole

This lonely lodgepole pine stands forty miles by snowmobile into Yellowstone National Park. The photograph is an example of optical extraction accomplished with a 35-350mm zoom lens set at approximately 300mm. Using a telephoto zoom lens for landscape photography allows the photographer to fine-tune the image without having to move from an accessible vantage point. In this case, deep snow restricted movement. 50 ISO film.

Aspen and Pine

Contrasts of color and texture can be extracted from our surroundings if we view them as a telephoto lens does. This patchwork of yellows and greens on a mountainside above Telluride, Colorado is compressed and concentrated when extracted by a 500mm f/4.5 lens. 50 ISO film

Mt. Wilson Sunrise

Sometimes getting up and out in the cold at sunrise has its compensations in exceptional photographic opportunity. One fall morning at Skyline Ranch near Telluride, Colorado, rising before dawn was rewarded with this 600mm view of 14,250 foot high Mt. Wilson. So much happens while we're sleeping–or just looking the other way. 50 ISO film.

Saguaro Sunset Silhouette

Once a photographer discovers the power of a telephoto lens for extracting images like this pair of saguaro cactus against a setting sun, he or she will want longer and longer optics. Tele-extenders can satisfy some long-lens needs and add impact when used with the sun or moon. A 500mm f/4.5 lens with 1.4X tele-extender (700mm) gave me a sun and cacti large enough to stand alone. 50 ISO film.

Mono Lake and Distant Clouds

I've photographed California's Mono Lake every June for thirteen years. During the three weeks I usually spend in the area I visit the lake many times. It's always different, and it's always beautiful. Telephoto lenses reach into the vista to show distant nuances missed by naked eyes. 400mm f/5.6 lens. 64 ISO film.

OPTICAL EXTRACTION FOR LANDSCAPE

Looking with a telephoto lens at the elements composing a scene can reveal additional subjects like this thunderhead cloud over the Sierra Nevada Mountains. I was taking the first image, a wide-angle landscape of Mono Lake, when I noticed that the distant clouds were a photographic composition in their own right. The clouds were photographed using a 400mm f/5.6 lens. 50 ISO film.

As we stand before a magnificent landscape, we tend to take in the whole scene. Most photographers, hoping to convey to future viewers of their images not only the sight, but the feelings of vastness and beauty that inspired them, will endeavor to bring the full magnitude of the vista home on film. Usually they will be disappointed with the result. Something is lost between the time the picture was taken and the time it is shown to someone else. This is because only a very rare image can convey all of the visual elements that combine to form our overall impression of the landscape. Furthermore, the viewer of the finished image lacks all of the other external stimuli (sound, smell, or motion) that might have directed the photographer to the high points in the scene at the moment it was captured on film.

Many of the critical elements of a landscape are subliminal; that is, only the most discerning viewer will understand their essential contributions to the power of the scene. Developing the ability to recognize the critical elements of a scene is necessary to improve the quality of the overall photograph. But extracted from the landscape, the motivational elements themselves offer opportunities for more compelling images. This technique is called optical extraction, a term coined many years ago by my colleague Jack Kelly Clark.

Looking at the larger scene, the photographer must determine which features first drew his or her attention to it. Trained eyes, looking for the potential photograph within the confines of each lens's angle of view, will survey the area from the perspective of several lenses. Eliminating all elements that do not contribute to the message, concentrate on the very essence of the place. Telephoto lenses ranging from 135 to 600 mm, or even longer, are the best tools to accomplish optical extraction.

Lenses for Optical Extraction

Medium telephotos (135 to 300 mm). Single focal length medium telephotos are extremely useful for optical extraction, even though the effects they produce are not as spectacular as those some of the longer lenses will provide. The medium lenses are usually available to us. They are lightweight and less expensive, and even the lower-cost versions are generally critically sharp. While in most photography the medium telephotos are used hand-held, the fine detail sought in landscape photography demands a tripod to attain the very best definition a lens has to offer.

Zooms (75 to 300 mm). Although they offer the same focal length ranges as the medium telephotos described above, the zooms provide a distinct advantage: the ability to fine-tune a composition when the photographer must stay in a set position. Recent improvements in definition and contrast in high-quality zoom lenses make them a tool on par with even the best fixed focal length lenses, the proof of which is that most professionals now use quality zoom lenses on a regular basis. A cautionary note: Zoom lenses are more prone to flare than fixed focus lenses when shooting toward the sun, so the use of proper sunshades is a must.

Long telephotos (400+ mm). Long lenses give a compressed perspective that can be achieved in no other way. An aerial view might afford the same image area, but not the foreshortened perspective that renders the composition more interesting

A photographer appreciates a zoom lens when he or she is composing a landscape while perched upon the edge of a cliff and unable to move forward or to back up. Over the past few years I've used a 100-300mm zoom as a standard landscape lens. It allows the fine-tuning of compositions while maximizing the preciously small 35mm format. Recently I've been using a radical 35-350mm zoom lens for landscape photography. As long as a solid tripod is used and the lens is stopped down, the quality matches the versatility. 50 ISO film.

Bigger isn't always better; but in this case a borrowed monster 800mm f/5.6 lens gave me the effect I wanted. I've never owned a lens of this size because of its many drawbacks: distant minimum focus, heavy price, and sheer bulk. But for exotic optical extractions of landscapes it does have its place. 50 ISO film.

by isolating the critical element within the scene. The longer lenses see a smaller portion (usually less than six degrees) than the photographer's overall view (360 degrees), so using them effectively demands the ability to identify the fine points of the vista. Such skill comes only from considerable practice and concerted effort.

Maximizing Quality with Telephoto Lenses

The landscape techniques discussed here apply to all telephoto lenses, but most particularly to the longest, with which it is more difficult to achieve critical sharpness.

Tripods. Telephoto lenses cannot perform at their utmost quality unless they are secured on a tripod. The magnification of the lens exaggerates more than the image size: Every physical and technical flaw will be emphasized in the final image to the same magnitude as the power of the lens.

The nature of landscape photography usually allows time to set up the photograph with a quality tripod. Appropriate quality may mean greater weight and cost, but a reliable tripod is every photographer's most important accessory. My personal tripod preferences are the Bogen 3021 and 3221, the Gitzo Reporter and Safari, and heavier models from both manufacturers. I recommend the addition of a well made quality ball head capable of handling the largest telephoto lenses and a quick-release plate based on the Arca Swiss model.

Mirror lock-up. If even faithful and careful use of a quality tripod results in images that are not as sharp as you expect, the culprit may be internal mirror vibration. My tests have shown that with lenses shutter speeds in the 1/30 to 1/4 second range, it is impossible to achieve the resolution potential of a lens longer than 300mm. The landscape photographer often works early or late in the day, or under adverse weather conditions, which require longer shutter speeds. Coupled with longer lenses, the risk of internal mirror vibrations degrading the image is very high.

The best solution for internal mirror vibrations is a mirror lock-up. Unfortunately, many modern cameras do not offer this essential function. If your interest lies in quality 35mm landscape photography, give serious consideration to the purchase of a camera body with mirror lock-up capability.

If mirror lock-up is not possible, it is best to avoid risky shutter speeds when working with telephoto lenses. Modify the shutter speed-f/stop combination until the shutter speed becomes faster or slower than the high-risk 1/4 through 1/30 range. For example, f/22 might produce a reciprocal speed of one second, while f/2.8 might allow the use of 1/60 second.

With or without mirror lock-up, a remote or cable release will assure that tripping the camera does not cause additional movement of the system at the time of exposure. A two- to ten-second self-timer will accomplish the same objective.

Best f/stops. Every lens has its optimal area of sharpness relative to the f/stop used. Today's newer telephotos at their widest apertures are usually quite good and will achieve their maximum sharpness stopped down one to two stops, then will begin to lose resolution when stopped down to the last two f/stops. When working

Landscapes often are taken in the extremely low but interesting light of dawn or dusk. This Mono Lake photograph was taken an hour before the sun actually rose. With an exposure of approximately one minute it is necessary to use a good tripod, use a cable release to set off the shutter, and evade errant breezes. If a mirror lock-up provision is available on your camera, use it. 50 ISO film.

on landscapes, with the opportunity to optimize controls from a tripod, there is no reason to deviate from those apertures which give maximum resolution unless it is to avoid certain shutter speeds to reduce internal mirror vibration.

Filters on telephotos. Care must be taken when working with filters on telephoto lenses, because there is greater tendency for poor optical filters to affect sharpness and/or focusing of the lens. Poor quality filters (especially polarizing filters) placed on telephoto zooms may render lenses unable to focus at the higher focal lengths. Front-mounted external filters add two additional glass surfaces, increasing the possibility of flare. Many of the longer lenses accommodate small drop-in filters which are a better choice to maintain sharpness and avoid flare. With or without filters, all lenses should be used with the properly designated sunshade. In addition to helping to eliminate flare, lens shades protect the front surface of the lens from damage if it is bumped or dropped.

Taking the Long View

Optical extraction, then, relies upon long, fixed focal length or powerful zoom telephoto lenses to select the most powerful visual elements from a vast landscape. As with all high-magnification photography, special care must be taken to eliminate camera movement when taking the long view. But if you want to bring it all home, get out your wide-angles and read on.

WIDE-ANGLE LANDSCAPE

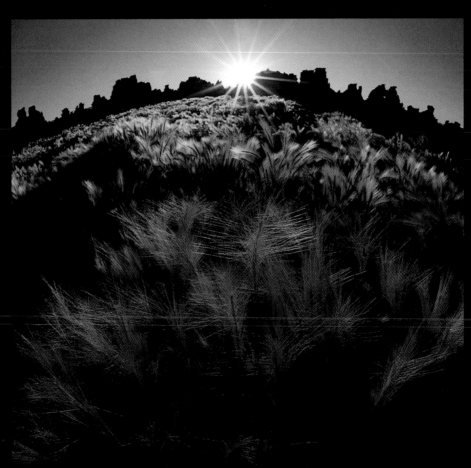

Grasses to Infinity

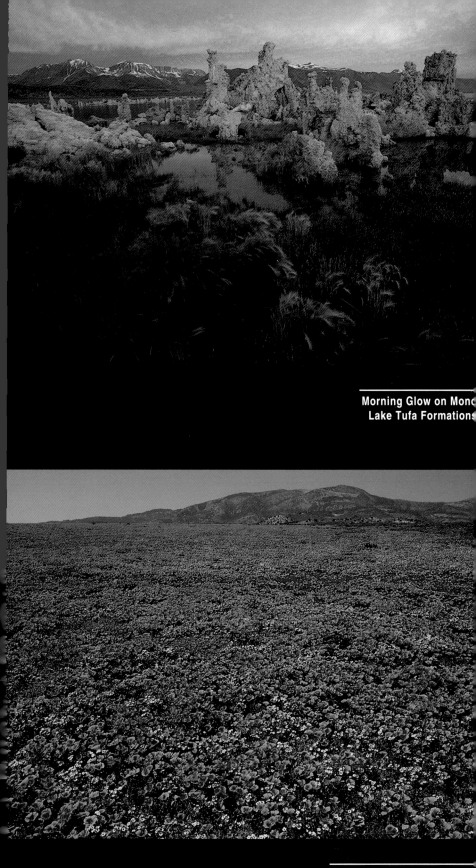

**Morning Glow on Mono
Lake Tufa Formations**

Poppies and Birds-Eye Gili

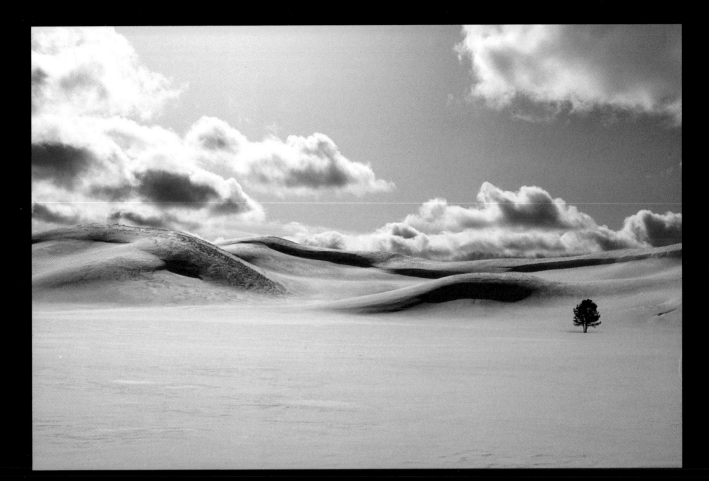

Lonely Lodgepole

Grasses to Infinity

A fish-eye perspective is evident in this early morning landscape of the grasses and tufa formations at Mono Lake, California. The lens will give a convex curve to a horizon located high in the frame and a concave curve to a horizon located low in the frame. For this image, I used a 16mm full-frame fish-eye lens set at f/22. 50 ISO film.

Morning Glow on Mono Lake Tufa Formations

First light on the Sierra Nevada Mountains adds a warm glow to the grasses and tufa formations at the edge of Mono Lake. An 18mm lens expands the view to include more of the foreground and distant mountains. At f/22 on 50 ISO film.

Poppies and Birds-Eye Gilia

In some springs these hills produce only an occasional poppy, while in other years the fields are carpeted with golden blossoms. A 20-35mm wide-angle zoom lens set at 20mm maintains sharpness from the foreground all the way to the distant hills. The proper use of hyperfocal distance is the basis for this type of wide-angle landscape. At f/22 on ISO 50 film.

Lonely Lodgepole

An expanse of snow leads the viewer to the lone lodgepole pine tree in the distance. In the course of two winters I photographed this tree in Yellowstone's Hayden Valley five times under very different lighting conditions. Using lenses from 20mm to 400mm varied the perspective. This rendition was photographed on 50 ISO film with a 20-35mm zoom lens set at 20mm. For a very different view of the same subject, see the photograph leading the previous chapter.

WIDE-ANGLE LANDSCAPE ☀

Wide-angle landscape is the classic photographic enterprise. This view, although traditional, is difficult to accomplish effectively because so much is included in the photograph. There is not always a center of interest, and the photographer may have to rely on design and color elements to create a dynamic image. Sunsets, sunrises, towering clouds, or lightning are either supportive or central elements in the landscape.

The grand view has been the bastion of the large-format photographer since the invention of the medium. Large formats have an advantage over 35mm formats because of the amount of detailed information they are able to bring forth on a larger film area. But 35mm formats add a new perspective with ultra-wide-angle lenses not available on 4x5 view cameras.

In order to compete in the information arena, it is imperative that 35mm photographers use the finest-grained films, highest-resolving optics, and techniques that maximize the potential of these tools. It is ironic that today's advanced photographic equipment and films are available at a time when the classic grandscape is diminishing due to the intrusion of other symbols of man's technological progress: power lines, roadways, soiled skies, and decimated forests.

Compositional Considerations for Wide-Angle Landscapes

The first consideration in composition of wide-angle landscape images is the position of the horizon in the frame. Where it is placed will determine the emphasis in the photograph: on the sky if the horizon is low, and on the foreground and middle areas if the horizon is high. Thus if magnificent clouds are the most impor-

A low horizon places the emphasis on the red clouds over the mountains of Yosemite National Park's Tioga Pass. The 18mm lens helped to create the expansive view, even though I was photographing from the base of the mountains. 64 ISO film.

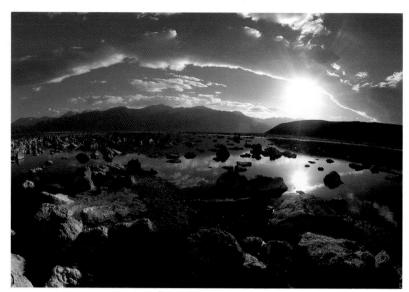

Bringing the horizon above the middle of the frame shifts the emphasis of the image to the foreground. The photographer needs to be sure that the strongest elements are located where the overall photograph's greatest emphasis lies. Mono Lake's north shore has many unusual pools and rocks. While the sky is interesting with the cloud formation and sunburst, the high horizon keeps it from overpowering the foreground. 20-35mm zoom lens and 50 ISO film.

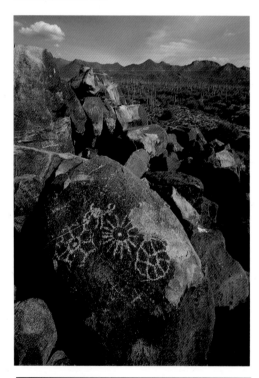

The expanded perspective of the wide-angle lens enables the photographer to showcase an object in the foreground while keeping the background sharp. The pictographs at Saguaro National Monument are emphasized in the bottom half of the frame, while their desert location is clearly shown in the upper right. 17mm lens set at f/22; 50 ISO film.

tant feature of your composition, keep the horizon low or they will lose their drama. A high horizon behind a weak foreground leaves nothing to lead the viewer into the landscape. When the emphasis is placed on the foreground, and the distance also is important to the image, depth of field should be maximized. This is accomplished by using a small f/stop or a tilt lens. In either case, a tripod is essential.

Wide-angle lenses change perspective; in the resulting image near objects will look relatively close, but distant shapes will appear to be farther away than they really are. This forced perspective is different from the distortion rendered by the artificial curvature of straight objects within the frame that once plagued landscape photographers using wide-angle lenses. Highly corrected modern lenses, other than fish-eye, have eliminated this unwanted effect.

Vertical objects such as trees, rock faces, or sandstone arches on one or both sides of the frame can effectively lead the viewer into the scene while adding depth to the image. Their contribution should be subtle and supportive of your subject. Otherwise, this technique can easily overwhelm and unbalance your composition.

Lenses for Wide-Angle Landscape

Wide-angle lenses for landscape can be grouped into three categories. The most commonly used are 28mm to 20mm, in zoom configuration or in single focal lengths of 28, 24, 21, and 20mm. The 28 and 24mm lenses in this group will show less distortion, while the 21 and 20mm lenses provide a greater wide-angle perspective. All vertical and horizontal planes will be rendered rectilinear with these lenses, which means that straight lines will not be curved artificially in the resulting image.

Included in the 28 to 20mm group, but less commonly used, are the tilt/shift lenses available from some manufacturers. These lenses allow the front elements to be tilted, altering the plane of focus and rendering more efficient use of depth of field. Even at large f/stops and fast shutter speeds, extensive depth of field can be achieved using the tilt/shift lens. For example, an expanse of flowers blowing in the wind calls for a fast shutter speed to stop movement, but an extensive depth of field to cover the entire mass. A 24mm tilt/shift lens set at f/5.6 with full tilt can give a depth of field equivalent to that of a standard lens of the same focal length set at f/22.

The 17mm through 14mm lenses are used for effect. These exaggerate the wide-angle look of the image just short of distortion. Using proper technique, depth of field can be incredible, with sharp focus maintained from less than one foot to infinity. Imagine the flower directly in front of the lens perfectly rendered and the mountain

Above: The Canon EOS 24mm tilt/shift lens set on maximum tilt. The angle of the front element shifts the depth of field to make it more usable for many landscape situations.

Below: Although the wind was ruffling these flowers, a 24mm tilt/shift lens stopped their movement by modifying the area of sharp focus to allow for use of a larger f/stop and faster shutter speed. 1/250 at f/5.6; 50 ISO film.

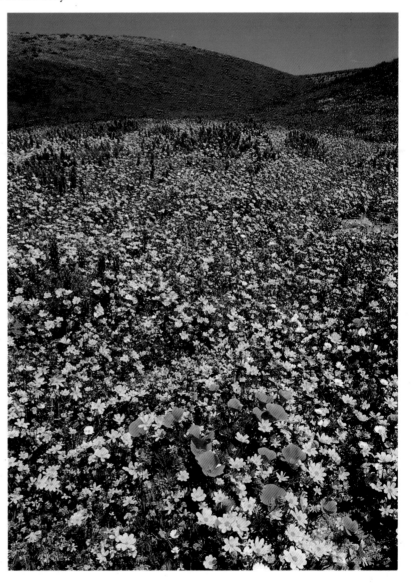

range in the background continuing in complete sharpness. The photograph is packed with information. We know what the flower looks like and where it resides, all from one image.

Fish-eye lenses come in two distinct varieties: full frame and circular. In my opinion, only full-frame fish-eyes are useful for wide-angle landscape photography. The circular fish-eyes do not fill the frame with the image and are quickly dismissed as gimmicks.

Above: Dwarf monkey flowers dot the arid desert floor on the east side of the Sierra Nevada Mountains. A 17mm lens stopped down to f/22 provides sharp focus from approximately ten inches to infinity. 50 ISO film.

Below: The full-frame 16mm fish-eye lens was used for effect by pointing it downward and allowing the horizon to become curved. The drama of the image is enhanced by the details of the waves in the immediate foreground and the storm clouds in the distance. 50 ISO film.

The full-frame fish-eye gives a distinctively distorted look to the image that most viewers will immediately recognize as a special effect. One element of the effect is the exaggerated curvature the lens attributes to every line except those exactly in the vertical or horizontal midpoints of the frame. A horizon bisecting the frame will look normal, but if placed in the upper half will give a round-earth effect and if placed in the lower half will give a bowl effect. Trees or other vertical subjects will curve more toward the center as they approach the outer limits of the frame. A second element of the distortion of fish-eye lenses is the forced perspective that occurs; even close objects are portrayed as being far from the lens, and the effect

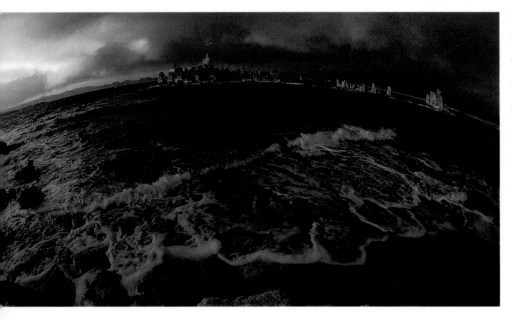

multiplies exponentially with increasing distance. Combined with the round-earth effect, your viewer sees the landscape from a skewed perspective which piques interest. Overdone, it loses its impact.

☀

Techniques for Wide-Angle Landscape Photography

Wide-angle lenses offer an expanded way of viewing our surroundings. The human eye sees the approximate equivalent of a 45mm lens, while wide-angle lenses can capture a 180 degree view or even greater. This expanded view requires particular techniques to maximize the offerings of the lenses.

Understanding of hyperfocal principles is essential to maximizing the depth of field critical to a fully detailed landscape. As described in "Creative Flower Techniques" earlier in this book, using the hyperfocal distance will greatly increase the usable depth of field to add emphasis to the foreground of your landscape. If you're using wide-angle zoom lenses, use the chart provided in the "flower" chapter to find the hyperfocal distance that corresponds to the f/stop being used, and set the focusing ring to that distance. Half the set distance to the camera will be sharp, as will the hyperfocal distance to infinity.

The Canon EOS 24mm tilt/shift lens set for maximum depth of field using f/22.

If a fixed focal length wide-angle lens is being used, set the infinity mark opposite the f/stop depth-of-field scale marker, and read the distance scale at the opposite same f/stop marker. This closest distance is the nearest zone of focus to infinity that will be sharp.

Include the Sun

Ignoring the "sun over the shoulder" adage and including the sun in the composition is one technique which adds interest to a landscape. The human eye naturally seeks to avoid the sun as part of a directly viewed image, so its inclusion in a photograph provides the viewer with an opportunity to see something unusual. When undertaking a sunscape, however, the photographer must remember parental cautions about looking directly at the sun; the camera and lens do not provide any protection. With a wide-angle lens the sun within the frame is relatively small and can be avoided while looking through the viewfinder. You can quickly note its position within the composition by using the depth-of–field preview button to darken the viewfinder.

Within a composition, the sun can be one of three things: a distracting washed-out area in the sky, a sunburst which adds impact and enhances other aspects of the composition, or the only center of interest in a darkened frame. Exposure controls the outcome. In

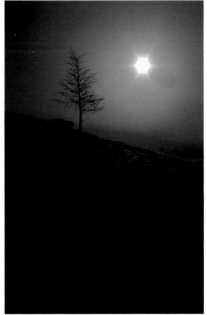

Here are three examples of including the sun in the photograph.

Left: In the first image, the overexposed sky doesn't provide enough contrast to clearly delineate the sunburst.

Center: This exposure is the best, in my opinion. There is plenty of detail in the foreground, and the sky is darkened just enough to emphasize the sunburst.

Right: Here the image is so heavily underexposed that the sunburst dominates the scene, and foreground detail is nearly obscured. Each image taken with 20-35mm zoom lens; 50 ISO film.

general, a one-stop underexposure from a 'sunny 16' will give an interesting but not overwhelming result: a slightly darkened sky delineating the sunburst and plenty of information still visible in the foreground. The best way to fine-tune the exposure is to bracket in one-half f/stops starting with 'sunny 16' and ending with two stops of underexposure.

A sky with clouds can be used to advantage. Place the sun behind a cloud so a normal exposure will allow the foreground to record, or have the sun peek from the edge of a cloud for an interesting star effect. This last technique will probably require the one-stop underexposure.

Having It All

By extending the depth of field from just in front of the camera to infinity, the photographer enables the viewer to see the entire scene. An interesting element can be used up front to pique the interest of viewers and start them on a journey through the image. The biggest problem in photographing the grandscape with a wide-angle lens is that it diminishes everything to such a small scale. Having larger elements in the foreground will do wonders for your landscapes. Finally, fine-tune your landscapes with filters. The difference between a nice picture and a dynamic image can be the slight difference a filter can make.

CREATIVE
FILTER
USE

Formation

Shooting Stars

153

Soft Surf

Ute Formation

The emphasis on the sky in this image is enhanced by use of a polarizing filter as well as a low horizon. The quickly changing cloud patterns altered the light placement as they moved. I waited for the sun to strike the unusual ground formation located near Ute, Colorado. 24mm wide-angle lens; 50 ISO film.

Silky Waters

Using neutral density filters, I extended the exposure time to allow the cascading water to record as silky strands flowing over the rocks. A 100-300mm zoom lens set at 300mm was used to extract this image from the huge waterfalls near Devil's Postpile, California. 50 ISO film.

Shooting Stars

In this image, a two-stop graduated split neutral density filter equalized the color intensity of the sky and the field of flowers. A sliding filter holder enabled me to place the filter's transition line along the horizon at the base of the mountains. The photograph was taken with a 24mm tilt/shift lens to help stop the effect of wind on the foreground blooms. 1/250 second at f/8 on 50 ISO film.

Soft Surf

An extremely effective 2.0 neutral density filter stopped down the lens by six stops, enabling a long exposure of the surf off the coast of Central California. The continuing exposure of the swirling waves under changing light at sunset gives a misty effect with unusual color. 28-105mm zoom lens; 1 minute at f/11 on 50 ISO film.

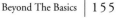

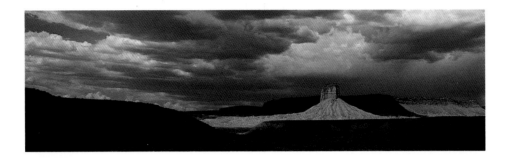

CREATIVE FILTER USE ⛰

Filters—tinted transparent disks of glass or plastic that are placed in the light path of the lens—are tools which alter the natural or ambient light entering the camera. Filters are appropriately used to correct undesirable light or film characteristics, and can greatly improve image quality under such conditions. Used with precision, filters also can enhance the overall image. They can make the difference between a good photograph and a great one by taking the image that last step to the best possible result.

Many photographers, eschewing the effort proper use requires, ignore the potential which filters offer their images. In importance to the dedicated nature/outdoor photographer, however, filters follow close behind the choice of camera, optics, tripod, and film. And, fortunately, filters are among the less expensive photographic accessories.

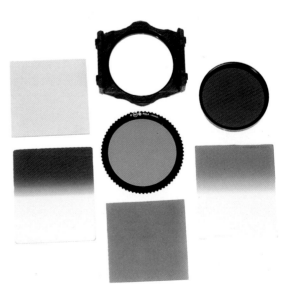

A selection of filters that I commonly use in the field: Pictured clockwise from the Cokin "P" filter frame at the top are a Tiffen .9 neutral density filter, a Tiffen two-stop graduated split neutral density filter, a Singh-Ray two-stop square neutral density filter, a Tiffen three-stop graduated split neutral density filter, a Cokin 81B warming filter and, in the center, a Cokin circular polarizing filter.

Principles for Filter Use

Filters can be tools to modify an image creatively, to enhance or improve light conditions, to alter the color bias of a film, or to modify the light within parts of a scene to accommodate the contrast limitations of a film. Filters have been put to best use when their effect is subtly integrated into, but not obviously a part of, a successful image. Learning about the potentials of filters requires experimentation and documentation. The trial is simple: Record the same image with and without various filters, and keep notes.

Certain principles apply to the use of all filters. First, the placement of a piece of glass or plastic in front of a lens will have some impact on the image quality. The influence of most major-brand filters of high optical quality is undetectable, while others may cause serious degradation of image sharpness and lens focus.

Second, because filters are handled a great deal and located up front while on the camera, they are frequently exposed to fingerprints, dirt, and scratches which will subtly spoil your image. It is essential to keep filters scrupulously clean and unscratched.

Third, in some cases lens hoods do not fit when a filter is added, so care must be taken to throw a shadow across the filter when in use. This will prevent unwanted flare and will maintain the color and contrast evident before the filter was added.

Fourth, while most photographers have lenses with various front-element sizes, it isn't necessary to purchase sets of filters in several sizes. Filters designed for larger lenses can be modified by using step-up rings to fit them to the smaller lenses. Be sure that the size of the filter is adequate for wide-angle lenses and not so small or thick that it causes vignetting at the extreme wide-angle end of the zoom.

Finally, use of filters should always be deliberate. That is, each use should be the result of a considered decision rather than a leftover from a previous photographic session. Except for some particular special effects, only one filter should be used at a time. Always remove the protection filter from the lens before adding another type.

A variety of adapters allow use of the Cokin "P" filter frame with lenses having filter threads of 52mm to 77mm.

Types of Filters

There are five basic types of filters that I believe are useful for outdoor/nature photography. While there are many varieties of each type, it is not necessary to carry them all. On any one trip, depending on the scope of the planned photography, I may carry from a minimum of four to an extended array of the following filters.

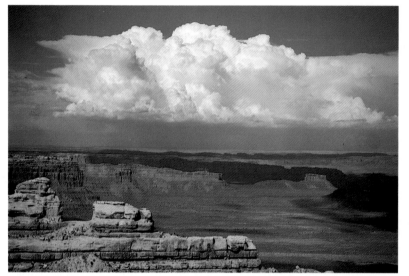

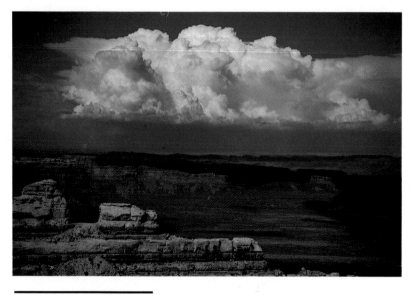

The image on top above, taken without a polarizing filter, is washed out by the light scatter associated with atmospheric haze. In the image on the bottom, a circular polarizing filter enriches the color saturation from the sky to the foreground rock formations. This view of the Valley of the Gods was photographed with a 100-300mm zoom lens from a vista point in southern Utah. 50 ISO film.

Polarizing filters. Linear and circular polarizing filters restrict the direction of extraneous light entering the lens, and so eliminate reflections and heighten the color of some subjects. Until recently, only linear polarizers were available. With the advent of autofocus and sophisticated auto-exposure, the circular polarizing filter was developed so as not to interfere with those mechanisms. Now linear polarizers are useful only when using older cameras and in cross-polarization techniques. For all other uses, modern cameras utilizing autofocus and auto-exposure modes require circular polarizers. Both types of polarizing filter render the same effect.

Polarizing filters can darken skies if the camera is angled at 90 degrees to the sun. Caution is needed with extreme wide-angle lenses, as their angle will exceed the possible area of polarization; that is, the portion of the image that is in the 90 degree angle to the sun will be polarized and dark, while the outside area will lighten. Some slide films accentuate the polarizer's sky-darkening effect. The intensity of the effect can be modulated by the rotation of the filter.

Within clusters of vegetation and groups of rock faces and on bodies of water, various reflective surfaces may reduce the saturation of color reaching the lens. To determine if polarization can improve the color saturation in the image, observe the area through a rotated, hand-held polarizing filter.

Neutral density filters. Neutral density filters are available in various intensities of neutral gray. The designations are .3, .6, and .9, with respective densities of 1, 2, and 3 f/stops. The filters are available in round or square glass or acrylic shapes as well as square acetate. Unfort-unately, not all neutral grays are truly neutral. Before you buy, check for true neutral gray coloration and be sure the filter's optical quality will not undermine your lenses.

Neutral density filters are primarily used to lengthen exposures, which creatively blurs the subject's movement. This can be particularly effective with moving water such as waterfalls, streams, and ocean surf.

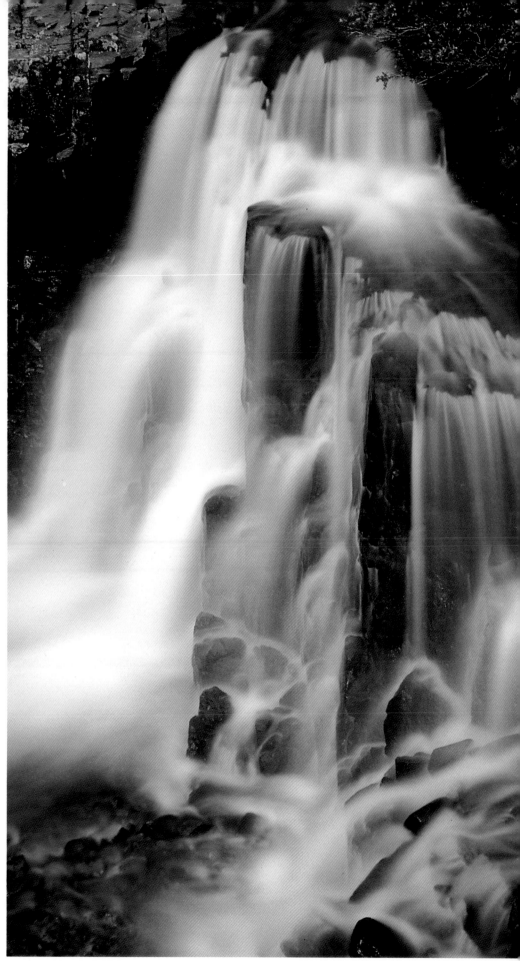

Even at bright midday, the exposure for this waterfall was slowed down with a .9 neutral density filter and a polarizing filter. The resulting exposure of ten seconds gives the flowing effect. With streams and falls, like these in Colorado's Yankee Boy Basin, the photographer can choose between stopping moving water with a fast shutter speed or this rendition, which suggests motion. 28-80mm zoom lens; 10 seconds at f/22 on 50 ISO film.

·*Left:* In this image, proper exposure for the mustard in the foreground results in a grossly overexposed sky.

Center: Exposing for the interesting sky obliterates detail of the mustard field beneath it.

Right: A three-stop graduated neutral density filter equalizes the intensity and detail of the sky and field. Placed in a sliding filter holder, the graduated filter's line of transition can be placed at the horizon, wherever it occurs.

Graduated split neutral density filters. These filters have both clear and neutral density gray portions joined by a graduated transition area. They bring two distinctly different areas of an image closer together in terms of exposure. For example, a vivid sky may be two stops lighter than the landscape below it. Exposing to allow sufficient detail in the land will wash out the sky; but holding back the sky with a two-stop graduated neutral density filter will properly render both areas of the scene with the same exposure. The filters are available in circular forms with the graduated area located in the center, but these are not recommended because they restrict the placement of the transition, which is seldom in the center of the image. A better configuration is rectangular. Used in a sliding filter holder, the transition may be positioned for best effect. Care must be exercised in determining where the graduated transition takes place in the image. It is easy to place the transition along a straight horizon, but a natural-looking transition is difficult to accomplish against a jagged range of light-colored mountains.

These filters are generally available in three shades of varying intensity—one stop, two stops, and three stops—and are composed of glass or hard-resin plastics. The glass is more resistant to scratching, but the plastics are more affordable. Either will perform well in front of the camera.

Enhancing filter. Made of special didymium glass, the enhancing filter selectively improves the color saturation of reds and oranges and leaves the other colors within the image unaffected. Fall colors, for example, are particularly responsive to the enhancing properties of the filter. The filter requires a compensation of from 1/2

to one stop of light, and the best results are achieved when used with transparency films. The cost of an enhancing filter is about the same as a quality circular polarizer.

Warming filters. Overcast skies and shade cast bluish tint on the subject. This will be evident in the resulting photograph. Simulating the warmer color of full sunlight, a warming filter will modify the light before it hits the film. The filters are available in three increasing levels of intensity: the 81A, 81B, and 81C.

Some transparency films already are biased towards warm tones and may require only an 81A to correct a bluish light. "Cold" films may require the stronger 81B or 81C for correction under the same light source. In the end, the variety of warming filters available provides a sufficient range to satisfy each photographer's personal taste.

Shade casts a bluish light that is evident on most films and gives the colder look of the photograph at left above. An 81B warming filter eliminates the blue tones and warms the overall scene in the image on the right. 20-35mm zoom lens at 20mm; 50 ISO film.

\mathcal{A}FTERWORD

In the end, different photographs come from the same places. With varied equipment, experience levels, opportunities, and a unique perception of what is important, each photographer brings home a selection of images that will define the place, the subject, and the personal vision of the photographer. Don't let anyone tell you not to bother because it's already been done. Even if you are the one who's already done it, it will be different if you do it again.

Nature photography is a little like fishing: You don't always catch the big one or hook the great shot, but being out there can be enough. Just be ready.

Gone ~~Fishing~~ Photographing

*S*EE HOW WILLINGLY
NATURE POSES HERSELF
UPON PHOTOGRAPHERS'
PLATES.

JOHN MUIR, 1872

INDEX

Italicized page entries refer to captions;
bold entries refer to photographs.

Afterword:

Page 162: **Northern Sunset.** Churchill, Manitoba, Canada. 600mm f/4 lens with 1.4X tele-extender (840mm); 50 ISO film.

Page 163: **Sun Rays.** Commercial airliner over Louisiana. 28-80mm zoom lens; 50 ISO film.